CLAUDE LORRAIN

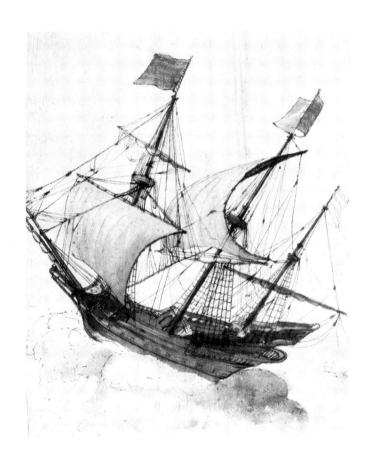

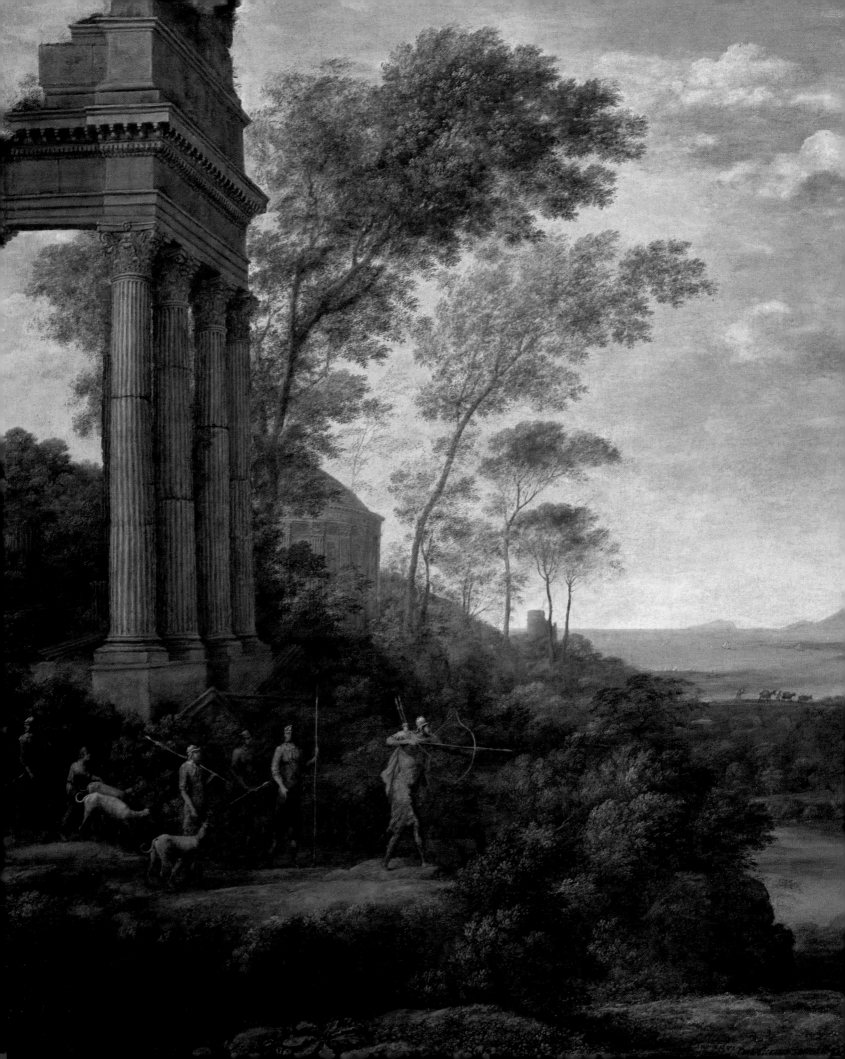

CLAUDE LORRAIN

HELEN LANGDON

GUILD PUBLISHING · LONDON

This edition published 1989 by
Guild Publishing
by arrangement with
Phaidon Press

Typeset in Apollo by BAS Printers Limited, Over Wallop, Hampshire
Printed in West Germany by Mohndruck Graphische Betriebe GmbH.,
Gütersloh

Acknowledgements

This book draws on the discoveries of many earlier scholars and writers on
Claude Lorrain, and the author would like to express her particular
indebtedness to the catalogues of the paintings and drawings by Marcel
Roethlisberger; to Michael Kitson's many stimulating articles on Claude, and
particularly to the exhibition catalogue of the *Liber Veritatis*; to Marco
Chiarini's sensitive descriptions of the drawings; to the new research of Diane
Russell, particularly on Claude's relationship with Colonna and other patrons;
and to Michael Wilson's discussions of pictures in the National Gallery,
London. A fuller bibliography is given in Diane Russell, 1982. The author
would also like to express her gratitude to the Society of Authors for an award
which enabled her to travel in Italy, France and Spain whilst researching this
book.

By permission of Birmingham Museum and Art Gallery 61; Courtesy, Museum
of Fine Arts, Boston, Seth K. Sweetser Fund 15: Picture Fund 121;
Braunschweig, Herzog Anton Ulrich-Museum, Museums foto B.P. Keiser 20;
Archivi Alinari, Florence 30, 36, 44, 51; Scala, Florence 19; By permission
of Viscount Coke and the Trustees of the Holkham Estate 8, 72, 92, 105, 111;
Reproduced by Courtesy of the Trustees of the British Museum 3, 4, 5, 6,
9, 18, 22, 33, 34, 53, 54, 62, 78, 88, 96, 97, 99, 103, 112, 115, 117; The National
Trust Photographic Library 90, 102, 118; By kind permission of His Grace
the Duke of Westminster 64; Reproduced by Gracious permission of Her
Majesty the Queen 59; © Prado Museum, Madrid. All Rights Reserved 42,
43, 45, 46, 47, 48; Artothek Munich 107, 108; Cliché des Musées Nationaux,
Paris 14, 17, 24, 28, 32, 89; Cliché: Musée de la Ville de Paris © by SPADEM
1987 37, 66; Arte Fotografica, Rome 58, 70; Istituto Centrale per il catalogo
e la documentazione, Rome 13, 27, 40, 51, 65; By permission of the Fine Arts
Museum of San Francisco. Achenbach Foundation for Graphic Arts Purchase
31; National Gallery of Art, Washington, Ailsa Mellon Bruce Fund 67;
Windsor Castle, Royal Library. © 1988 Her Majesty the Queen 25; By kind
permission of the Marquess of Tavistock and the Trustees of the Bedford
Estates, Woburn Abbey.

Half-title: *Ship in a Storm*. c.1638. Pen and brown wash, 27 × 22 cm.
(10⅔ × 8⅔ in.). London, British Museum.

Frontispiece *Landscape with Ascanius shooting the stag of Silvia*. 1682.
Oil on canvas, 120 × 150 cm. (47¼ × 59 in.). Oxford, Ashmolean
Museum. This was Claude's last picture; he died before he had time
to include it in the *Liber Veritatis*.

CONTENTS

Introduction

9

Arrival and early fame in Rome

19

Pastoral Painting 1640–50

61

The Grand Style 1650–60

101

Romantic Mythologies, the 1660s

121

Legendary Heroes

141

Notes

158

Bibliography

159

Index

160

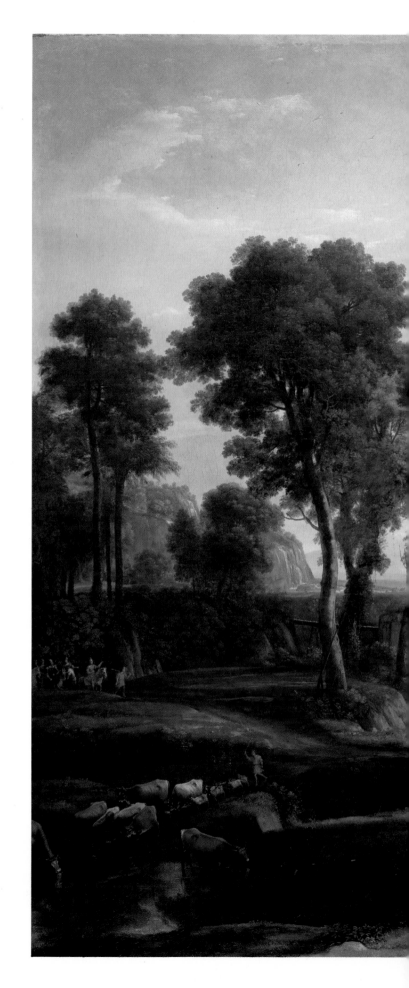

1 *Landscape with Dancing Figures (The Marriage of Isaac and Rebecca or The Mill)*. 1648. Oil on canvas, 159 × 197 cm. (62⅔ × 77½ in.). London, National Gallery. The title, the *Marriage of Isaac and Rebecca*, is inscribed in French on the tree stump in the centre. It has little relevance for the picture, which is a classical rendering of the theme of the country dance.

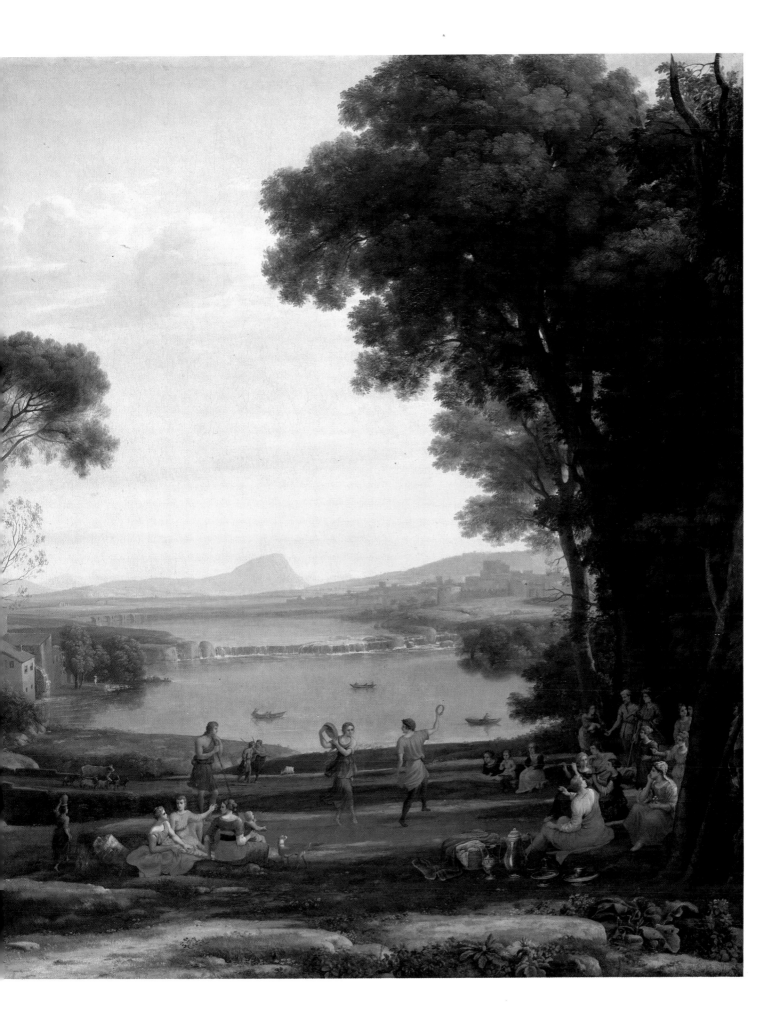

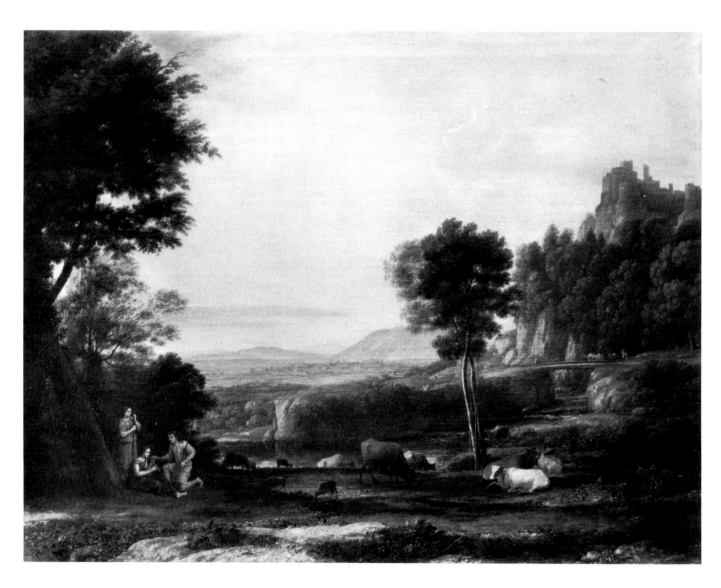

2 *Pastoral Landscape*. 1645. Oil on canvas, 101·5 × 134 cm. (40 × 52¾ in.). Birmingham, The Barber Institute of Fine Arts, The University of Birmingham. In the 1640s Claude painted many pure pastorals, and this serene picture is one of the loveliest; it perfectly conveys the mood of Virgil's *Eclogues* where the shepherd's piping suggests the harmony between man and nature, the animals adding a sense of richness.

INTRODUCTION

*'Pure as Italian air, calm, beautiful and serene, springs forward the works
and with them the name of Claude Lorrain. The golden orient or the amber-
coloured ether, the midday ethereal vault and fleecy skies, resplendent
valleys, campagnas rich with all the cheerful blush of fertilization, trees
possessing every hue and tone of summer's evident heat . . .'*
(J. M. W. Turner)

The landscapes of Claude Lorrain create an intensely imagined and flawlessly consistent poetical world. His vision is based first of all on a passionate study of nature, in the countryside around Rome, and along the Neapolitan coastline. This landscape was the constant inspiration of his art, and he revealed the beauty and grandeur of its changing light, its glittering seas, its distant plains and majestic trees as though seen for the first time. His is the vision of an artist from northern Europe, responding to the clear light and enchantment of a sunny Mediterranean land.

Yet from such studies Claude created an ideal world, classically structured and balanced, ordered and harmonious. His landscape evokes a dream of pastoral peace, where mankind and nature are in harmony, and where summer is eternal. It is a landscape rich in history, where the splendour of classical remains recalls those great myths and legends of Roman Antiquity that were so passionately revered in the seventeenth century.

Claude was an outstandingly successful artist, who painted for the Popes and great Italian aristocrats; his works were admired throughout Europe by the most distinguished and learned patrons. To such patrons the world of Virgil (70–19BC) and Horace (65–8BC), who had celebrated the beauty of Italy and of the Roman Campagna, was intensely real, and underlying the beauty of Claude's landscapes is a vision of nature inherited from classical antiquity and enriched by the poets of the Renaissance. In antiquity, when the natural world was threatening and the real world turbulent, poets sought refuge in the *locus amoenus*, or lovely place – a landscape that offered the coolness of trees beside a shady pool or brook, the sweet shelter of mossy cave or woods, where birds sang and shepherds piped. In such a landscape the shepherds of Theocritus' (fl. c.270BC) *Idylls* took refuge from a lush Alexandrian court. Virgil's *Eclogues* developed the theme; his shepherds, Tityrus and Meliboeus, who came to symbolize the pastoral life, inhabit the

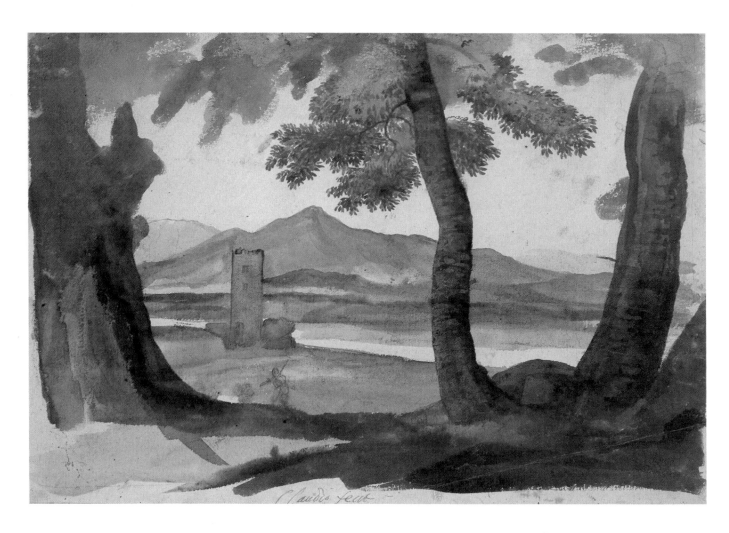

3 *Tree Trunks in the Campagna*. Chalk and dark brown wash with pink wash at the bottom, 22·1 × 33 cm. (8⅓ × 13 in.). From the Campagna book. London, British Museum.

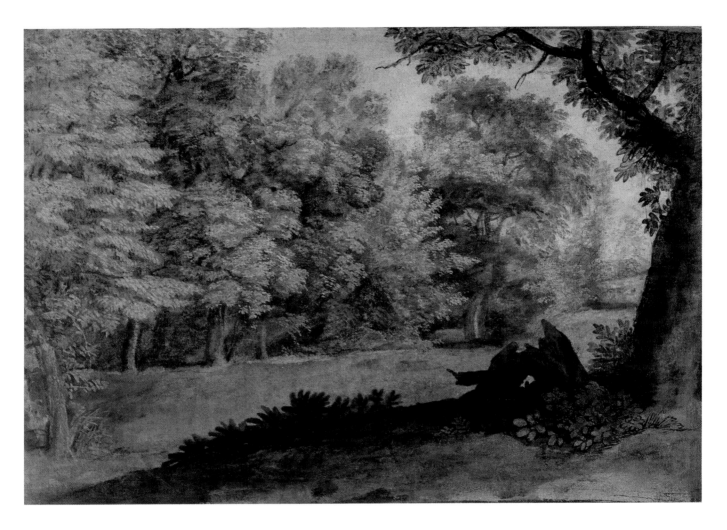

4 *Wooded View.* c1645. Brown and grey wash, with heightening, pink wash in the middle distance, on blue paper, 22·4 × 32·7 cm. (9 × 13 in.). London, British Museum. In the 1640s Claude did fewer spontaneous nature studies; this highly finished, carefully framed and balanced drawing characterizes the new tendency of his art. It looks back, in both mood and technique, to the gouache drawings of Elsheimer.

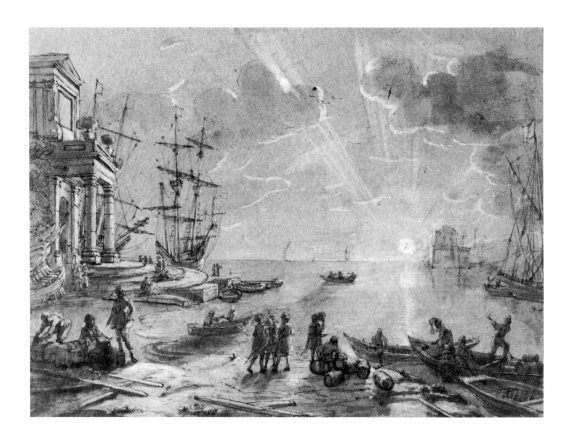

5 *Liber Veritatis* 26. Pen, brown wash and white heightening on blue paper, 19.2 × 26.2 cm. ($7\frac{1}{2}$ × $10\frac{1}{3}$ in.). London, British Museum.

enchanted countryside of an imaginary Arcadia, where they sing of their herds and their loves. The landscape of the *Eclogues* is bright with colour and light, the hot light of midday, and the melancholy evening light, when 'oxen now bring home their yoke-suspended ploughs, And the sun, going down, doubles growing shadows' (*Eclogue* 2). Man and nature are in harmony; trees and rocks echo the shepherds' song; even the animals, marvelling, forget their pasture. In the later *Georgics* the poet moves from his dream world to the celebration of a hard and simple way of life. Yet the most famous part of the poem praises the virtues of country life in purely pastoral terms:

> How lucky, if they know their happiness,
> Are farmers, more than lucky, they for whom,
> Far from the clash of arms, the earth herself,
> Most fair in dealing, freely lavishes
> An easy livelihood . . .

Renaissance poets revived these pastoral themes. Sannazaro's *Arcadia* describes an idyllic landscape, yet one deeply tinged with melancholy, where idealized shepherds lament lost love. His poem is rich in descriptions of the landscape – 'But when bright daylight was come, the rays of the sun appearing on the tops of lofty mountains, and the shining drops of fresh dew being not yet dry on tender grass, we drove our flocks and herds from the closed in valley to pasture among green meadows' – and adorned with small temples and altars that suggest the presence of Virgilian country gods – 'Pan and old Silvanus, And the sister nymphs.'

In the seventeenth century such themes retained their power; Sannazaro remained widely popular, and his pastoral vein was elaborated by Tasso in the *Aminta*, with its famous ode to the Golden Age, and in the *Gerusalemme Liberata*. A longing for an idyllic landscape, green and flowery, that offers refuge from the court and city, persisted throughout

seventeenth-century lyric poetry. The courtier's life was desperately insecure, and the court, bitterly decried by contemporary poets, came to be seen as a microcosm of evil. Satirical poets, such as Salvator Rosa, attack its vices with Juvenilian fury, yet many courtly lyrics echo Horace's famous *Epode*, *Beatus Ille*, and praise the sweet peace of rural retirement:

> Pleasant now to recline beneath a tree
> And now on some luxuriant sward
> As the waters glide by lofty banks,
> Birds quire in the woods
> And purling brooklets babble
> Lulling to gentle slumber.

Such poets as Fulvio Testi set against the terrors of the court, 'where he who smiles in the morn, weeps at even' an idealized image of the shepherds' life, at peace beside the purling brook. The poets Paolo Giordano Orsini and Maffeo Barberini – both early patrons of Claude – celebrate the peace of country life and decry the vices of the city. The Roman nobles sought *otium*, or relief from care, in the green hills of Frascati, and they decorated their country villas as the ancient Romans had done, with landscapes that themselves refresh the spirit with their shady tranquillity. So widespread was this idealization of an innocent rural life that it drew the occasional bitter attack; Sforza Pallavicino angrily declaimed 'And is the countryside indeed that Arcadia of riches which the Italian poets today describe? For who more than the peasant is ruled by his appetites – the Golden Age is for those that have gold.'

For such courtly patrons, steeped in classical literature, Claude's landscapes created the enchanted world – free from care – of pastoral poetry. It was brought to life by a perfect craftmanship; few pictures are so full of lovely detail, of magical effects of light, of pockets of interest that delight and charm the eye. His early pastorals, with their small temples and altars, their piping shepherds, are in tune with the spirit of the *Eclogues* and of Sanazzaro. There are few contemporary comments on landscape painting; yet the learned scholar Agucchi had written a pro-

6 *Pastoral Figures.* Black chalk and grey wash, 18.1 × 26 cm. (7⅕ × 10¼ in.). London, British Museum.

13

7 *Seaport with the Setting Sun*. 1637. Oil on canvas, 74 × 99 cm. (29 × 39 in.). Alnwick Castle, Duke of Northumberland.

8 *View of Genoa*. Pen and brown wash, 21 × 32.2 cm. (8¼ × 12⅔ in.). Holkham Hall, Viscount Coke.

9 *View from Mont Mario*. c.1640. Brown wash, 18.5 × 26.8 cm. (7¼ × 10½ in.). London, British Museum.

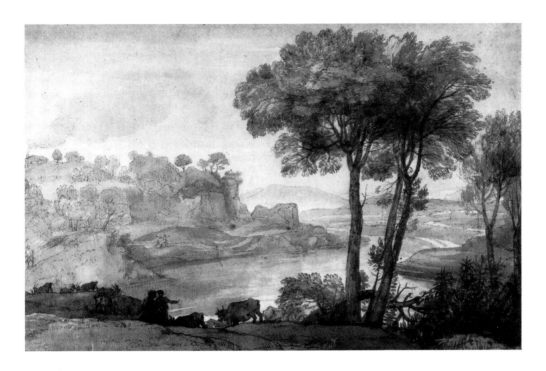

10 *View of the Aqua Acetosa*. Pen and brown wash, 26 × 40.3 cm. (10¼ × 15⅞ in.). Cleveland Museum of Art.

gramme for a picture of Erminia and the Shepherds, where he describes the 'beautiful view of fertile land with mountains, hills, valleys, plains . . . a castle . . . in sum, the entire landscape like a place of quiet retreat and blissful Arcadia, a tranquil day of the finest season'.

At the same time such patrons were acutely aware of the history of the landscape. In a Latin poem Maffeo Barberini describes the variety and fertility of the landscape, where from the summit of a hill, one may see 'Towns, the extent of the plains, rough woods, fields, gentle hills, vines, lakes, the seas, mountains, and the legendary walls of Rome . . .' He then moves on to celebrate the association of the landscape with the glorious days of early Rome, of Aeneas, Ascanius, and Numa, where myth and history meet. To such seventeenth-century humanists the Campagna with its splendid Roman ruins was filled with the memories of a glorious past. Claude's later landscapes convey a deepening response to classical history and mythology.

Yet Claude seems to have been essentially an unliterary man whose response was imaginative and poetic rather than learned. He left no scholarly letters, unlike the more learned Poussin and Rubens; no vivid descriptions of his life and times that may compare with the fresh and personal letters of Salvator Rosa; few colourful anecdotes gather round his name. He was silent about his art and life; and there are few contemporary references to fill out the picture. Those that there are suggest a peace loving, gentle man, devoted to his art. Sandrart, who knew him as a young man, writes 'In his manner of life he was no great courtier, but good-hearted and pious; he searched for no other pleasure beside his profession.' However, learned men clearly enjoyed his company; Pascoli tells us that Claude was greatly esteemed by the Popes, Alexander VII, and the 'two Clements.' Seventeenth-century descriptions leave no doubt that what most delighted his contemporaries was his naturalism; Baldinucci writes 'One must understand, then, that the great quality of this artist was a marvellous and still unsurpassed imitation of nature in those of its various aspects which condition the views of the sun, particularly on the sea and the rivers at dawn and evening . . .'

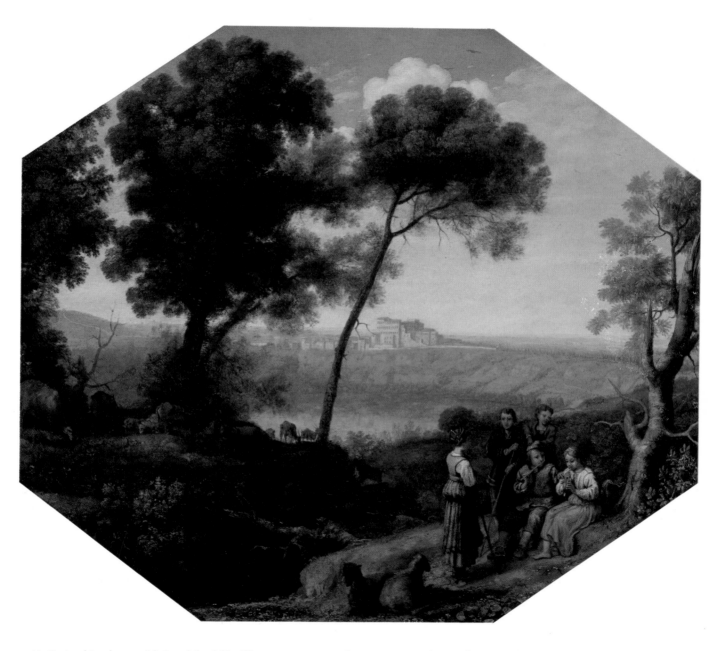

11 *Pastoral Landscape with Castel Gandolfo*. Oil on copper, octagonal, 30·5 × 37·5 cm. (12 × 14¾ in.). Cambridge, Fitzwilliam Museum. On the far shore of Lake Albano, bright in the sunlight, stands the Pope's summer residence, Castel Gandolfo; it has been shown that the view is accurate, with the omission of a medieval tower.

ARRIVAL IN ROME

Claude Gellée was born in 1600 in the village of Chamagne near Nancy in the duchy of Lorraine. The two main sources of his life are the biographies written by Joachim von Sandrart, the German painter and writer on art, and the Italian biographer, Filippo Baldinucci. The two biographies sometimes contradict and sometimes complement one another.

Sandrart was a close friend of Claude in his earliest Roman years; his life is an affectionate account of Claude's first studies as a landscape artist. Baldinucci, a Florentine scholar, perhaps met Claude on a visit to his studio in 1680. Much of his information came from Claude's heirs, and his is a more scholarly work, that attempts to give a fuller account of Claude's life and a list of his most celebrated pictures. Claude came from a large family, the third of seven children; his background seems to have been reasonably prosperous, and he remained in touch with his family throughout his life. Sandrart's biography opens on a romantic note, suggesting a bad beginning and 'strange things to tell of him'; he describes his poor achievement at school, followed by his leaving to become a pastry-cook, like so many others of his countrymen. He then left for Rome, where he went to work for Agostino Tassi, the decorative fresco painter, first as a servant, later as a painter. In contrast, Baldinucci writes that Claude, orphaned when only twelve, yet having already revealed a great gift for drawing, went to live with his elder brother Jean who was established as a 'worthy maker of wood intarsia in the city of

Freiburg in Alsace; and under his tutelage he occupied himself for about a year in drawing arabesques and foliage.' Claude then, in about 1613, seized the opportunity to travel to Rome with a relative of his, a lace merchant. Here he settled near the Pantheon, and supplemented by a modest allowance from Lorraine, studied painting. Next, attracted by the 'much lauded brush of Goffredo, the painter of landscapes, distant views and perspectives', Claude left for Naples; on his return to Rome he lived in the house of Tassi. Goffredo Wals was a Cologne born painter; recent research, which has pieced together his works, tends to support Baldinucci's statement.

At the end of April 1625 Claude travelled back to Nancy; he was welcomed with affection by a relative who obtained for him an introduction to the court painter Claude Deruet. Deruet had worked in Rome and was much valued in Nancy for his wide knowledge of Italian painting. In September 1625 Claude signed a contract to work as Deruet's assistant for a year; in June 1626 Deruet began to fresco the vault of the Carmelite church in Nancy, where Claude painted 'all the architecture'. Claude may also have met the engraver Jacques Callot, who had worked in Italy: he was attracted by the vivid charm of Callot's figure style, and perhaps by his luminous wash drawings from nature.

In 1627, after a sea journey from Marseille, Claude returned to Rome. He never again left Italy; his links with Lorraine remained strong. In 1627 as many as

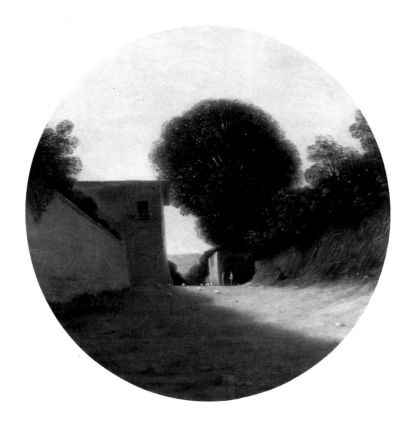

12 Goffredo Wals (op.1615–31). *A Country Road by a House*. Oil on copper, 24·5 cm. diameter (9⅓ in.). Cambridge, Fitzwilliam Museum. A small group of pictures have recently been attributed to Wals, Claude's teacher. He liked a circular format, and this work suggests his interest in light and in simple, almost geometric forms.

a thousand Lorraine artists are described as living in Rome, forming a separate 'nation Lorraine' fully distinct from the French. Claude's friends, such as the painter Charles Mellin, were often fellow countrymen; and he preserved this sense of national identity until his death.

In the early years of the century the Roman world of art and letters was bright with hope. With the accession of Maffeo Barberini as Urban VIII in 1623 scholars and poets had heralded a new Golden Age, for the Pope – inordinately vain of his gifts as a poet – was deeply cultivated, and passionately interested in art and antiquities. Historians, scientists, poets and lovers of art flocked to the court of the new Pope; the papal nephews, and newly noble families, rose to power and wealth and amassed splendid collections of art. Their display of wealth was lavish, and courtly life one of brilliant festivals. In the 1630s Claude sent many paintings to Paris, Naples and else-

where in Europe; yet increasingly he was to attract sophisticated and distinguished collectors from the most noble Roman families and the brilliance and distinction of his early patrons is striking. A commission from the Pope himself, the leader and arbiter of taste, ensured the most glittering success.

The severity of the Counter Reformation had already waned; the art of the early baroque, intensely naturalistic, glows with warm light and colour, delights again in sensuous pagan themes, and explores new subjects, such as landscape and still-life. In the early seventeenth century, Rome and Haarlem became the centres of a new kind of realist landscape. In the late sixteenth century a tradition of decorative landscapes in fresco had been established by Paul Brill, the great Flemish landscape painter, and developed by his pupil Agostino Tassi. Tassi had made such decorations fashionable in Roman palazzi and villas, and enriched his land-

scapes and coastal scenes – often dramatic stormy seas and bold rock arches – with illusionist painting of ornate Renaissance logge, where he displayed his skill as a *quadraturista* (a specialist in painting perspective effects). At the same time, in tiny, delicate pictures on copper, the German artist, Adam Elsheimer, was developing a new interest in light and an idyllic mood; his works influenced the Italian Filippo Napoletano, whose *Landscape with a Country Dance* with its bright highlights and picturesque detail, conveys a sense of the charm of rustic life. Goffredo Wals belongs to the same moment; he painted outstandingly original small circular works on copper, of pastoral themes, that are distinguished by their boldly simplified, almost geometric compositions, and by their delicate exploration of the light of different times of day (Plate 12).

Claude's early friendships were formed amongst the Dutch and Flemish artists who lived in the lively colony that sprang up around the Piazza di Spagna and the via Margutta and who were developing these older traditions. The grandeur of the Roman ruins had long fascinated northern painters; they drew and sketched amongst the ruins, and painted *capricci*, fanciful arrangements of celebrated monuments in imaginary settings. In the sixteenth century such compositions had an archaeological flavour, and their compositions, with high viewpoints, and sharp tonal contrasts, were decorative. In the seventeenth century painters became more interested in the landscape itself, with its shifting patterns of light and shade. Brill, in his late pastorals, fresh and idyllic, discovered the poetry of the Campagna (Plate 17); the Dutch artists, Cornelis Poelenbergh and Bartholomeus Breenbergh, popularized a new type of ruin picture – small, tranquil scenes where goats and herdsmen wander amongst the ruins of the forum or in the Campagna, with melting distances. In the art of the Dutch painters of everday scenes, the Roman ruins become the setting for vivid vignet-

13 Agostino Tassi (*c*.1580–1644). *Seascape with a Shipyard*, *c*.1615. Oil on canvas, 80 × 108 cm. (31½ × 42½ in.). Rome, Galleria Doria-Pamphili.

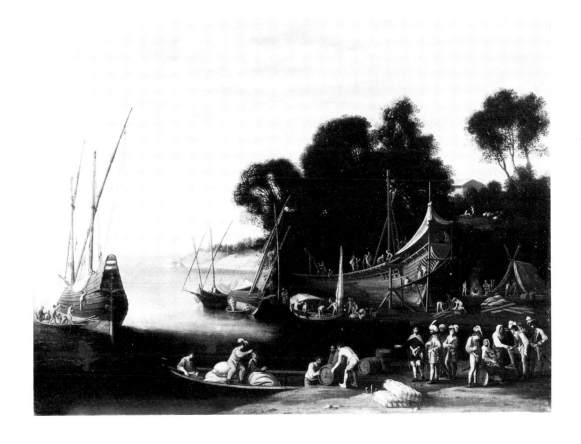

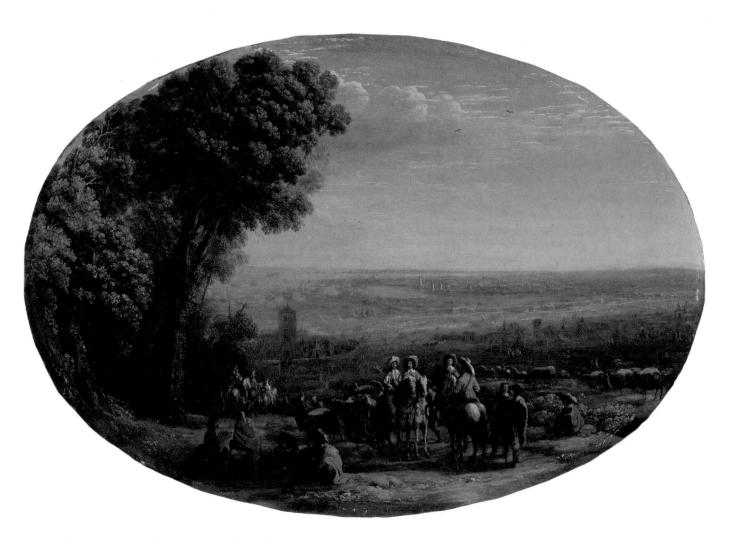

14 *The Siege of La Rochelle by Louis XIII*. Oil on silvered copper, 28 × 42 cm. oval (11 × 16½ in.). Paris, Musée du Louvre. An artist sketches the siege of La Rochelle. The aerial recession is wonderfully delicate; in the distance the tiny walls of the city catch the light, and yet beyond gleam the pearly greys of the sea, dotted with white sails.

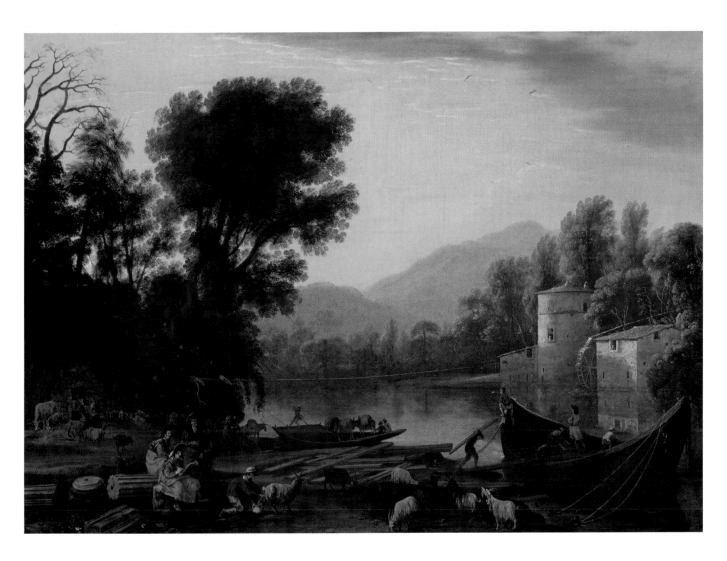

15 *Landscape with a River*. *c*.1631. Oil on canvas, 61 × 85 cm. (24 × 33½ in.). Boston, Museum of Fine Arts. Such lively incidents – the artist sketching, the boatmen, the goatherd – fill the paintings of many northern artists. Yet the effects of light – the trees dark against a rosy sky, the light softly enveloping the middle distance, and the bright sunlight on the mill – are already strikingly new.

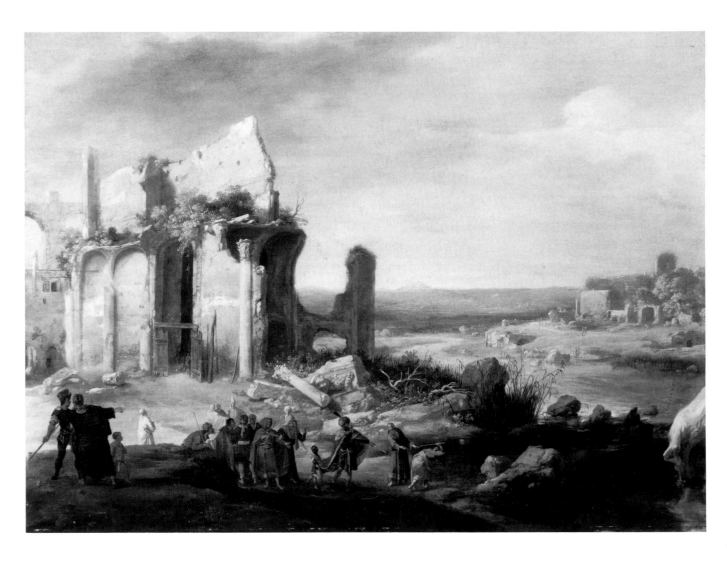

16 Bartholomeus Breenbergh. 1631. *Moses and Aaron changing the Rivers of Egypt to Blood*. Oil on canvas, 58 × 83 cm. (22$\frac{4}{5}$ × 32$\frac{2}{3}$ in.). Malibu, the J. Paul Getty Museum.

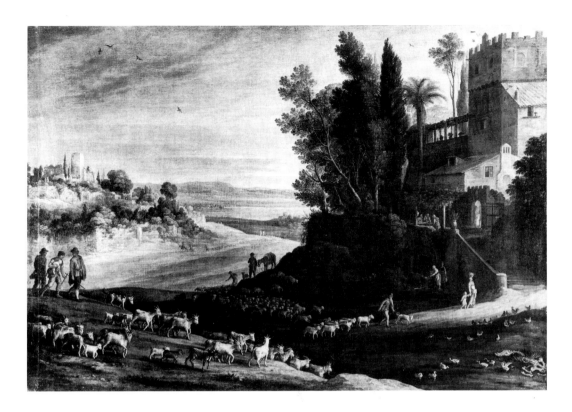

17 Paul Brill (1554–1626). *Landscape with Christ at Emmaus.* 1617. 95 × 146·5 cm. (37½ × 57⅔ in.). Paris, Musée du Louvre. This late painting by Brill suggests the beauty of the Roman Campagna; its pastoral serenity looks forward to Claude.

tes from contemporary life. These painters were dubbed *bamboccianti* or 'clumsy babies' after their leader Pieter van Laer, a man whom Claude knew well. The seventeenth-century critic Passeri tells us that their pictures opened a window onto life, painting what they saw without alteration. Their pictures show tattered figures playing cards beside old Roman walls; men selling water and cakes; fortune tellers and gypsies; bandits attacking travellers in a rocky ravine.

In his earliest years Claude experimented with the variety of landscape types that attracted other artists from northern Europe. Little is known about his art in the 1620s, and he was perhaps involved with the many projects of Tassi's large studio. Tassi was well placed to introduce Claude to the most princely Roman palaces, and Claude made his own reputation with decorative frescoes for noble Roman families; Sandrart writes with enthusiasm of the 'many magnificent works' in fresco which established his fame. Baldinucci lists three series, for the Cardinal Crescenzi and for the Muti family, none of which definitely survive. However a frieze of seven small landscapes in the Palazzo Crescenzi, close in style to the palace decorations of Brill and Tassi, has been plausibly attributed to him; here wild mountainous landscapes contrast with idyllic scenes of country life in the Roman Campagna. Sandrart describes in rich detail how Claude decorated 'the four high walls in a great hall at Cavalier Mutio'. His description suggests that a continuous illusionist landscape ran round the four walls, leading the spectator through all the variety of the natural world, from forest to open plains and mountains, and onto a glimpse of the stormy sea and a rocky landscape strewn with grottoes and decaying ruins. Already Sandrart comments on Claude's naturalism, on how 'each tree can very well be recognized according to its special characteristics in trunk, foliage, and colouring, all as if they rustled and moved in the wind.' Claude did not again work in fresco, but these must have been important works, and it was perhaps at this

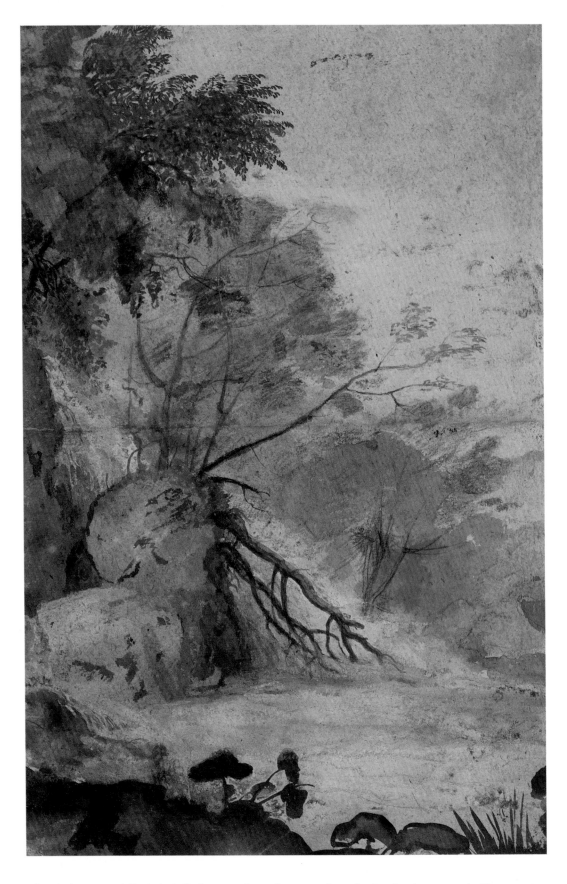

18 *Trees and Rocks by a Waterfall*. Black chalk, brown and grey-brown wash, with white heightening on buff paper, 38·8 × 25·2 cm. (15⅓ × 10 in.). London, British Museum. Signed and dated on the verso. Dated nature studies are rare and this provides a key to the dating of similar works. The motive is dramatic, and Claude seizes its elements with a free combination of different media, suggesting the bright cascade with white heightening and black chalk, and the foreground with deep brown wash.

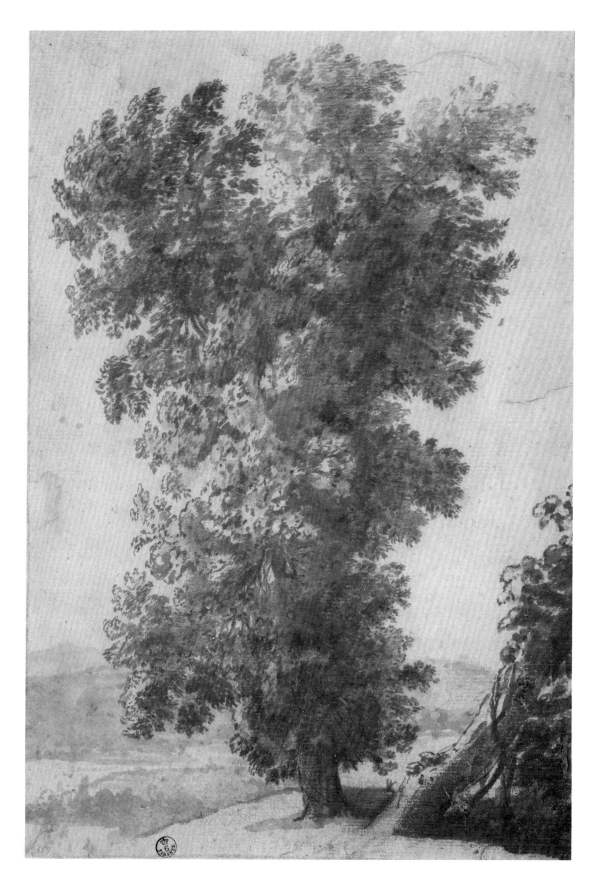

19 *Oak Tree in the Campagna*. Chalk and brown wash, 32·9 × 22·4 cm. (13 × 8¾ in.). Signed and dated on the verso. Claude 1638? Florence, Uffizi.

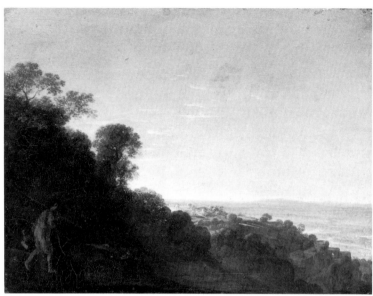 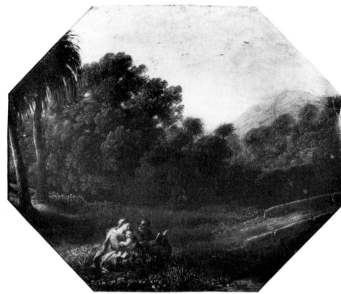

20 Adam Elsheimer (1578–1610). *Aurora, c.* 1606. Oil on copper, 17 × 22·5 cm. (6⅔ × 8⅘ in.). Braunschweig, Herzog Anton Ulrich Museum.

21 *Rest on the Flight into Egypt.* 1631. Oil on copper, 28 × 33·7 cm. (11 × 13¼ in.). By kind permission of His Grace the Duke of Westminster.

period that Gaspard Dughet, whom Baldinucci describes as a pupil of Claude, worked in his studio; he later painted similar frescoes at the Palazzo Muti-Bassi and the Palazzo Colonna.

Claude's independent development as a painter of cabinet pictures was surprisingly slow. His earliest dated picture is *River Landscape* 1629 (Plate 23); in 1630 he dated his first etching *The Tempest* (Plate 22). Both works are strikingly close to Filippo Napoletano and to Tassi and suggest that Claude broke very slowly with their style. A number of genre scenes – paintings of estuaries, occasionally with galleys, and riversides, often brightly decked with orange trees and shrubs, where artists sketch, men milk goats and load timber, or pastorals, with goatherds in a countryside dotted with little temples, rock arches, small caves and grottoes – may be dated to these early years. In a sense these works, that so strongly suggest an older tradition, are old fashioned; and yet from the start they are strikingly original in their treatment of light – in the highlights which catch the backs of animals; in the bright sunlight that plays on buildings; and above all in the sense that light and air fill the landscape,

eliminating the sharp transitions of Mannerist pictures. The *Landscape with a River* (Plate 15) is a particularly attractive example, crowded with picturesque detail, and with the light sparkling on a watermill that was to become a favourite motif.

These pictures are often rather broadly handled, the paint free and the detailing impressionistic. Yet at the same time Claude was also producing a series of small pictures on copper which are of a jewel-like finish. In 1631 he signed a small oval *Rest on the Flight into Egypt* (Plate 21). Claude painted this subject many times; here the tender mood, the simple shapes, the softly rounded trees and delicate shafts of light suggest the influence of Elsheimer and Goffredo Wals, who had both also painted on copper. In the same year two exquisite small coppers startlingly announced his growing mastery. These works, *The Siege of La Rochelle by Louis XIII* (Plate 14) and the *Pass of Susa* (Paris, Musée du Louvre), are distinguished by the beauty of their atmospheric perspective. They record Louis XIII' successful siege at La Rochelle in 1628 and his victory over the forces of the Duke of Savoy in 1629. Claude's figures, vivid, elegant, minutely detailed, recall Callot, and the pic-

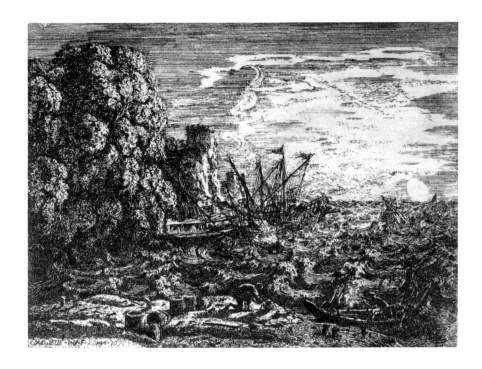

22 *The Tempest*. 1630. Etching, first state, 125 × 173 cm. (49 × 68 in.). London, British Museum. This is Claude's first dated etching. It is linked to frescoes of stormy seas by Tassi and Filippo Napoletano; the unusual effect of moonlight suggests Elsheimer, whose influence on Claude's etchings was particularly strong.

23 *River Landscape*. 1629. Oil on canvas, 106·5 × 148·5 cm. (42 × 59½ in.). Philadelphia Museum of Art, George W. Elkins collection. This is the first picture by Claude which is signed and dated. The framing trees, the crossing diagonals, and the bright highlights are in the tradition of Tassi and Filippo Napoletano.

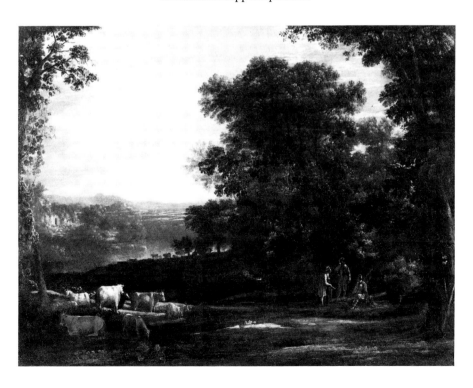

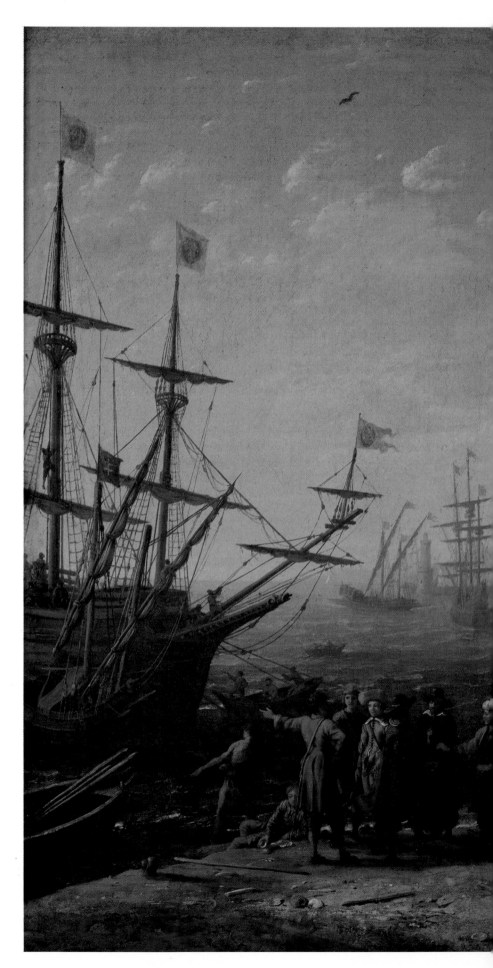

24 *Harbour Scene with the Campidoglio*. 1636. Oil on canvas, 53 × 72 cm. (21 × 28⅓ in.). Paris, Musée du Louvre. This sharp, witty juxtaposition of the real and the fanciful was popular in the 1630s; the vivid, strongly characterized figures stand on the shore framed by an imaginary Roman arch, and by the palace designed by Michelangelo that stood on the ancient Capitol.

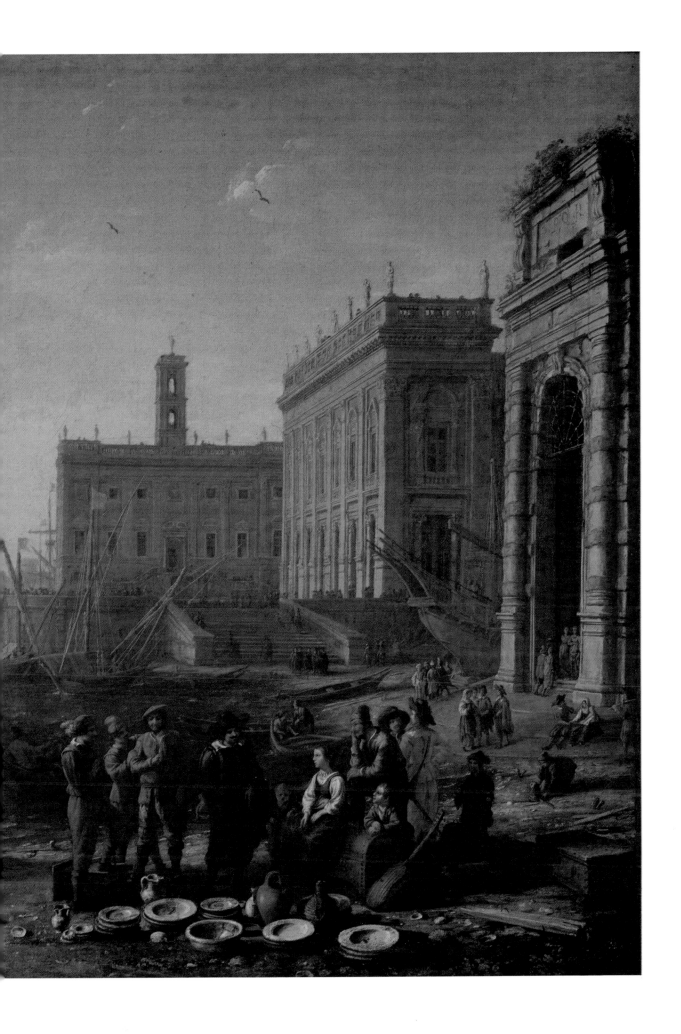

25 *The Campo Vaccino.* Pen and brown wash, 12·8 × 9·4 cm. (5 × 3¾ in.). Windsor Castle, Royal Library. This small sheet comes from an early sketchbook perhaps made in the 1620s. It shows a corner of the Roman forum where Vignola's gateway lead to the Orti Farnesiani; the gateway with its elegant rustication, inspired some of the imaginary buildings in Claude's harbour scenes.

tures contain quotations from Callot's topographical etching, the *Siege of Breda*.

In the 1630s Claude shared with his northern neighbours – with Sandrart, who had arrived in Rome in 1628, and with Breenbergh, in Rome from 1619–29 – an interest in the ruins of ancient Rome. Claude's interest was to be comparatively short lived, yet a small sketchbook, which may date from as early as 1627–8, is filled with pen and wash sketches of medieval and ancient buildings, picturesquely decaying. They show great arches, overgrown with ivy, against the light; the ruins of the Palatine and Colosseum; a dark house silhouetted against a bright sky. These sheets are spontaneous and intimate. They capture with vivid freshness a sudden effect of light in a tranquil corner of Rome (Plate 25); the delicate play of light and shade is of far greater interest than the monuments themselves. Claude's drawings are less dramatic than those of Breenbergh, whose remarkable drawings capture, by the use of deep brown wash against spared paper, the brilliance of southern sunlight on crumbling masonry. They look forward to the quiet naturalism of Stefano della Bella's studies of Rome.

The fruits of such studies are revealed in the few *capricci* and views of Rome that Claude painted in the 1630s. Most celebrated are two pictures, *The Roman Forum* and the *Harbour Scene with the*

Campidoglio (Plates 32 and 24), probably of 1636. They were painted for Philippe de Bèthune, French ambassador to Rome and the first of four to patronize Claude. He owned a fine collection of pictures and sculptures, and by this date, aged 65, had retired to his château at Selles; Claude's pictures recalled the beauty and grandeur of that city where he had led a spectacularly successful career.

The paintings contrast the real and the imaginary – an accurate view of the Roman forum is coupled with a fanciful scene where the palaces of the Capitol stand beside a watery lagoon. They celebrate Roma Antica e Moderna. This was the city admired by the Grand Tourist – ancient Rome, enriched by the most famous of its monuments; and modern Rome, whose splendours had been restored and rivalled by the genius of Raphael and of Michelangelo, who had designed the palaces on the Capitol. Many travel writers eulogize the splendour of the sixteenth-century palaces; Joachim du Bellay, whose passionate hymn to antiquity, *Les Antiquités de Rome*, lingered in the mind of later travellers, wrote too of modern Rome –

Regarde après, comme de jour en jour,
Rome fouillant son antique sejour
Se rebatist de tant d'oeuvres divines.

The Roman Forum (Plate 32) is Claude's only faithful rendering of a Roman scene. Paul Brill had earlier delighted in such motives. In the seventeenth century, the forum, or Campo Vaccino, was then used as a cattle market, and Brill's pictures create a fanciful contrast between brightly coloured vignettes of popular life and imaginary arrangements of the monuments of antiquity. Claude's picture, with its low viewpoint, and atmospheric light, is more realistic; it is one of the earliest paintings of a Roman view to attain the realism hitherto limited to drawings and engravings. The vivid groups of figures, so lively and lovingly detailed – in the *Harbour Scene* a wine seller offers a glass of wine; a slightly raffish porcelain seller displays his wares; in the distance, a fortune teller and procuress practise their trades – these are the scenes that delighted Claude's con-

temporary *bambocclanti* painters. Such an image of Rome, a city of imposing grandeur, and yet enriched by the lively life of street and square, was very different in feeling from sixteenth-century engravings and drawings, which tend to suggest a sombre meditation on past glory. Claude etched his picture of the Roman forum in 1636; this kind of print was very popular in northern Europe, and many northern artists made prints of Roman scenes. Other artists from Lorraine, such as Israel Silvestre and François Colignon, produced very many engravings of Italian scenes and festivals.

It was in this truth of light and atmosphere that Claude most surpassed the realism of his contemporaries, and in these early years, when he was laying the foundations of his style, he continuously drew and painted from nature. Sandrart gives a detailed and vivid account of the two artists meeting at Tivoli: 'He was thrifty and studied his art with great seriousness and application: he tried by every means to penetrate nature, lying in the fields before the break of day and until night in order to learn to represent very exactly the red morning sky, sunrise and sunset and the evening hours. When he had well contemplated one or the other in the fields, he immediately prepared his colours accordingly, returned home and applied them to the work he had in mind with much greater naturalness than anyone had ever done. This hard and burdensome way of learning he pursued for many years, walking daily into the fields and the long way back again, until he finally met me, with the brush in my hands, in Tivoli, in the wild rocks at that famous cascade, where he found me painting from life and saw that I painted many works from nature itself, making nothing from imagination; this pleased him so much that he applied himself eagerly to adopting the same methods; thanks to great laboriousness and continuous exercise he attained such naturalness that his landscapes were demanded by amateurs from everywhere . . .'

It was this naturalism that most enthralled Sandrart, and he expands on the pleasure that he and Claude shared in painting in oils directly from nature. He describes how he himself was looking for

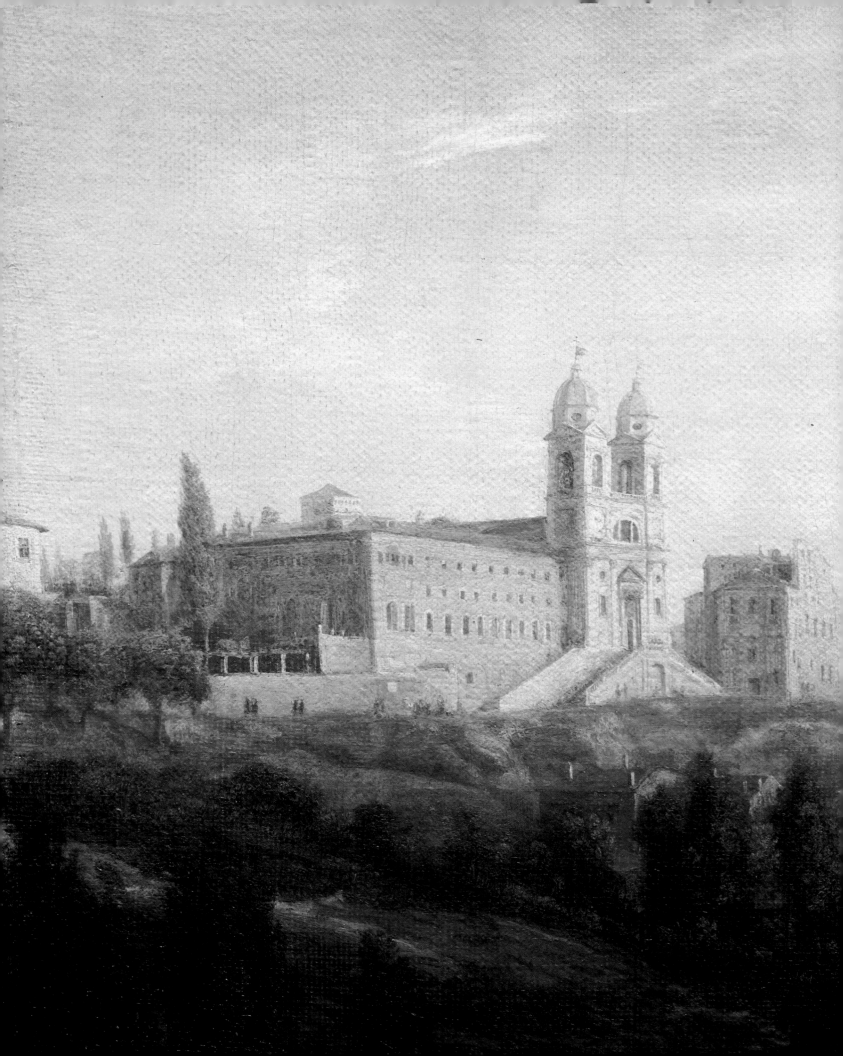

26 *View of Rome with the Trinità de' Monti.* 1632. Oil on canvas, 59·5 × 84 cm. (23¼ × 33 in.). London, National Gallery. Detail opposite.

good motifs for the backgrounds of his history paintings, while Claude was painting 'on a small scale, the view from the middle to the greatest distance, fading away towards the horizon and the sky'; he describes a morning piece that Claude had given to him 'in which one can truly recognise how the sun, risen for some two hours above the horizon, dissipates the nebulous air and how the dew floating upon the waters really mingles astonishingly with it; the sun plays over the grounds in all parts and lights up the grass, bushes, and trees almost as in life . . .' Elsewhere he stresses the superiority of painting 'entirely from nature with colours on prepared paper and cloths' over drawing; 'in the drawings, on the other hand, one goes too far back, since the true shape of things no longer appears really as pure.' One senses, in such descriptions, an excitement in the discovery of new kinds of perception that recalls the early days of Impressionism. Gaspard Dughet too made such sketches; the practice may have been developed in Naples, where Salvator Rosa made

expeditions along the coastline and in the countryside around Naples sketching in oil on paper directly from nature. No such studies survive, yet Rosa's earliest landscapes, and those of his contemporary, Micco Spadaro, mark the beginnings of a new kind of fresh and spontaneous Neapolitan landscape. Claude had himself studied in Naples; he made a brief visit there in 1636 and shortly afterwards sent there four of his most naturalistic landscapes. Some of his early coastal scenes, with their hazy atmosphere and medieval towers, are not unlike early pictures by Rosa.

Sandrart's account is in some ways puzzling. No pictures from nature by either Claude or Sandrart survive. Yet amongst Claude's early works are pictures of such freshness and brightness that they seem, as do some of Monet's early paintings, to herald a new vision. One of these is the small picture, *View of Rome with the Trinità de'Monti* (Plate 26). Here the foreground, with its bamboccesque procuress, is imaginary; yet the distance shows an accu-

27 *The Farmhouse on the Tiber.* Recto; chalk and brown wash, 21·3 × 32·1 cm. (8⅓ × 12⅔ in.). From the Campagna book. Rome, Gabinetto
Nationale della Stampe. It has been shown that this drawing was made not far from Claude's house on the left bank of the Tiber, looking
downstream towards the Ripetta.

rate view, possibly from Claude's rooftop, and
perhaps painted out of doors, of the Trinità de'
Monti. The sunlight on the buildings is caught with
vivid directness, in boldly handled planes of delicate
colour.

Though no such pictures definitely survive, there
are many nature drawings that chart Claude's
sketching expeditions in Rome and in the surround-
ing countryside. On such expeditions Claude
explored those tranquil areas in Rome not far from
his house; around the famous Ponte Molle, only a
few miles away; in the south he followed the ancient
Via Appia to the Tomb of Cecilia Metella; beyond
lay the gentle wooded valley of the Caffarella, with
the church of S. Urbano, and the cool grotto of
Egeria, where artists and travellers enjoyed the
shade. Here were distant views of the Campagna,
marked by the arches of the Roman aqueducts.
Claude sketched too in the parks of the Roman villas.

Longer expeditions led him to the celebrated beauty
spots of Tivoli, already famous for their association
with artists, and to the wild countryside around
Subiaco; to Velletri; and up the Tiber to Mount
Soratte.

Earlier artists had begun to draw from nature;
Filippo Napoletano had sketched in the Tuscan land-
scape, brilliantly evoking the light of a bright sum-
mer's day on fields and rustic buildings;
Breenbergh's ink wash drawings explore unexpec-
ted and dramatic effects of light in the hill towns
and wooded countryside around Rome; Brill's draw-
ings, more naturalistic than his pictures, occasion-
ally convey an enchanted pastoral mood that
strikingly anticipates Claude.

Yet Claude's drawings are from the start unparal-
leled in their sense of freedom and grandeur, in their
wide range of motives, in their sense of the
mysterious beauty of trees, rocks and woods newly

28 *Cattle*. Pen and brown wash, 14·9 × 21·1 cm. (5¾ × 8⅓ in.). Paris, Musée du Louvre.

revealed by brilliant sunlight. They strike us first with their spontaneity, and yet their beauty is also decorative. Claude framed many of his drawings with a free-hand pen-line that reveals how he sought a pictorial composition, framing and encircling his motif, and stressing the abstract patterns of light and shade. It is this that distinguishes them from the less decorative, more minutely handled drawings of Breenbergh. They are entirely new too in their technical inventiveness. The earliest drawings are in pen and brown ink and bistre wash; later he combined these with both black chalk and white heightening, with exceptional freedom using these different media for different parts of the same sheet (Plate 18). Most brilliant and dramatic are the pure wash drawings, where the lovely richness of the deep brown washes set against the brightness of the untouched paper seems to fill the drawings with light and air. Claude drew in a wild and thickly wooded

countryside; rocks reflected in a still pool; a close-up view of plants on the surface of the water; the soft shimmer of light in a dark woodland interior; the dazzling contrasts of light and dark in a sunlit glade; the gloomy beauty of the cloudy Tiber valley. These nature drawings culminate in an outstanding group of the late 1630s which come from a bound sketchbook now known as the Campagna book. At the centre of his interests lie his many tree studies. In a splendid drawing of an isolated tree (Plate 19) silhouetted against the horizon, Claude achieves – in pure wash – the effect of dappled sunlight, wind and air, suggesting the movement of the leaves, transparent where they turn to the light, absorbing deep shadow in the centre, and delicately touched in at the edge, dark leaf by leaf, against the bright sky. The contre-jour was a favourite effect, and in a drawing of trees in the Campagna (Plate 3) Claude sets dark tree trunks against distant hills. The decorative

planes of deep wash – their boldness set against the tenderly detailed leaves – contrast with the bright areas of sky to create a rich surface pattern. Other drawings startle with their bold economy. *The Farmhouse on the Tiber* (Plate 27), suddenly reveals the landscape as a play of luminous shapes, of clear cut rectangles sharply set against the dark shadows of cylinders and cubes.

Yet despite Claude's strong interests in naturalism and his links with northern painters, there was another aspect to his art that grew in importance through the 1630s. He began to attract the attention of the most distinguished collectors from the Italian aristocracy, and for them he painted a different kind of landscape, grander and more ambitious, and enriched by mythological subjects. A series of outstandingly important commissions saw the development of a breadth of design that is Italian rather than northern. Perhaps the first of the great patrons to

be drawn to Claude was the Marchese Vincenzo Guistiniani, who at the accession of Urban VIII owned the richest and most eclectic art collection in Rome. He was a patron of Sandrart, who describes how he and Claude 'painted – instead of drawing – large trees, landscapes, and cascades from nature in the garden of Prince Giustiniani.' By this date, the Marchese's attention had turned to Antique art, yet he bought a painting with a mythological subject, a *Landscape with Cephalus and Procris*, (destroyed) from Claude, which he hung as a pair to a picture by Swanevelt.

Yet it was the Cardinal Guido Bentivoglio who set Claude on the path to the most brilliant success. The Cardinal, who is known to us from Van Dyck's wonderfully rich and vivid portrait, (Florence, Galleria Pitti), lived in the palazzo Borghese, which he had had decorated with glowing mythological scenes by Giovanni da San Giovanni, and with landscapes

29 *Coast Scene with Europa and the Bull*. Oil on canvas, 170·8 × 199·7 cm. (67¼ × 78⅔ in.). Fort Worth, Kimbell Art Museum. The story is from Ovid; Jupiter, in the form of a white bull, tempts Europa away from her maidens so that he may carry her out to sea. Claude etched this important composition in 1634, and did four other paintings of the theme, the last in 1667. Detail opposite.

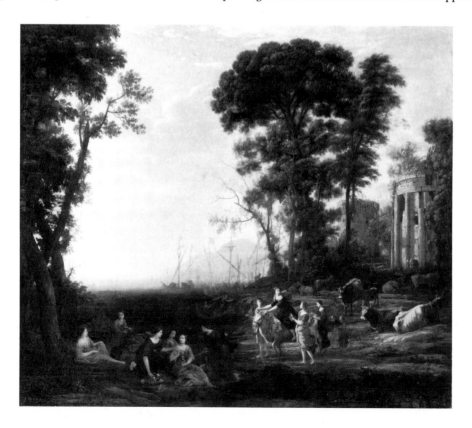

38

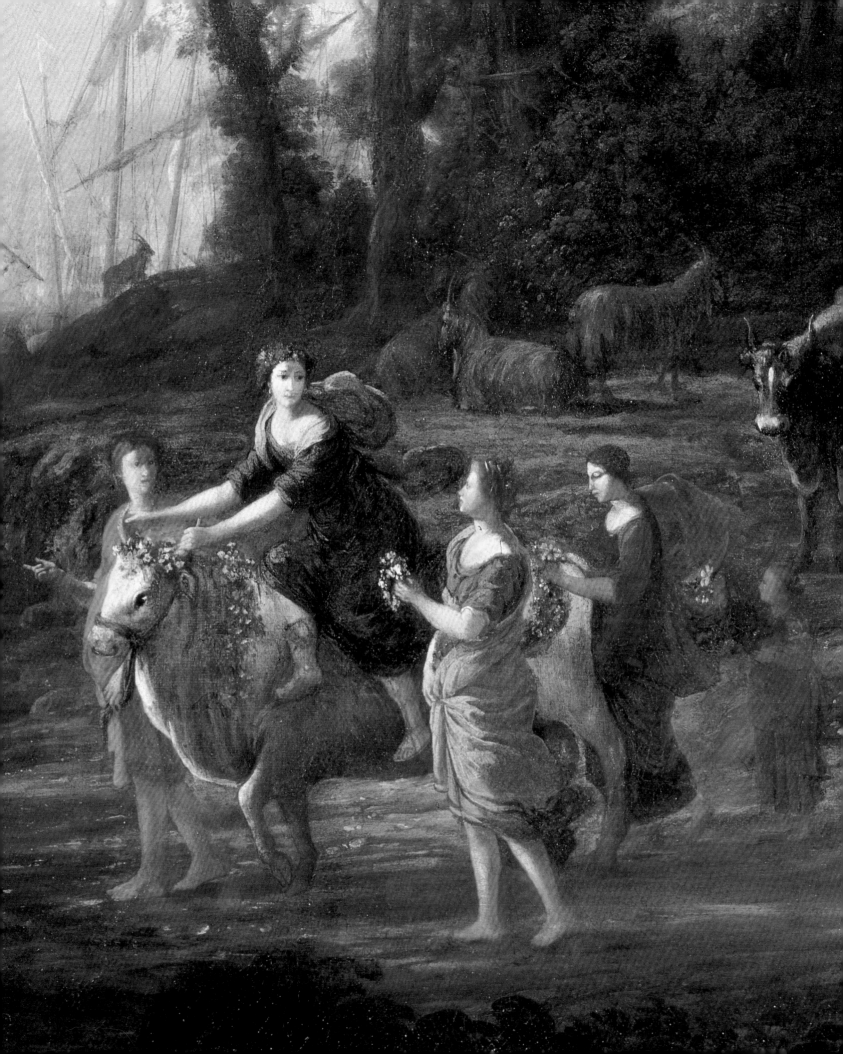

·by Filippo Napoletano. He was a distinguished historian and a man of letters; from 1616 to 1621 he had served as nuncio in Paris. His letters from France describe its landscape with unusual precision. He liked variety in landscape, views which both formed a lovely whole and were lovely in detail; he disliked rugged scenery, preferring a green and pastoral land, and lamenting that the loveliest parts of France lacked their Sannazaro. He was the most enthusiastic of Claude's earliest patrons; Baldinucci describes how he commissioned Claude to 'make two landscapes which earned him so much credit, not only with that great prelate, but also with his Holiness Pope Urban VIII, that from that time Cardinal Guido Bentivoglio primarily, then other cardinals, and finally princes of all ranks, began to frequent his studio.'

The most ambitious of Claude's early works is a *Coast Scene with Europa and the Bull* (Plate 29) of 1634. Here both colour and atmosphere – and the subject itself, whose most famous rendering is the *Rape of Europa* by Paolo Veronese (Rome, Palazzo Barberini) – remind one of Venetian painting. Sandrart, in his life of Titian, describes a visit to the Aldobrandini Palace to look at one of Titian's famous Bacchanals which had recently been brought there from Ferrara: 'When once, in the company of Pietro Cortona, Francesca du Quenoy the sculptor, Poussin, Claude Loreyn, and others, I had a chance to see one of them, we inspected it thoroughly with great patience and agreed wholeheartedly that there existed nothing more pleasant, delicate, and beautiful by Titian.' These works had a profound influence on contemporary Roman painting, apparent in the works of all the artists who accompanied Sandrart – strikingly in the warmth and brilliance of Pietro Cortona, and in Poussin's Bacchanals and romantic Ovidian scenes of the 1630s.

30 Paul Brill (1554–1626). *Harbour View*. 1617. Oil on canvas, 86 × 116 cm. (33⅜ × 45⅝ in.). Florence, Uffizi. This type of harbour scene, crowded with lively incident, inspired Claude's early harbour scenes.

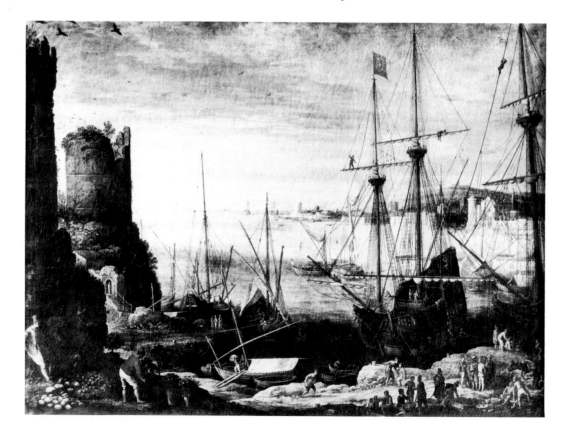

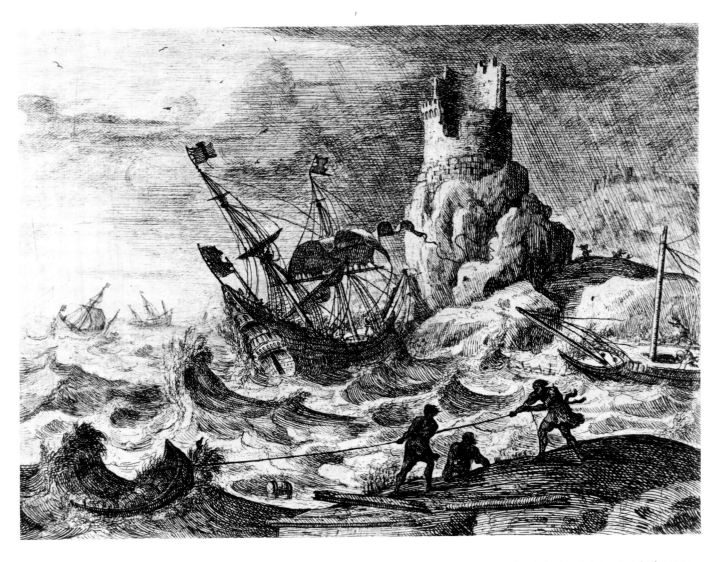

31 *The Shipwreck*. Etching, first state, 126 × 179 cm. (49⅓ × 70½ in.). San Francisco, Fine Arts Museum. Claude both painted and etched storms in the 1630s and early 1640s, following the tradition of Brill and Tassi. This etching is after a painting done for Paolo Giordano Orsini, Duke of Bracciano, a poet and a man of letters; his motto was 'against wind and waves', and he owned two galleys.

In Claude's painting, warm light filters through the richly massed tree trunks where autumnal golds and greens mingle and are echoed in the colours of Europa's maidens' dresses. The figures themselves are strikingly different from the bamboccesque types of Claude's genre pictures. They are ambitiously Raphaelesque and look forward, even in their slight stiffness and odd disparities of scale, to such a mature classical work as *The Marriage of Isaac and Rebecca*. It has been very plausibly suggested that this splendid picture, obviously an outstandingly important commission, was perhaps one of those done for Cardinal Guido Bentivoglio, whose pictures were to attract the attention of Urban VIII.

This introduction to Urban VIII crowned Claude's brilliant success and led to the commission of two pairs of pictures. The first pair, painted in 1637, are the *Landscape with a Country Dance* (Plate 35) and the *Seaport with the Setting Sun* (Plate 7). They are pendants, and by this date Claude was already refining his practice of painting in pairs; such pairs, with shared horizons, are usually of contrasting compositions and different types of light. In the early years very often a landscape contrasts with a

32 *The Roman Forum*. 1636. Oil on canvas, 53 × 72 cm. (21 × 28⅓ in.). Paris, Musée du Louvre. This picture shows an accurate view of the Roman Forum. Amongst the buildings shown are, on the left, the Arch of Septimus Severus; at the far end of the Forum, the Arch of Titus; in the middle distance the columns of the Temple of Castor and Pollux; and in the foreground, the columns of the Temple of Saturn.

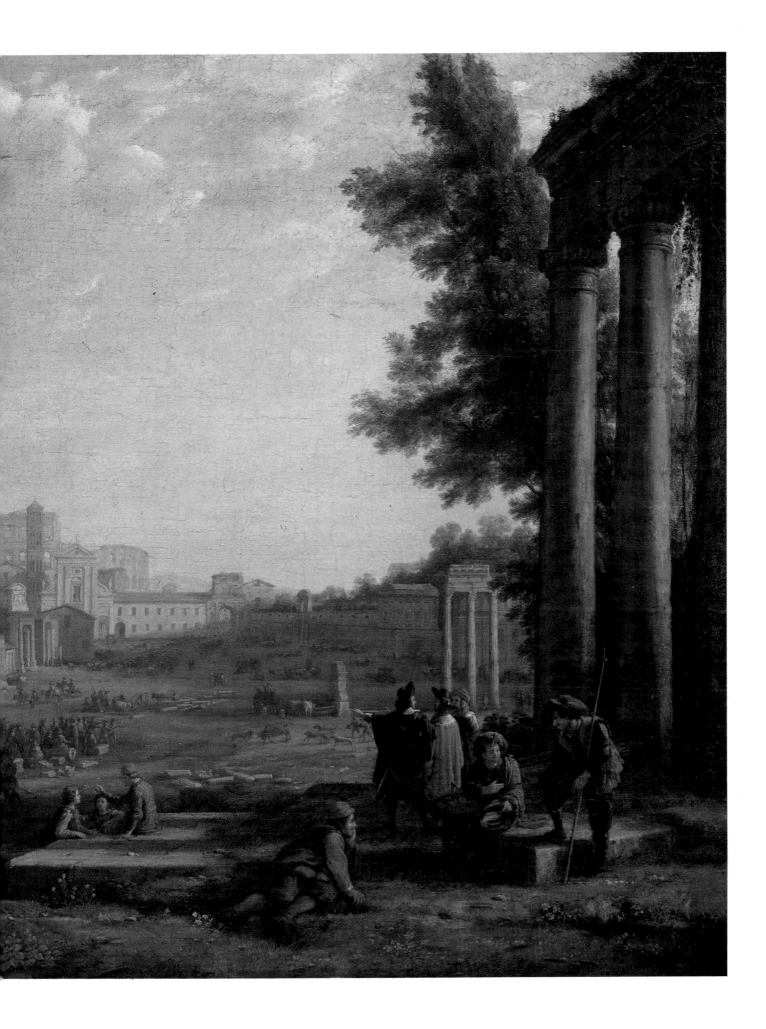

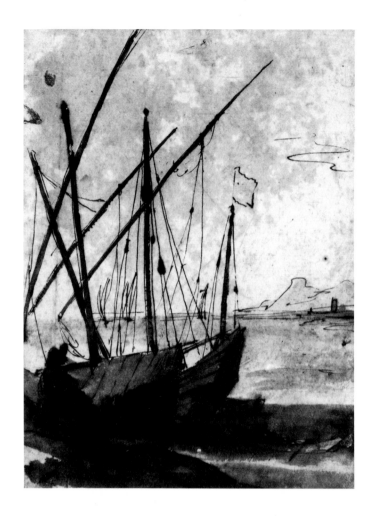

33 *Coast with Sailing Boats*. Pen and dark brown wash, 23·6 × 17·5 cm. (9¼ × 6¾ in.). London, British Museum. This kind of nature study
underlines the dramatic patterning of masts and rigging against the sky that recurs in Claude's harbour scenes of the 1630s.

seascape, setting the earth against the sea, the abundance of nature against majestic human architecture.

The Seaport brilliantly established Claude's supremacy in this kind of art. Brill had painted harbour scenes with ruins of medieval buildings and enriched with lively incident; Tassi had framed his compositions with graceful prows and the pattern of masts. Yet Claude, while indebted to the opulence of Tassi's architecture, developed a new sense of space and theatrical grandeur. Never before had an artist painted so dramatic an effect of sunlight. The rays of the setting sun fill the sky; a distant tower is veiled in misty air, an almost suffocating red glow shimmers on the water and buildings and throws the

foreground into dramatic darkness, where the masts of the ships create a web of pattern, and the lively gesturing figures – some of whom shield their eyes from the glare of the sun – are vividly silhouetted against the light. The flawless beauty of the craftsmanship is overwhelming, and the picture delights with the lovely details of the figures; of the little boats; of the infinitely delicate patterning of the masts against the dark windows of the palace. This is one of the boldest of Claude's contre-jour effects. The light-filled channel of water creates a sense of deep space, emphasized by the steep perspective of ships and buildings. Baldinucci wrote that Claude was famed for his 'wonderful perspectives', for his rendering of sunlight and his 'different mutations

44

of the same colour' that so subtly convey the light reflected on water and the rhythm of the sea. At the same time this picture moves away from realism. The elegant architecture, whose varied surfaces reflect the light, so richly adorned with an array of classical sculptures, rustications and low relief, evokes the beauty of an ideal city that lies beyond the lively scene in the foreground. Claude's architecture was imaginary, yet it recalls the celebrated Renaissance palaces of Rome, the Villa Farnesina, the Cancelleria, the Villa Medici. His harbours often suggest perspective views of ideal cities created in the sixteenth century as stage designs; in the Barberini theatre such bold perspective effects, framing the setting sun, were also explored. The Pope was the leader of taste, and the picture set a fashion; Claude painted variants on the theme for the great Cardinals from Urban's entourage, including one for Cardinal Leopoldo de'Medici which includes a flattering reference to the Villa Medici and to the Medici Venus (Plate 36).

In the pendant, *The Landscape with a Rustic Dance* the effects of light are less spectacular, yet one may sense the result of Claude's many studies of woodland glades. A party of cavaliers and their ladies watch the dance, and two of them wait to join in. Light filters through the trees, catching within the shady glade the curved brim of a hat and a sword hilt dark against the sky. The meeting of town and country suggests the courtier's idealization of the charm and peace of country life, where the herdsman with his goats, the sweet rustic figures, the woman and her vivid baby, and even the animals are drawn into the mood and together celebrate the beauty of nature. Urban VIII loved the country, and himself wrote bucolic verse that echoed the sentiments of Horace's *Beatus Ille*. The picture seems to capture their mood, with their invocations to the city dweller to seek the innocent joys of rural life:

Ab urbe rura nos vocant ad otium
Bonae quietis innocensque gaudium.

34 *Harbour with Rising Sun.* 1634. Etching, second state, 13·7 × 19·7 cm. (5⅜ × 7¾ in.). London, British Museum.

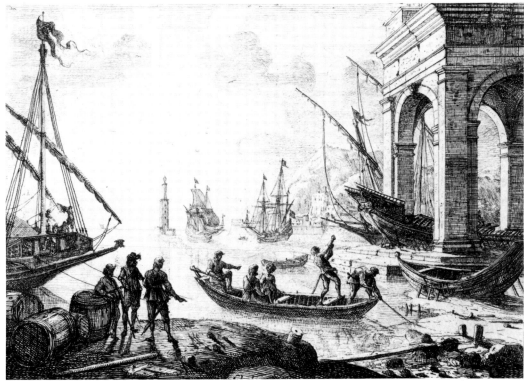

35 *Landscape with a Country Dance*. Oil on canvas, 71 × 100·5 cm. (28 × 39½ in.). Private collection. The theme was a favourite one, and Claude both painted and etched it in the 1630s and later; it looks back to similar subjects by Callot and Filippo Napoletano.

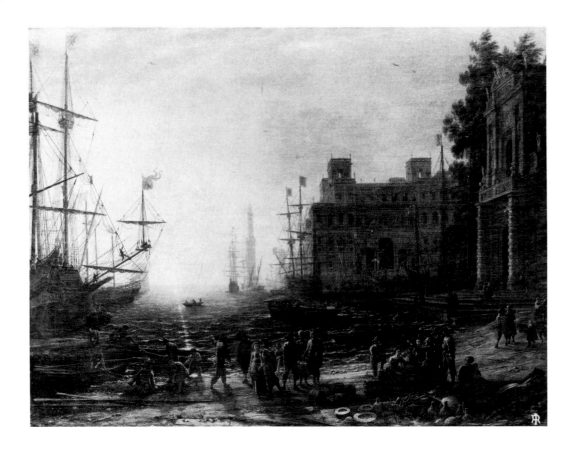

36 *Seaport with the Villa Medici*. 1637. Oil on canvas, 102 × 133 cm. (40 × 52⅓ in.). Florence, Uffizi. This picture develops, in a more elegant, lyrical vein, and with a more silvery light, the earlier *Seaport* (Plate 7); the Medici Venus crowns the fanciful rusticated buildings, and the Medici palle decorate its pediment and the ships in the harbour.

These pictures were soon followed by a second pair of small jewel-like pictures on copper, the *Pastoral Landscape with Castel Gandolfo* (Plate 11) and the *Coast Scene with the Port of Santa Marinella* (Plate 37). Urban VIII was particularly fond of his summer residence at Castel Gandolfo, recently completed by Maderno. He took with him there poets and writers – amongst them the aged Gabriele Chiabrera – and Sandrart did an etching of him going down to the lake to fish. The beauty of Castel Gandolfo, where he who 'content with little, seeks nature', is celebrated in several of his poems; an early Italian sonnet describes the beauty of the lake, of the distant prospect of the sea, where the blue sky is filled with the golden rays of the sun, of the green hills and flowery meadows touched by a gentle breeze. Claude's picture conveys this mood; the grand palace, set back, feigning modesty, and bright

in the sunlight, contrasts with a tender vignette of country life where the rustic folk, so gravely and sweetly, make music beneath a sheltering tree. The *Port of Santa Marinella* (Plate 37) was commissioned to record a small harbour south of Civitavecchia which the Pope intended to expand. Claude visited the harbour, and a series of penline drawings of the coastline and of Civitavecchia record this journey. There is evidence which suggests that the picture was completed by 1638, and Claude must have made the journey in 1637–8. The picture is unexpected for a topographical work; it has a vivid freshness and spontaneity.

In the later 1630s Claude's response to effects of light deepened and widened. He painted the rosy light of morning or evening on misty river scenes; the bright light of early morning, when highlights glint on dewy plants; the soft light that illumines

48

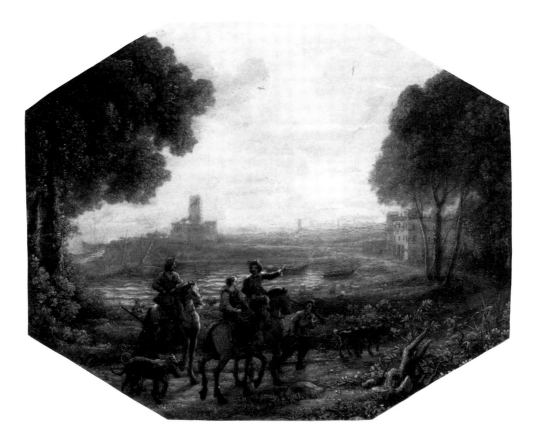

37 *Coast Scene with the Port of Santa Marinella.* Oil on copper, octagonal. 30 × 37 cm. (11¾ × 14½ in.). Paris, Petit Palais. Claude has embellished the view of the small port of Sta Marinella with an imaginary bay; the square palace with corner towers appears in many of his early works.

foliage or deeply wooded river banks. Light fills the atmosphere, creating a new unity between distance and foreground. These pictures convey a sense of the untouched calm of the virgin countryside; often the figures are very small and seem to wonder at the beauty of a world new made. Other artists in the 1630s were painting richly atmospheric landscapes; Jan Both painted the golden glow of late afternoon; Swanevelt's wooded scenes are filled with a warm reddish glow (Plate 40). Yet Claude's vision of nature is at once naturalistic and at the same time intensely poetic. Such effects delighted the most sophisticated patrons. Giulio Rospigliosi, later Pope Clement IX, and a life-long friend of Claude, coveted a picture painted in the gardens of the Vigna Madama (Plate 39) 'for which His Holiness Clement IX offered him as many doubloons as would cover it completely, but it was never possible to get it out of his hands because he said that he used it every

day to see the variety of trees and foliage.'

In such pictures as the *Pastoral Landscape* (Plate 38) where a shepherd pipes, a small temple suggests a sacred place, and dark trees shelter the deer, Claude echoes the poetry of Giorgione. The mood is touched with the idyllic charm of Virgil's *Eclogues*, where Tityrus, lying back beneath wide beechen cover, meditates 'the woodland muse on slender oat'. Yet at the same time it conveys the enchantment of solitude that had been so keenly felt by Renaissance poets. It is a mood richly developed by French poets in the early years of the seventeenth century, as in Thèophile de Viau's ode *Solitude*, which opens with the lines:

Dans ce val solitaire et sombre
Le cerf qui brame au bruit de l'eau
Penchant ses yeux dans un ruisseau
S'amuse a regarder son ombre.

49

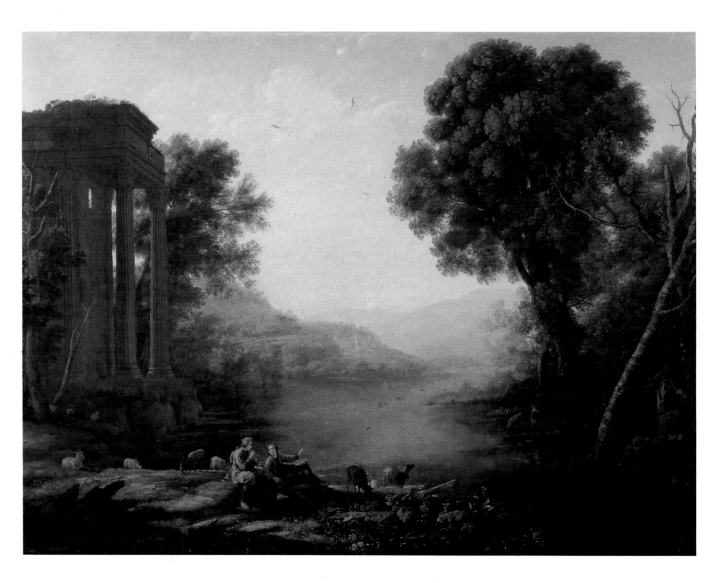

38 *Pastoral Landscape*. 1638. Oil on canvas, 100 × 132 cm. (39⅓ × 52 in.). West Sussex, Collection at Parham House.

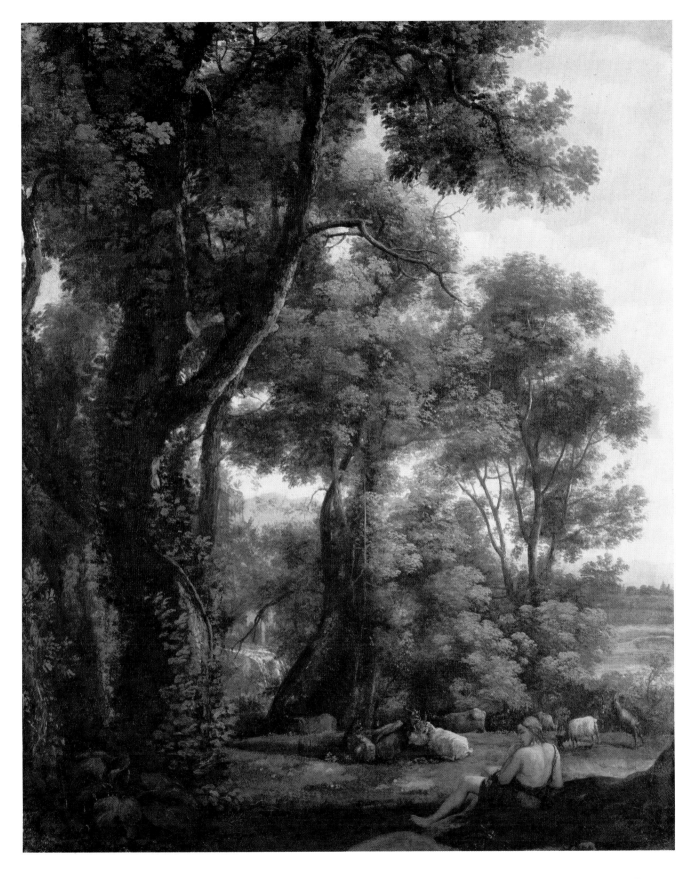

39 *Landscape with a Goatherd*. 1637. Oil on canvas, 52 × 41 cm. (20½ × 16 in.). London, National Gallery. It is just possible that this is the picture painted out of doors in the grounds of the Vigna Madama, and coveted by Clement XI. It is very close to tree drawings made in the park in the 1630s; moreover it is a wonderfully fresh study of soft light filtering through the boughs, with here and there a pin point of bright blue sky. The classical goatherd, and the little temple add an Arcadian note.

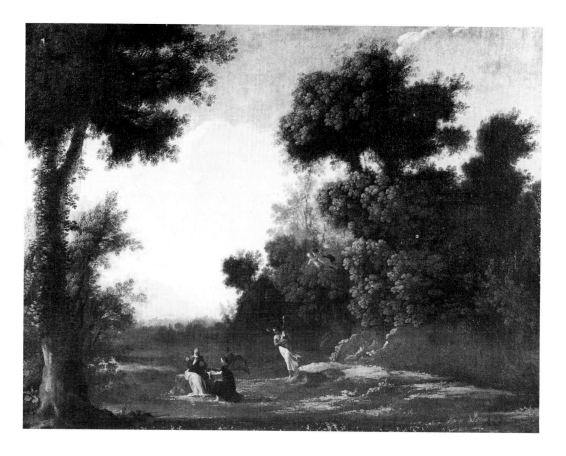

40 Herman van Swanevelt (1600–55) *Landscape with Christ tended by Angels*. Oil on canvas, 100 × 152 cm. (39⅓ × 50 in.). Rome, Galleria Doria-Pamphili. Swanevelt was in Rome for the late 1620s until at least 1644. In the 1630s he painted richly atmospheric wooded landscapes close to Claude's; his free, luminous drawings in the countryside around Rome record his solitary wanderings there, from which he was nicknamed 'l'eremita'.

Sant Amant's love of the solitude of deep green woods also seems to recall the very dawn of the world. It is not clear how much Claude knew of ancient landscape painting, yet often his blend of landscape with ancient ruins and bridges seems to capture their spirit (Plate 44).

Claude's most illustrious patron of the 1630s was the King of Spain, Philip IV. In the 1630s the King was building a vast royal pleasure palace called Buen Retiro; this was girdled by extensive gardens, and lay on the wooded outskirts of Madrid, near the monastery of San Jeronimo. The vast grounds dominated the palace, and were embellished with a series of hermitages which suggest a craving for a renunciation of that power and splendour so richly symbolized by the palace itself. The palace was decorated with works of art; amongst other ensembles was a gallery of landscape painting, decorated with fifty-five works by contemporary landscape painters in Rome. It is not entirely clear who commissioned this wealth of pictures. One possible candidate is Crescenzi in whose palace Claude had painted some early frescoes; another, perhaps more likely, is the Marquis of Castel Rodrigo, the ambassador to the Holy See. Rodrigo was a learned and discerning collector of art; he certainly knew Claude, who executed a series of etchings of fireworks for him which showed the festivities held to celebrate the election of Ferdinand of Hungary as King of the Romans. This was the most important and exciting landscape commission in early seventeenth-century Rome, an opportunity for the new art to attain a new grandeur. Many northern artists contributed to the series; Poussin, Jan Both,

Swanevelt, Dughet, Lemaire and Jacques d'Arthois. Yet Claude's contribution was the richest; Baldinucci tells us that he sent eight pictures to Madrid. In fact there may have been more: two medium-sized pictures, probably for Buen Retiro (although it has been suggested that these two works were bought later by Philip V); three, or perhaps four large, horizontal pictures, certainly for Buen Retiro; and a later group of four large upright pictures also for Philip IV's palace.

In the sixteenth century, Venetian artists followed by their northern contemporaries had painted landscapes which reflect the solitary meditations of anchorite saints; wild, moody prospects, with dark forests and deep ravines, all echoing the torment of the penitent. These images were popularized through engravings, and the pictures at Buen Retiro often derive from the well known series of engravings of saints after Marten de Vos. Claude's pictures are variants on this theme, and display marked contrasts in mood and atmosphere. A desolate range of mountain peaks, flooded with fiery sunset light, surround the anguished *St. Onofrio* (Plate 45), while *St. Maria Cervello* (Plate 46) kneels in the bright morning light before a soft pearly distance where the soul, in solitude, recovers a sense of innocence and tranquillity. The *Temptation of St. Anthony* is, for Claude, the most unusual; this is an eerie moonlit scene, where devilish boatmen row on a ghostly river, and the saint is tormented by Bosch-like demons. In these grave and sombre pictures Claude moved away from the delicacy of his more northern

41 *The Cowherd*. Etching, first state, 126 × 195 cm. (49⅔ × 76¾ in.). Oxford, Ashmolean Museum. The etching's Virgilian mood where the bright hot sunlight fades, and the tall shadows fall, is close to the *Pastoral Landscape* (Plate 2); the arching trees, and the glimpse of a farmhouse suggest tranquillity at the end of a long summer's day.

42 *The Finding of the Infant Moses. c.*1640. Oil on canvas, 209 × 138 cm. (82⅓ × 54⅓ in.). Madrid, Museo del Prado. This, and the three following pictures, were an outstandingly important commission from King Philip IV of Spain. They are two sets of pairs which relate to one another as pendants and as contrasting pairs.

43 *Landscape with the Burial of St. Serapia*. Oil on canvas, 212 × 145 cm. (83½ × 57 in.). Madrid, Museo del Prado. This subject is unique in painting. St. Serapia was the servant of St. Sabina, whom she converted to Chritianity. Her martyrdom was thought to have taken place on the Aventine, where the church of St. Sabina later stood. The site is suggested by the majestic ruins and the Colosseum in the distance.

works towards an Italian scale and grandeur.

Four upright pictures completed this commission in the years around 1640. These works are the culmination of Claude's early period and mark a sudden turning point in his art. This series was composed of two pairs; *The Finding of the Infant Moses* and the *Burial of St. Serapia*, and the *Port of Ostia with the Embarkation of St. Paula* and the *Tobias and the Angel* (Plates 42, 43; 47, 48). In each pair the compositions of the two pictures are carefully balanced, so that tall, majestic trees are balanced by classical columns, and throughout, horizontal and vertical accents create a more stable framework and stronger formal accents than in earlier pictures. Above all, in these landscapes which are his first scenes from biblical history, Claude wished to create nobler, more ordered scenes that should reflect the deep portent of these deeds of a dramatic and long distant era. *The Port of Ostia with the Embarkation of St. Paula* shows Saint Paula, a widowed Roman matron with five children, who in AD 385 left her family – except for one daughter, St. Eustochium – to be near St. Jerome in Bethlehem; later she founded the Jeronomite order. The tall architecture is more majestic than hitherto, suggesting the splendour of

ancient Ostia. St. Paula herself is a figure of touching dignity, as she prepares to leave the tender circle of friends and daughters. A child gives alms to a beggar, contrasting poignantly with the vast distances suggested by the bright sunlight and deep space. *The Burial of St. Serapia* conveys a deepened feeling for antique Roman ruins, painted with a new archaeological feeling, which suggest the site on the Aventine where the saint was martyred. Most striking is the Roman grandeur of the composition, where shattered fragments of a temple and clear-cut, almost geometric blocks of masonry lead the eye into an ordered perspective. These pictures announce Claude's desire to create a classic landscape that should suggest the grandeur of an ancient world; yet still they are paired with such intensely romantic works as the *Tobias*, a haunting melancholy evocation of a dusky evening landscape, where the small figures are isolated in the wild beauty of a desolate valley and windswept sky.

Claude associated with this commission for Philip IV the beginnings of his *Liber Veritatis*, a remarkable record of his painted works. In 1634 a young artist, Sebastien Bourdon, had arrived in Rome and had begun to paint for dealers; Bourdon developed into

44 *Antique Landscape.* Landscape fresco from the Villa dei Quintile (Via Appia) – Villa Albani, Rome.

45 *Landscape with St. Onofrio.* Oil on canvas, 158 × 237 cm. (62 × 93½ in.). Madrid, Museo del Prado. The intensely romantic mood of this painting, and the wild and desolate grandeur of the mountain scenery, are rare in Claude's art; the torrents and jagged trees are the fruits of such nature studies as *Trees and Rocks by a Waterfall* (Plate 18).

46 *Landscape with St. Maria Cervello.* Oil on canvas, 162 × 241 cm. (63¾ × 95 in.). Madrid, Museo del Prado. This picture, and the *Landscape with St. Onofrio*, belong to a group of three or perhaps four pictures with anchorite saints that Claude painted for the palace of Buen Retiro in Madrid. St. Maria Cervello was a thirteenth-century saint who came from Barcelona.

a remarkably eclectic artist, whose mature works are often decorative interpretations of Poussin or Dughet. He visited Claude in his studio, and Claude showed him a landscape still unfinished. Bourdon swiftly painted an imitation of this work, which to Claude's grief was accepted in Rome as a fine picture by Claude. This forgery was probably not an isolated example and encouraged Claude to protect himself; for this purpose he began his *Libro d'Ivenzioni* or *Libro di Verità*. Baldinucci gives a long account of the purpose and origins of this book, which, he writes, Claude himself showed to him at his house in Rome 'to my great delight and astonishment'. The book had been started 'about the time that he was painting his first pictures for the King of Spain'. He was working for the King on the said pictures which he had indeed hardly begun, when certain envious and dishonest men not only stole his compositions but even imitated his manner, and the copies so produced were sold throughout Rome as originals from his own brush; this brought discredit to the master, disserved the illustrious person for whom the pictures were painted and defrauded the buyers who bought the copies as originals.' Claude therefore

began to copy all his pictures into a book, inscribing these copies with the name of the person to whom they had been sent. Prospective buyers then could look through the book and see their pictures there: 'since the forger, although he had stolen the composition, had been unable to put in all the details, the difference was immediately apparent to all eyes and the deception was exposed.'

The book was begun about 1635; it is a bound book in which four white pages alternate with four blue. In style the early drawings, mainly in pen and brown ink, have something of the freedom of the early nature drawings. And yet, as the project developed, Claude's approach became both more meticulous and more poetic; the book itself grew into a work of art of extraordinary richness and beauty. It lies at the centre of Claude's art; as one looks through the drawings, the themes and compositions that absorbed Claude unfold; one sees Claude inventing an idea, enriching it and expanding it, balancing it against a contrasting composition, abstracting its essential nature and beauty; motifs, and arrangements, interweave with and echo one another through the years.

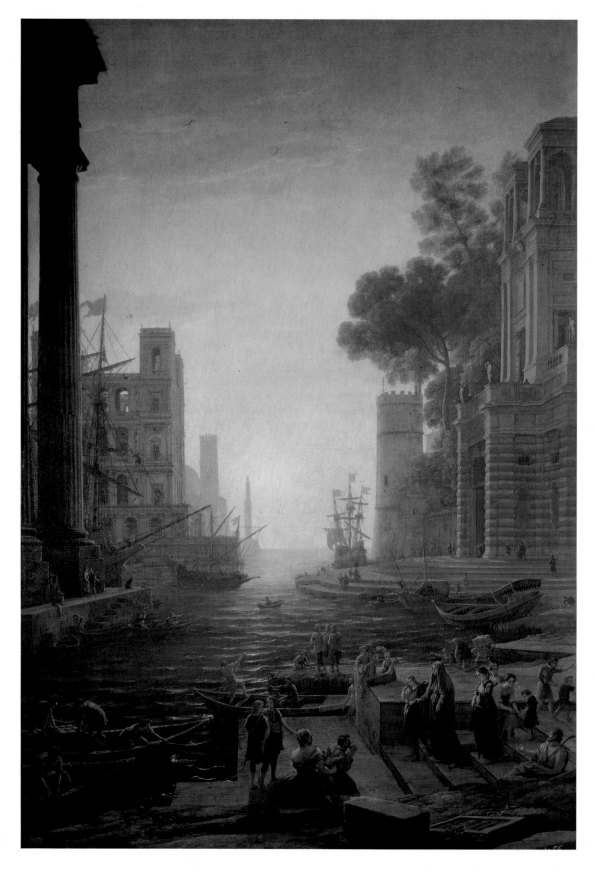

47 *The Port of Ostia with the Embarkation of St. Paula.* Oil on canvas, 211 × 145 cm. (83 × 57 in.). Madrid, Museo del Prado.

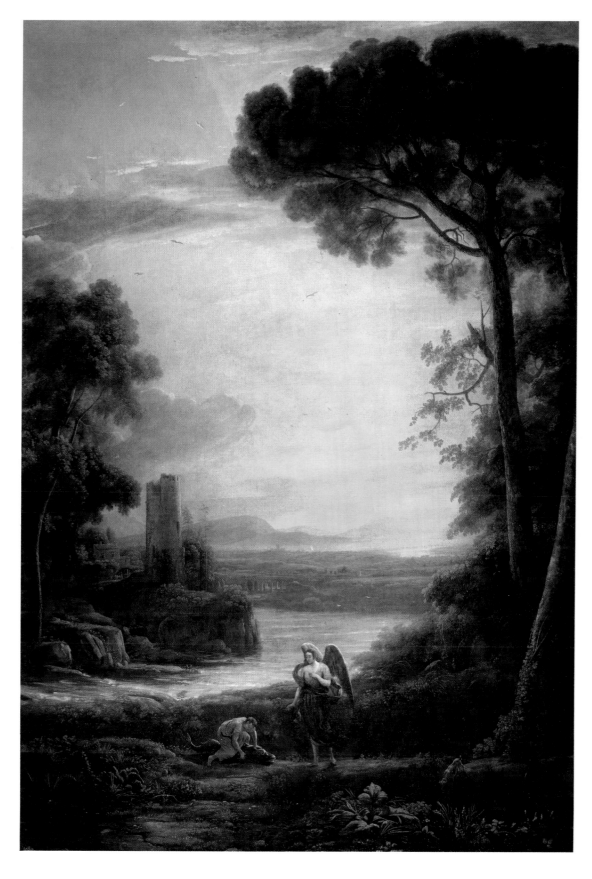

48 *Landscape with Tobias and the Angel*. Oil on canvas, 211 × 145 cm. (83 × 57 in.). Madrid, Museo del Prado. Here the dramatic sunset contrasts with the bright morning light of the pendant. The landscape, with its ruined tower and melancholy light, creates an unusual sense of romantic solitude; the little inn with the travellers is almost hidden.

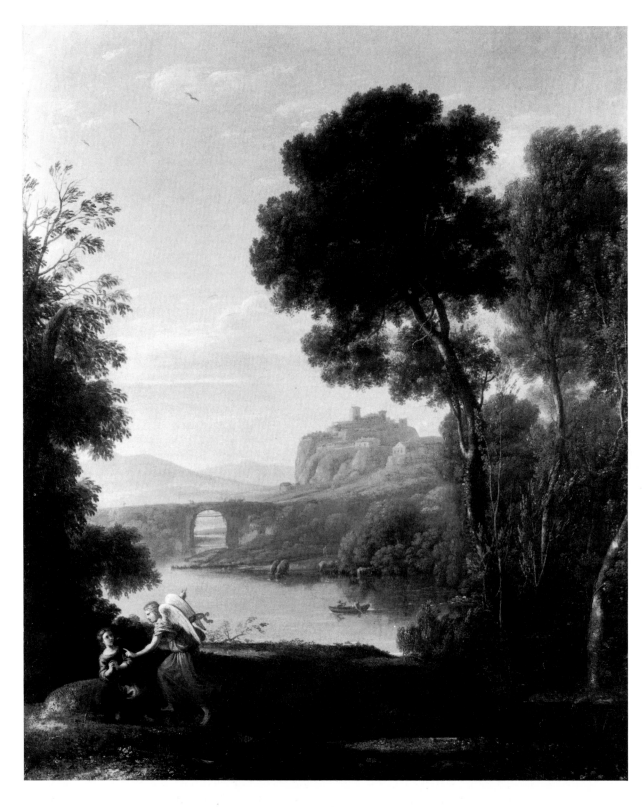

49 *Landscape with Hagar and the Angel*. Oil on canvas, 52 × 44 cm. (20½ × 17⅓ in.). London, National Gallery. This composition is based on a work by Domenichino (Plate 55). The shaded foreground frames a luminous vista, yet at the same time emphasizes the surface pattern of shapes and colours. The clearness and brightness are characteristic of the 1640s.

PASTORAL PAINTING
1640 ‑ 50

In 1641 Urban VIII embarked upon the disastrous War of Castro. His papacy had already become unpopular, and the wealth and power of the papal nephews was attacked with increasing bitterness in the final years of his pontificate. In 1644, with peace scarcely concluded, the Pope died. His successor, Gianbattista Pamphili, who took the name of Innocent X, was renowned for his taciturnity; his portrait by Velasquez still hangs in the Palazzo Doria Pamphili in Rome, where, stern and deeply suspicious, he glowers at the spectator. A contemporary diarist immediately lamented, 'This Pope is no friend of letters, nor of orators nor poets', and his court was to display none of the rich literary and artistic culture that had so distinguished the court of Urban VIII. Innocent confined his patronage to works dedicated to the splendour of his name and family. His rule was moreover a troubled one, marked by financial crises, and by the severe flooding of the Tiber and consequent famine in 1647. Within the papal family sensational scandals and dramatic reversals of fortune coloured the age; these centred around the formidable Olimpia Maidalchini, the Pope's sister-in-law, an ambitious and powerful woman who for several years dominated the papal court.

Innocent's election saw the dramatic reversal of the fortunes of both nobles and artists who had flourished under the Barberini. Those whom the Barberini had favoured, Innocent rejected, and for many artists his pontificate was a lean and troubled time. Yet Claude's fortunes remained secure. By this date he was one of the most fashionable artists in Rome, indeed in Europe; some potential buyers were shocked at his high prices, and in 1640 Elpidio Benedetti, Mazarin's secretary in Rome, wrote to Mazarin that the painter 'was not ashamed to ask for 300 ecus for one of his largest pictures and eight months wait! His impertinent pretension has persuaded me that you should free yourself of the desire to own one of his pictures which, in the end, are not miracles!'

With the change of Pope, Claude's patrons changed, establishing a lasting pattern. A new circle rose to take the place of the great Cardinals from Urban VIII's entourage who had manifested such intense rivalry in their commissions to the painter. Foremost amongst them was Camillo Pamphili, the papal nephew; the only Pamphili with a love of the arts, Camillo was an enthusiastic collector of landscapes, and commissioned five pictures from Claude. Throughout the 1640s, too, the vogue for Claude's pictures continued in France, especially in Paris. Outstanding amongst the French collectors were the ambassadors and diplomatists who had worked in Rome, and who followed the fashion set by Philippe de Bèthune – amongst them François du Val, the Marquis de Fontenay – Mareuil, who was French Ambassador to Rome from 1641–46 and 1647–50, and the Duc de Bouillon, in Rome from 1644–47 as general of the papal army. Du Val also bought pictures for the distinguished collector Roger du Plessis

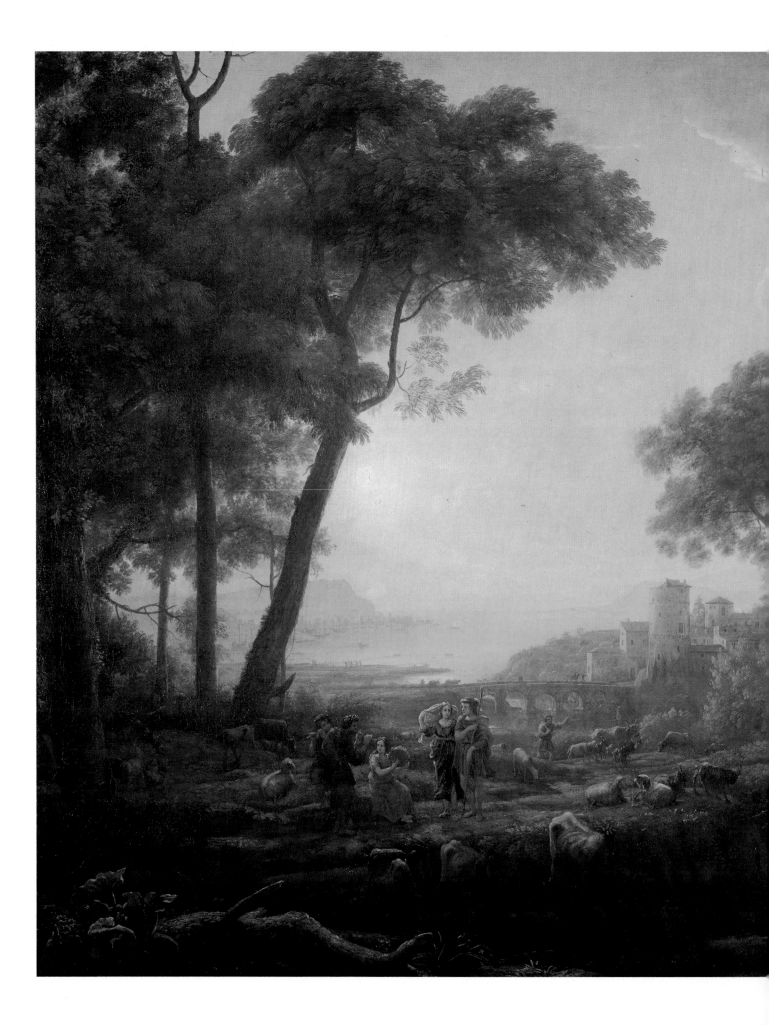

50 *Landscape with a Rustic Dance*. c.1640–1. Oil on canvas,
118 × 148·5 cm. (46½ × 50 in.). Woburn Abbey, Marquess of
Tavistock. This is a more classical rendering of the earlier *Landscape
with a Country Dance* (Plate 35). It was painted for Pietro Pescatore,
a Flemish merchant in Rome, whose casino at Frascati was decorated
with scenes from the lives of the gods.

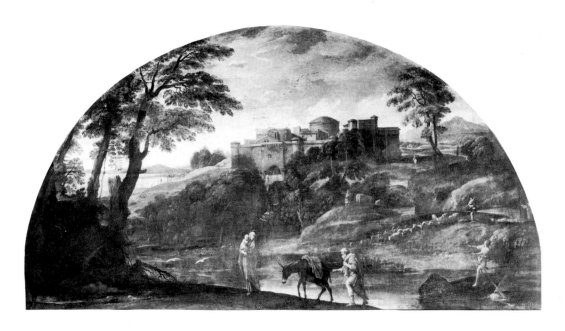

51 Annibale Carracci (1560–1609). *Landscape with the Flight into Egypt.* c.1604. Oil on canvas, 122 × 230 cm. (48 × 90½ in.). Rome, Galleria Doria-Pamphili. This work is seminal to the development of ideal landscape painting in seventeenth-century Rome; its influence may be felt in different ways at varying stages of Claude's career.

de Liancourt, who owned landscapes by Brill and Poelenbergh and pictures by Annibale Carracci. André Felibien, who was to become the champion of the classical style of Poussin, accompanied du Val to Rome as his secretary; in 1647 he visited Claude's studio, where he saw 'his little landscapes painted in tempera on wood' – none of which has definitely survived.

Claude's circle of patrons was very different from that of Poussin, who was patronized by the intellectual bourgeoisie; yet they shared some patrons, such as Giulio Rospigliosi, poet and dramatist, and Michel Passart, the accountant general in Paris, who bought two works from Claude in the 1640s, and owned some outstandingly important pictures by Poussin. Passart remained in touch with Claude over the next twenty years.

In the early 1640s Claude's pictorial range was wide, and often his landscapes still glow with sunset light and explore richly atmospheric effects; the most brilliant of his drawings from nature date from the years around 1640, and in these years there is a close relationship between drawing and painting. Yet slowly he moved towards a greater classicism,

in the sense that his pictures became increasingly clear and balanced in composition and enriched by subjects from the Bible and from mythology. He began to accentuate the middle ground, and to lead the eye, through a series of clearly defined horizontal planes, crossed by rivers and bridges, to a distant vista: the spectator becomes an imaginary traveller, moving towards this light.

The *Landscape with a Rustic Dance*, (Plate 50), a large and exuberant work, heralds this move towards a new clarity and grandeur. The trees of the foreground and middle distance suggest an immense arch which frames the beauty of the distance where the great golden globe of the sun draws the eye to the horizon. Here, where the harbour is dotted with little white sails, and fishermen draw in their nets, the sun on the water is pale and smooth, caught in the most delicate tints of mother of pearl. Between the dark branches of the tree, the pinks and greys of the water blend with rosy sunlight. The brushwork is fluid, and the picture – rich in picturesque detail, and vivid with bright highlights – is in a sense the culmination of the romantic pastorals of the 1630s. Yet it is more grandly structured, and inhab-

ited by Arcadian shepherds; it suggests the lovely fertility of an ideal Italy, eulogized in Virgil's *Georgics*, where there is 'perpetual spring, and summer weather'.

In this move towards a more classical landscape Claude began, in the years around 1640, to be attracted both by the spirit and the structure of the ideal landscapes that had been evolved earlier in the century by the Bolognese painter Annibale Carracci and his pupil Domenichino. The most celebrated of Annibale's landscapes were two lunettes, the *Landscape with the Flight into Egypt* (Plate 51) and the *Landscape with the Entombment of Christ*, painted between 1600 and 1604 for the chapel in the Palazzo Aldobrandini. In these landscapes the noble and sombre forms reflect the drama of great events. Claude responded both to the awe-inspiring

grandeur of the *Entombment*, and to the order and harmony of *The Flight into Egypt*, where trees frame the foreground, and a massive building is the focus of the middle distance. The flights of birds, the small herdsmen, the boatmen in contrapposto, gently lead the eye across water and hills, balancing each movement with a countermovement.

Domenichino took up the theme, and his later landscapes are increasingly rocky and majestic. Early in his career, between 1616–18, Domenichino decorated a room in the Villa Aldobrandini at Frascati with frescoed scenes from the life of Apollo. These were painted for an aristocratic patron who sought, as the ancient Romans had done, the 'lovely place' of Virgil's poetry in the cool hills of Frascati, where Domenichino's frescoes suggest a green and tranquil retreat. These landscapes are pale and still;

52 Domenichino (1581–1641) and assistants. *The Flaying of Marsyas*. 1616–1618. Fresco transferred. 210·2 × 331·4 cm. (81⅝ × 130½ in.). London, National Gallery. This is one of a series of frescoes which once decorated the Villa Aldobrandini at Frascati. Such decorations became popular for country retreats; Claude's patron Pietro Pescatore commissioned a similar series for his casino at Frascati.

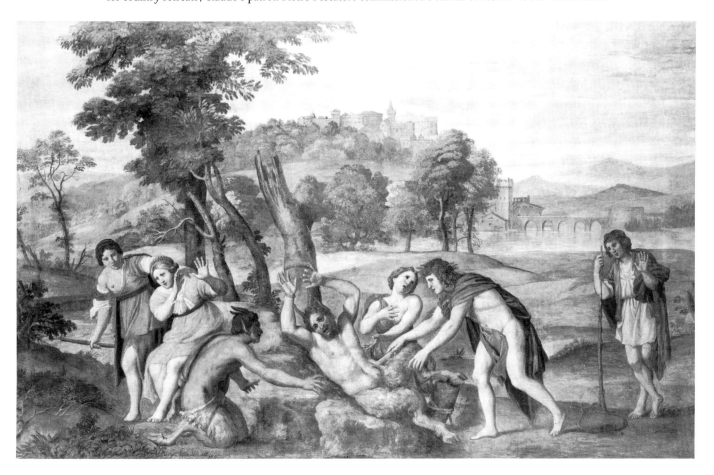

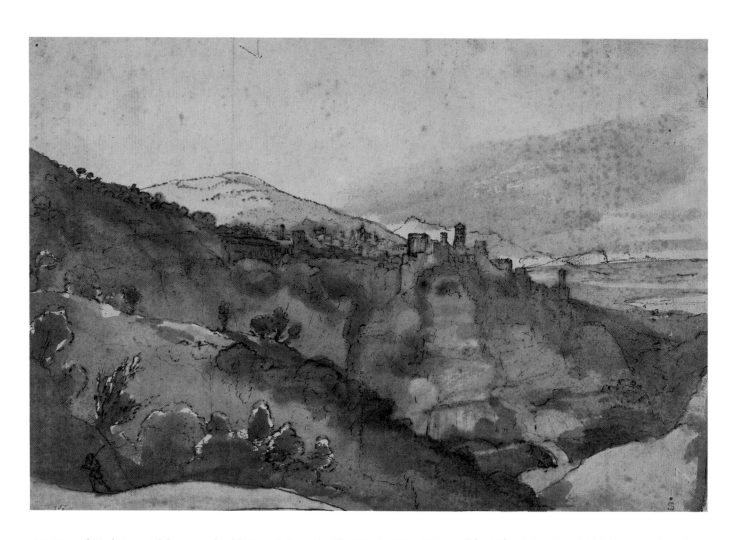

53 *View of Tivoli*. Pen with brown and reddish wash. From the Tivoli book. 21·5 × 31·6 cm. (8½ × 12½ in.). London, British Museum. Here the sun rises, lighting the distant hills, touching the deep shadows in the valley with rosy pink, and circling with light the edges of foreground trees and plants.

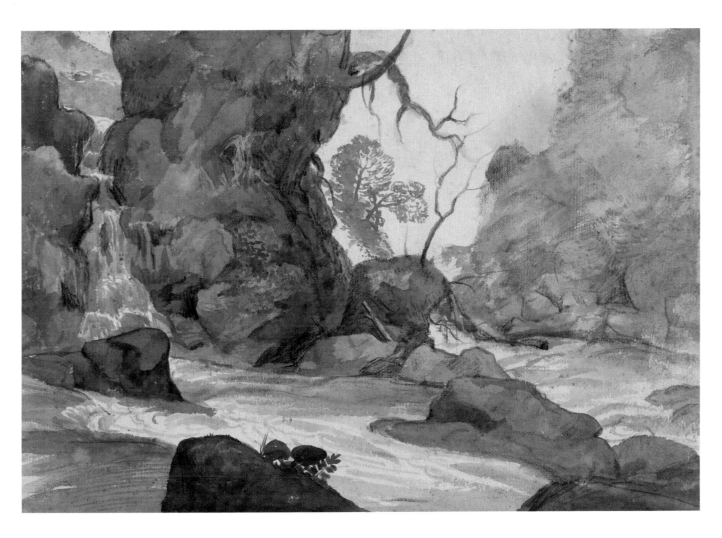

54 *Rocks by a Torrent*. Chalk with brown wash. From the Tivoli book. 21·6 × 31·2 cm. (8½ × 12½ in.). London, British Museum. Claude drew rocks and torrents many times in the 1630s. This drawing, immediate and direct, composed with startling freedom, and vivid in its contrasts of light and dark, is one of his most dramatic drawings from nature.

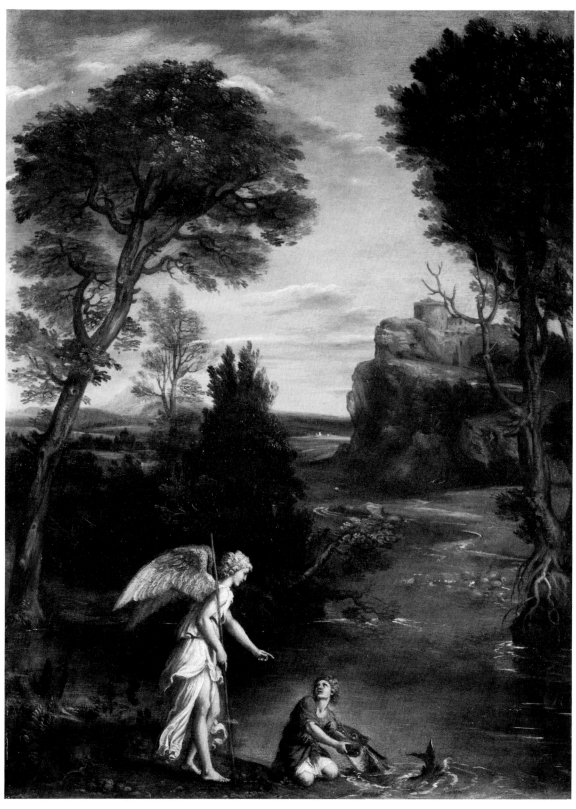

55 Domenichino (1581–1641). *Landscape with Tobias laying hold of the fish*. *c*.1615. Oil on copper, 45 × 33·9 cm. (17¾ × 13⅓ in.). London, National Gallery.

the gentle rhythms of rounded meadows and trees, broad bridges and lofty hill top towns overlooking distant plains, all create a virgin calm broken only by the terror of myth (Plate 52).

There was a widespread renewal of interest in Bolognese painting in the 1640s. Annibale Carracci had died in 1609, and although he had never been forgotten, time had begun to add new lustre to his name. Both Italian and French patrons were enthusiastic collectors of Bolognese landscapes, and the great landscape painters of the 1640s – Poussin, Gaspard Dughet, Claude – sought both to renew and to rival the tradition they had founded. In their formal symmetry, nobler forms, and stronger middle distances, Claude's landscapes began to echo Domenichino (Plates 55, 2 and 49).

In the early 1640s Claude's pictures became more brightly coloured, sunnier than the misty wooded scenes of the 1630s. Many pictures celebrate the beauty of the countryside around Rome; they show, under brilliant Mediterranean skies, an open countryside increasingly reminiscent of the Tiber Valley, and beyond, the plains of the Campagna, with its aqueducts and medieval towers; the beauties of Tivoli; and the most famous ancient monuments of Rome itself – the Arch of Titus, the Colosseum, the Arch of Constantine. Such works were often done for French patrons, and, through the 1640s, it is almost always possible to tell whether a picture was intended for a Roman patron or for France. Through the seventeenth century, links between Italy and France were strong. French gentlemen, writers and painters were drawn to Rome above all by the cult of Antiquity; Rome was the *patria comune*, and the French sought there the roots of that ancient civilization that had so richly formed their own.

Many French travellers published accounts of

56 *The Cascades of Tivoli.* Chalk with a light cream wash. From the Tivoli book. 22·4 × 31·9 cm. (9 × 12½ in.). Thos. Agnew and Sons Ltd. Many northern artists drew the rocks and torrents in the wild countryside around Rome, yet here Claude's vigorous chalk lines block in the forms with a new grandeur and weight.

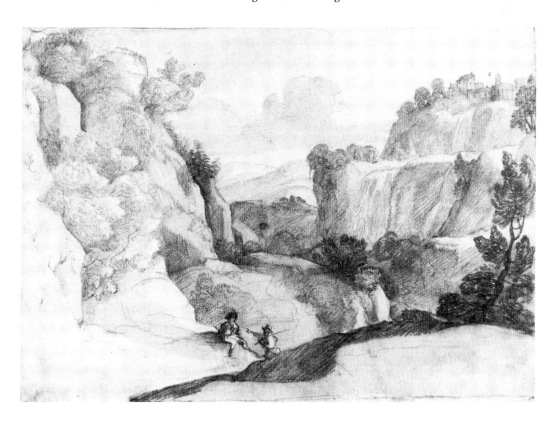

57 *Landscape with an imaginary View of Tivoli.* 1642. Oil on copper, 21·6 × 25·8 cm. (55 × 10 in.). London, Courtauld Institute Galleries (Prince's Gate collection). A horseman with his servants crosses the bridge; before him is the Temple of the Sibyl and the Cascatelle Grandi; beyond a glimpse of the lofty arches of the villa of Maecenas; glittering on the skyline, the dome of St Peters.

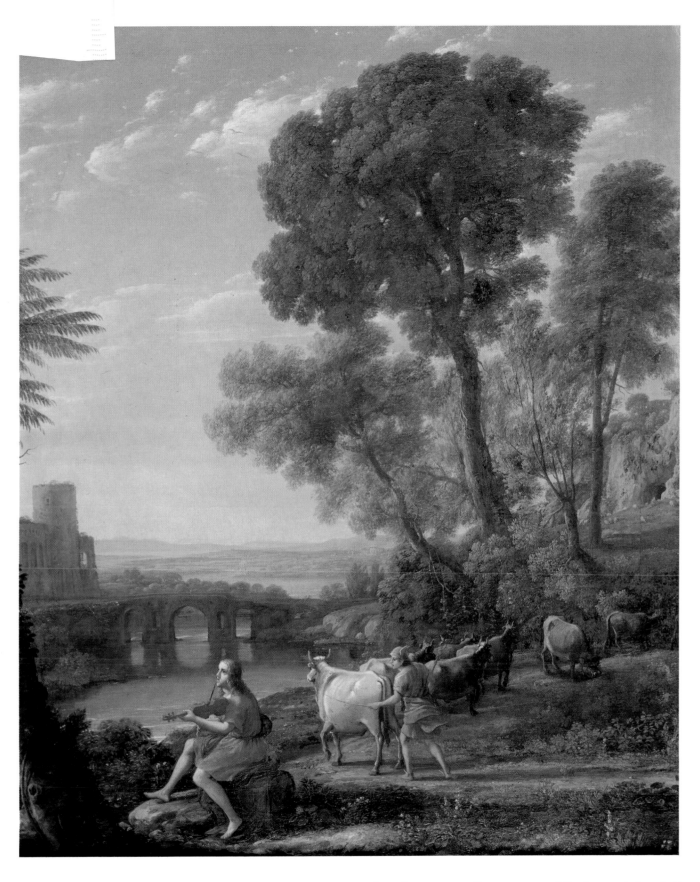

58 *Landscape with Apollo and Mercury.* 1645. Oil on canvas, 55 × 45 cm. (21⅔ × 17⅔ in.). Rome, Galleria Doria-Pamphili. The story is from Ovid; Apollo, grieving over the dead Coronis, comforts himself with his reed pipes; his straying cattle are stolen by Mercury. Claude's Apollo plays the violin, and may be derived from Raphael's *Parnassus* in the Stanza della Segnatura, which inspired a later picture.

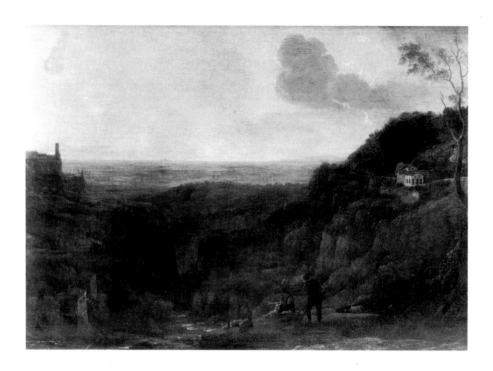

59 *A View of the Roman Campagna from Tivoli.* 1644. Oil on canvas, 93·5 × 129·5 cm. (36¾ × 51 in.). Royal collection. It has been shown that this is Claude's most accurate picture of a real view in the countryside, looking towards Tivoli with St. Peters on the horizon.

their journeys, amongst them Claude's patron, the Marquis de Fontenay-Mareuil; in 1644 Pierre du Val dedicated to the Duc de Bouillon a collection of notices and descriptions of Italy. These accounts provide disappointingly few descriptions of landscape, yet the Journal of the libertine, Jean-Jacques Bouchard, who was a friend of Poussin, provides a fascinating exception. Bouchard visited Naples in 1632, when every site of that fabled coastline recalled a description in Virgil or in Sannazaro, and where a glimpse of sailors inevitably called to mind the companions of Aeneas, and he ended his journey with a passionate hymn to the beauty of the Roman Campagna, and to the splendour of the views from the mountains of Frascati; he concluded – 'On seeing Rome, that great and beautiful city, I felt myself seized with a religious awe, on thinking of the great deeds of other times; then I began to feel a certain tenderness, as though I had seen my native city . . . At the same time, the ruins of so many temples, sepulchres, arches, palaces, aqueducts, roads, the desolation and solitude of the Campagna, once so fertile, . . .

brought to mind the Regrets of Joachim du Bellay. . . .'

Amongst the small towns that surrounded Rome, Tivoli was most celebrated as a beauty spot and had long been associated with painters. Every traveller went there, and there are many celebrated literary descriptions of Tivoli. It offered the splendour of nature, where the Cascatelle Grandi plunged into the rocky ravine below, throwing up a rainbow the colour of fire. The so-called temple of the Tiburtine sibyl crowned the towering cliffs; in the distance lay the vast and vaulted arches of what was then thought to be the Villa of Maecenas, the patron of Virgil and Horace who had commissioned the *Georgics*. Tivoli claimed too the lustre of an ancient history; its beauty had been praised by Virgil, Catullus, and Juvenal, and many echoed Horace's

As for me, neither obdurate Sparta
nor bounteous plain of Larisa
has struck me so much
As Albunea's booming cavern, and head
long Anio, and Tibur's grove and orchards
watered with frolicking streams.

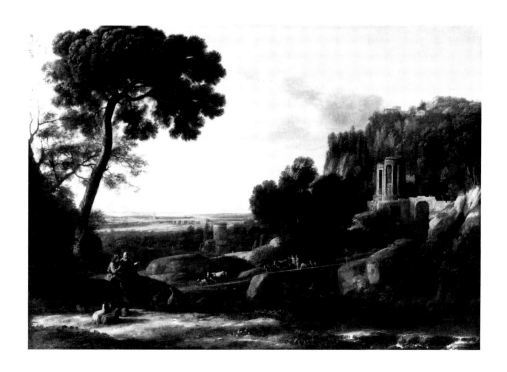

60 *Landscape with Shepherds. c.*1644. Oil on canvas, 98 × 137 cm. (38½ × 54 in.). Grenoble, Musée des Beaux Arts. This picture, with its emphasis on broad horizontals and an imaginary landscape reminiscent of the Campagna, is characteristic of the 1640s. A little later Claude painted a more classical variant of the composition, the figures strikingly reminiscent of classical sculpture the *Landscape with Argus guarding Io,* 1644 (Holkham Hall).

Underlying the pictures of these sites hallowed by Antiquity are some of Claude's loveliest drawings, the brilliant culmination of his studies from nature. Many of these come from a volume now known as the *Tivoli book* which, while close in date to the *Campagna book*, is bolder and more confident, and draws its motives from the wild countryside around Tivoli, with its cascades and rocky hills. Amongst them are drawings which continue, with a new grandeur, the themes of the 1630s – such as the deep woodland interior; trees and leaves patterned against a sunset sky; the bold, strange patterns of rocks by a pool (Plate 54). Others are more varied in style and technique. They include neat and accurate views of Tivoli, where the houses and buildings that cluster around the Temple of the Sibyl are drawn with sharp, geometric clarity. In the pure wash drawings he simplifies the forms into sweeping planes of light and dark. *The View of Tivoli* (Plate 53) shows the Temple of the Sibyl and the tower of the cathedral on the skyline; it vividly conveys a sense of the movement of bright morning light.

A small copper, the *Landscape with an Imaginary View of Tivoli* (Plate 57), charmingly catches the spirit of the seventeenth-century Grand Tour. The picture is not a view, but an anthology of the most celebrated sites; it is intensely romantic, the brilliant light evoking the wonder of such journeys; it recalls many passionate descriptions of Tivoli, amongst them Montaigne's:

This is the ancient Tiburtum, lying at the foot of the hills, the town extending along the first rather steep slope, which lends great richness to its situation and its view, for it commands a boundless plain in all directions, including the great Rome. It looks towards the sea, and has the hills behind it. It is bathed by this river Teverone, which near there takes a marvellous leap, descending the mountains and hiding in the hole of a rock, five or six hundred paces, and then comes out onto the plain, where it winds very playfully and joins the Tiber a little above the town.

61 *Pastoral Landscape with the Ponte Molle.* 1645. Oil on canvas,
74 × 97 cm. (29$\frac{1}{5}$ × 38$\frac{1}{5}$ in.). Birmingham City Museum and Art Gallery.

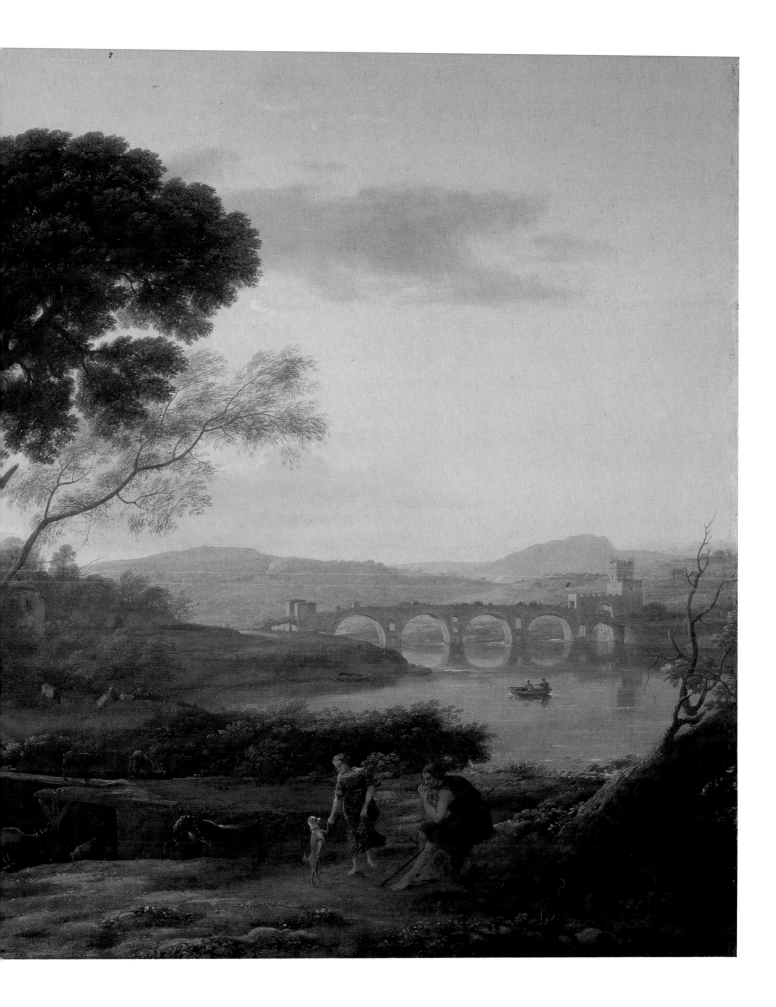

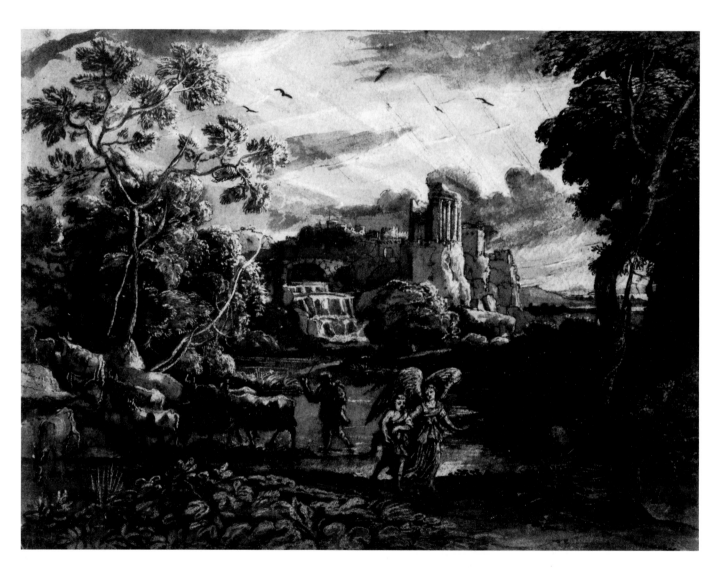

62 *Landscape with Tobias and the Angel.* 1642. Pen and dark brown wash; white heightening throughout, on blue paper, *Liber Veritatis* 65.
19·7 × 26·2 cm. (7¾ × 10⅓ in.). London, British Museum. This drawing (after a canvas destined to go to Paris) with memories of Tivoli, is stormier
and more dramatic than the painting, it is close in mood to Gaspard Dughet.

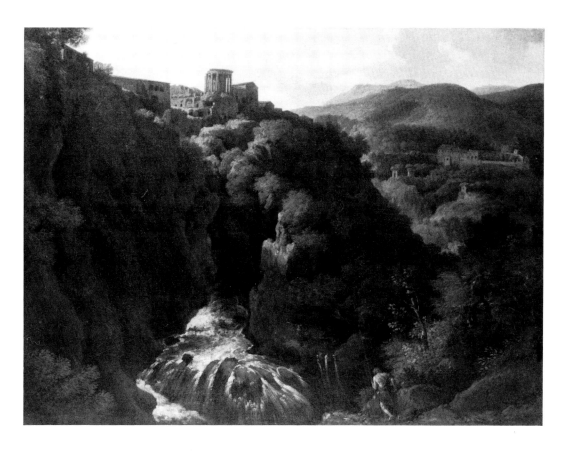

63 Gaspard Dughet (1615–75). *View of Tivoli*. Oil on canvas, 73 × 97·5 cm. (28¾ × 38⅜ in.). Newcastle upon Tyne, The Hatton Gallery. Gaspard Dughet painted many views of Tivoli; this view with its high horizon and towering cliffs is more dramatic than those of Claude, while having some points of contact with Claude's works of the 1640s. The date is uncertain.

Slightly later Claude combined the real and the imaginary in a new way. He painted a pair of pictures for Michel Passart, who knew Rome. The first, *Landscape with Shepherds*, (Plate 60) contains an unusually accurate rendering of the Temple of the Sibyl in an imaginary landscape; its pendant, *A View of the Roman Campagna from Tivoli* (Plate 59) is a strikingly realistic view, where the eye is swept across the boundless plains to St. Peters – silhouetted against a spectacular sunset sky. Such pictures combined the ideal and the real, as the traveller absorbed and then made his own his experience and memory of foreign lands. Gaspard Dughet too loved the beauty of the Roman Campagna, and rented houses at Frascati and Tivoli, where he painted, hunted and fished. His favourite view was the Temple of the Sibyl and the great cascade beneath. Occasionally Claude's capricci, particularly the most dramatic,

such as the *Landscape with Tobias and the Angel* (Plate 62) recall Gaspard Dughet (Plate 63).

The Tiber valley, where the Ponte Molle crossed the river, not far from Claude's house, was another favourite site. The Ponte Molle was a celebrated Roman bridge dating from the second century BC; here the Emperor Constantine had seen a flaming cross, and with this sign had conquered Maxentius and embraced Christianity. The Ponte Molle was the northern traveller's first and last view of Rome, and a picture such as Claude's *Pastoral Landscape with the Ponte Molle* (Plate 61) would have evoked a most poignant memory. The bridge appears in many of Claude's pictures and drawings, but this is the most precise portrayal of it as it was in the seventeenth century, with a fifteenth-century fortified gatehouse that has since been removed. The picture is intensely naturalistic; it captures the lovely play of light and

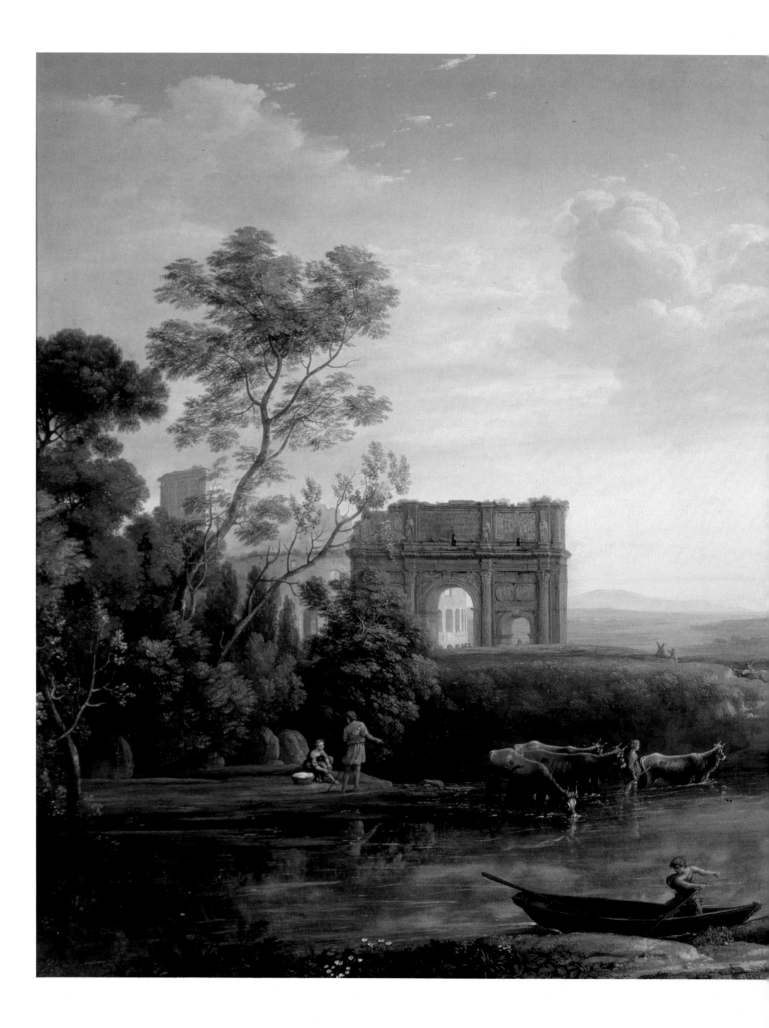

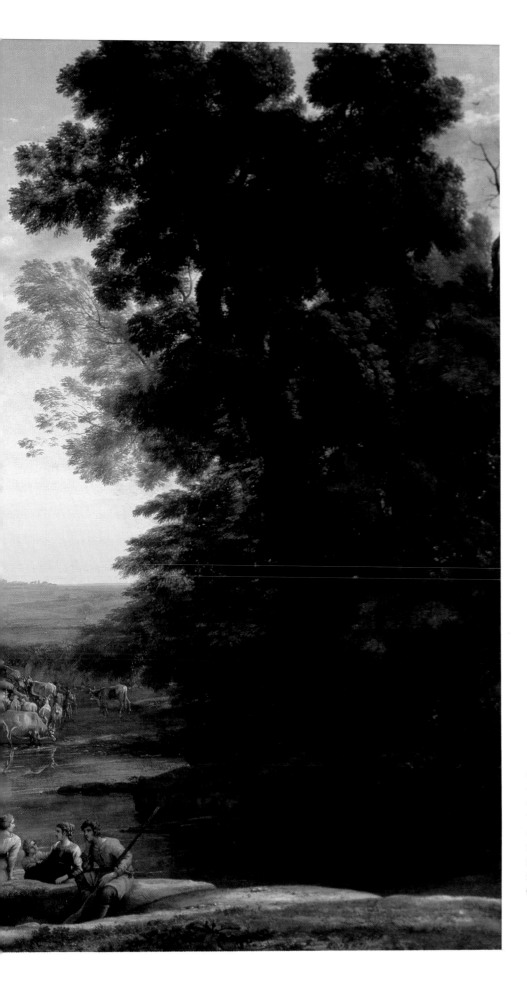

64 *Pastoral Caprice with the Arch of Constantine*. Oil on canvas, 98 × 145 cm. (38½ × 57 in.). Duke of Westminster. The picture is a capriccio, where the Colosseum and the Arch of Constantine stand in an imaginary setting; it was painted for a Swiss military engineer, Hans Georg Werdmüller.

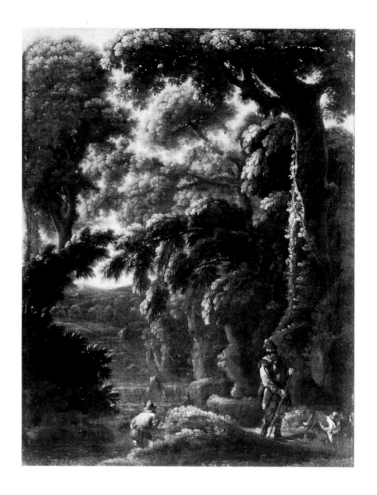

65 Angeluccio (Seventeenth century). *Landscape with Huntsmen.* Oil on canvas, 67 × 50 cm. (26⅓ × 19⅔ in.). Rome, Galleria Nazionale.

shade across the valley, and suggests with vivid freshness the bright sunlight on the bridge and water. Yet at the same time the almost geometric beauty of the buildings, the sense of balance and selection, idealize the landscape; it heralds the most tranquil and poetic of Claude's pastorals. A drawing, the *Tiber Valley* (Plate 66), (unusually signed and dated by the artist) creates a similar effect.

Amongst these pictures painted for foreign patrons that recall the grandeur of Rome are architectural capricci – less fanciful than those of the 1630s – where the famed monuments of classical antiquity are set in an idealized pastoral setting. The *Pastoral Caprice with the Arch of Constantine* (Plate 64), probably painted in 1648, is one of the loveliest of these. It conveys above all the poignant beauty of a bright, warm evening in the Campagna, when a gentle wind rustles the trees; the lovely

blues of the water reflect the shifting clouds; a chain of gestures from the woman pointing across the water, and the great arch of cattle, lead the eye into the distance, where small figures seem to marvel at the splendour of the distant plains, enriched by aqueducts and the hill top town framed by cypresses. The mood suggests both exaltation at Rome's beauty, and yet also its transience – the mood of Joachim du Bellay's:

Sacrez costaux, et vous sainctes ruines,
Qui le seul nom de Rome retenez,
Vieux monuments, qui encor soustenez
L'honneur poudreux de tant d'ames divines:

Arcz triumphaux, pointes du ciel voisines,
Qui de vous voir le ciel mesme estonnez,
Las, peu à peu cendre vous devenez,
Fable du peuple et publiques rapines!

In the mid-1640s Claude's assistant, Angeluccio, was most probably working in Claude's studio, and his works sometimes resemble such pictures as the *Pastoral Landscape with the Ponte Molle*. There is only one reference to Angeluccio in the early sources; Pascoli in his *Life of Claude*, 1730, writes 'Claude Gellée had little luck with pupils, and the only one who achieved renown was Angeluccio, who died young and who did not paint much . . . He was the only pupil worthy of him, for he did not seek to have pupils; and after the trouble with Giovanni Domenico he preferred not to have others in his studio.' Angeluccio painted thickly wooded landscapes (Plate 65), exploring the sous bois effects that Claude had introduced in the 1630s; yet his light is less subtle, and his foliage often enlivened with bright highlights. A series of drawings, in black chalk and body colour on coloured paper, often grey-blue, have also been attributed to Angeluccio. These are delicate, almost fragile studies of trees, plants, and leaves of great charm, yet lacking Claude's boldness and spontaneity.

Another aspect of Claude's art at this time was his increasing number of scenes from the Bible and from Roman literature. Ovid's *Metamorphoses*, which Claude read in a popular translation by Anguillara, became a favourite source. Ovid's tales of miraculous transformations, which bring together the myths and legends of Greece and Rome, had long enchanted northern landscape painters who saw the Ovidian landscape as a charming rustic playground, its vitality expressed in nymphs and shepherds, satyrs and gods. Claude's earliest Ovidian scenes are of well-known stories such as Diana and Actaeon, Cephalus and Procris, Apollo and Marsyas, and Narcissus. They continue in the light vein of Brill,

66 *Tiber Valley*. 1643. Pen, with brown and grey wash, 18·8 × 29·5 cm. (7⅓ × 11⅔ in.). Signed and dated. Paris, Petit Palais. Here a clear bright light suggested by the most delicate washes, plays on distant hills; yet this fresh naturalism has been absorbed into a carefully composed scene, framed by the light trees and dark pastoral figures.

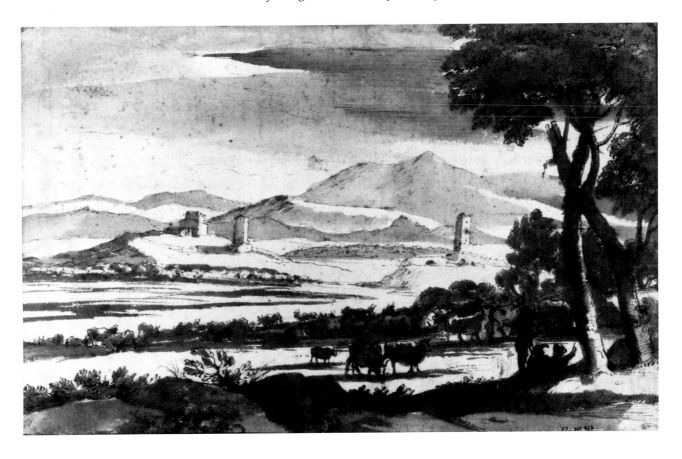

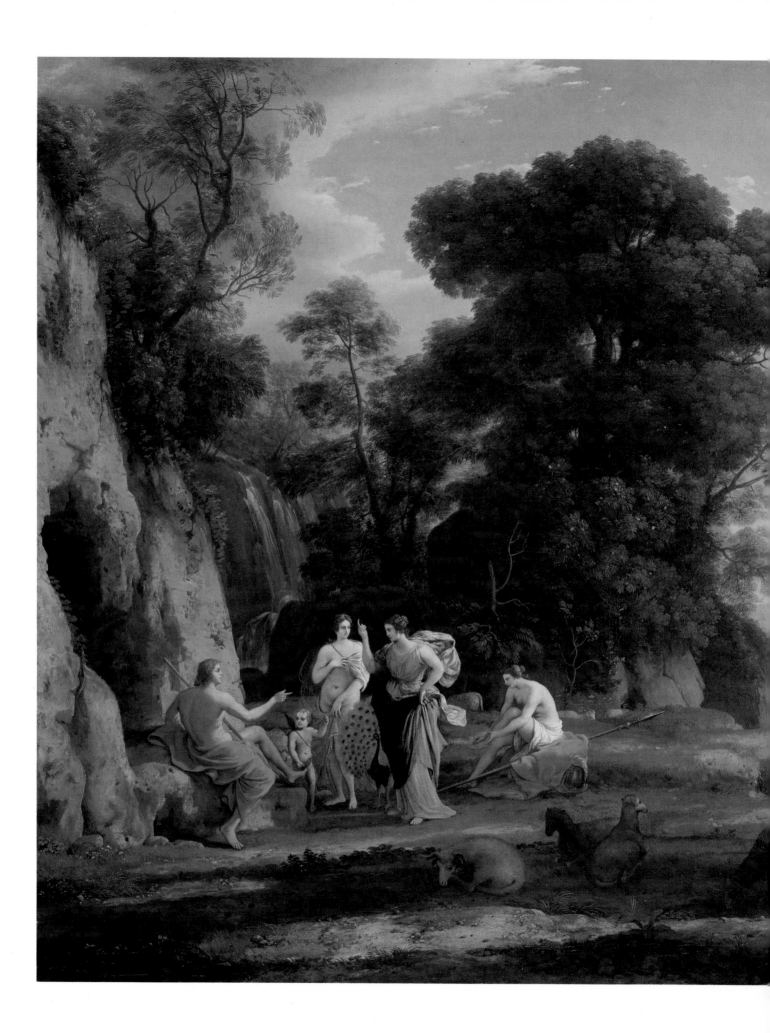

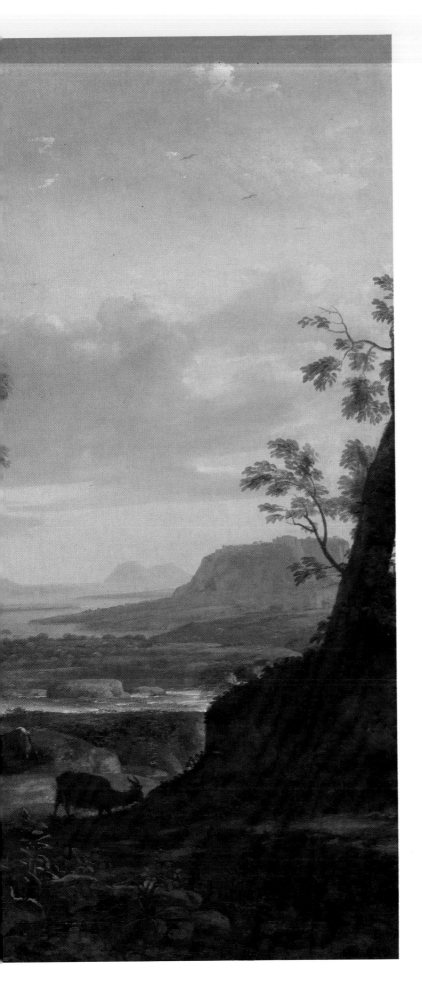

67 *Landscape with the Judgement of Paris*. Oil on canvas,
112·3 × 149·5 cm. (44¼ × 59 in.). Washington, National Gallery of Art.

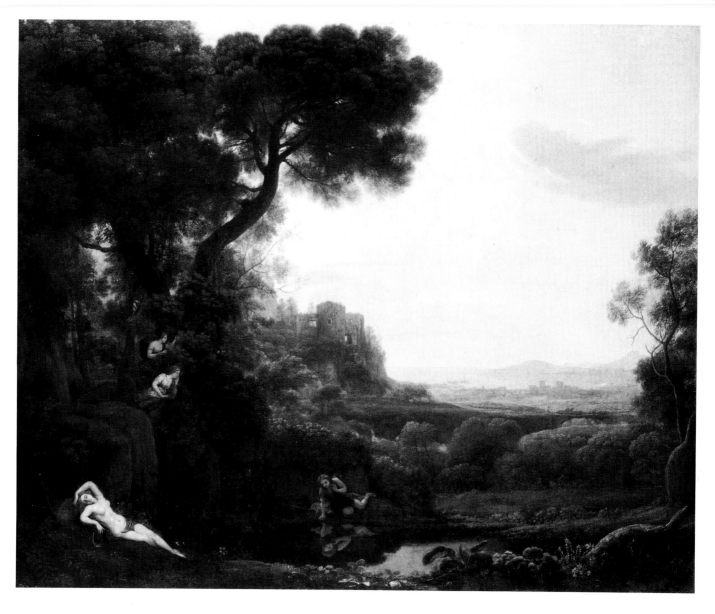

68 *Landscape with Narcissus and Echo*. 1645. Oil on canvas, 94.5 × 118 cm. (37$\frac{1}{5}$ × 46$\frac{1}{2}$ in.). London, National Gallery. The picture perfectly conveys Ovid's unusually lyrical description of a 'clear pool, with shining silvery waters, . . . encircling woods sheltered the spot from the fierce sun, and made it always cool.' Here Narcissus fell in love with his reflection; above, in the trees, the nymph Echo pines with love for him.

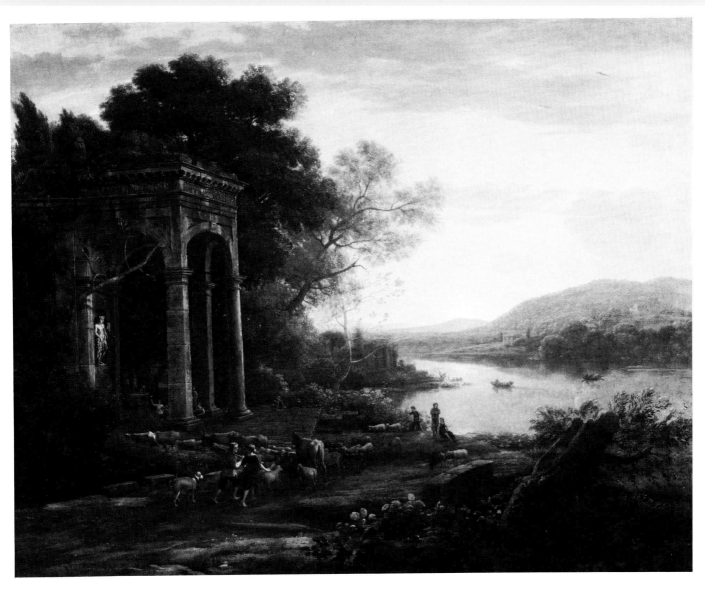

69 *Temple of Bacchus*. 1644. Oil on canvas, 95 × 122 cm. (37½ × 48 in.). Ottawa, National Gallery of Canada. This landscape, with its mixture of classical and small country figures is strikingly reminiscent of antique landscape painting (see Plate 53).

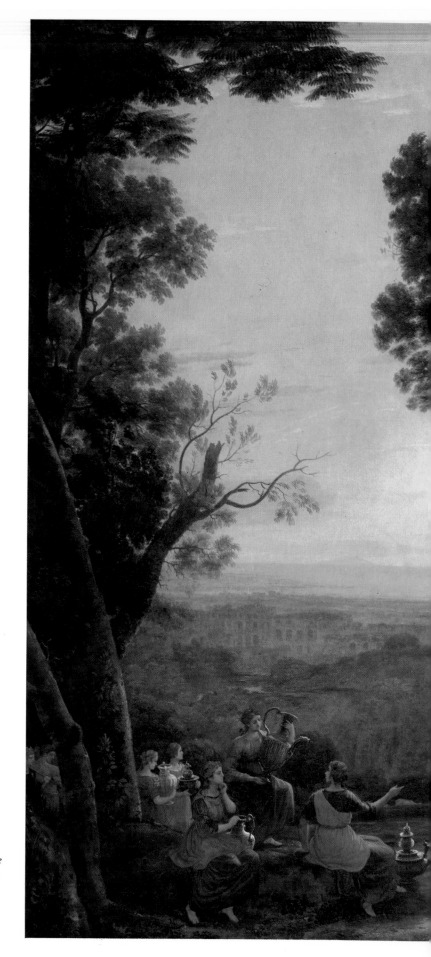

70 *Landscape with a Procession to Delphi*. 1650. Oil on canvas,
150 × 200 cm. (59 × 78¾ in.). Rome, Galleria Doria-Pamphili. This
picture, which is inscribed on the bridge, *Hac itur ad Delphes* (this
way to Delphi), has as its pendant a second version of the *Landscape
with Dancing figures*; later, Claude painted a more scholarly version
of the theme (Pl 110).

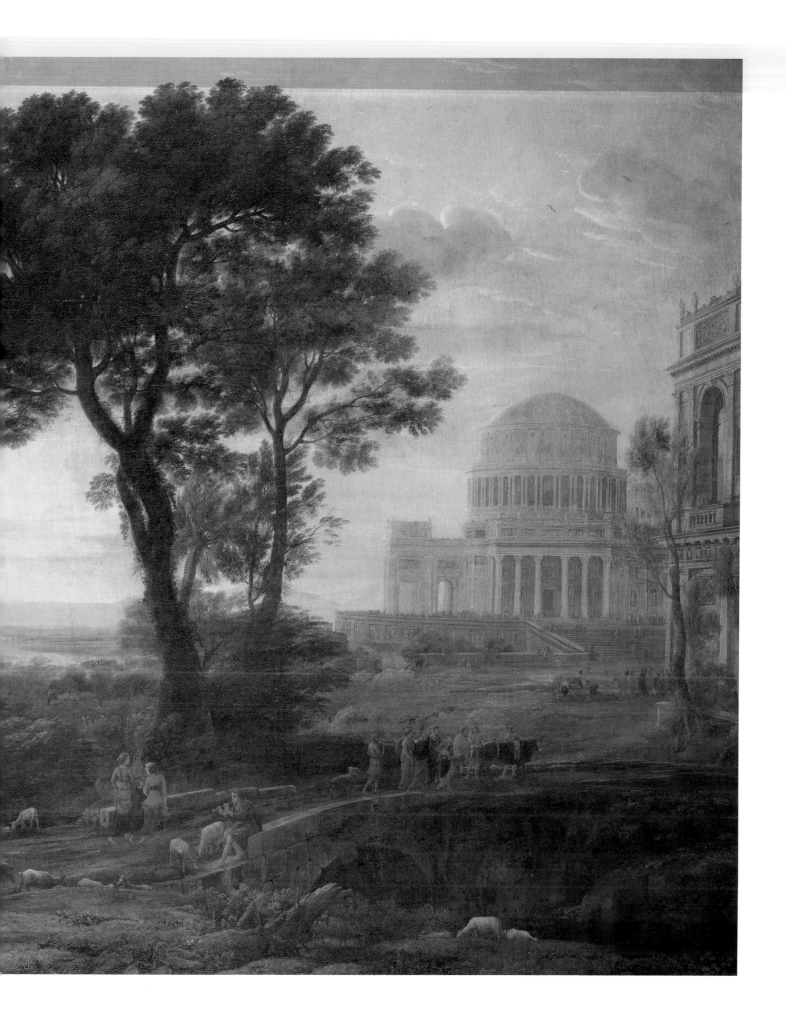

Poelenbergh and Elsheimer. The *Landscape with Narcissus and Echo* (Plate 68), and *The Temple of Bacchus* (Plate 69) suggest the beauty of a landscape inhabited by rustic gods, Virgil's 'Pan and Old Silvanus /And the sister Nymphs' – a beauty echoed through Sannazaro's *Arcadia*. Narcissus, enslaved by his reflection, fatally scorns the beauty of the 'spirits of the water and the woods'; in contrast, in *The Temple of Bacchus*, the country folk sacrifice at a rustic shrine.

Yet Claude was also moving towards a nobler, more harmonious rendering of classical subjects where the landscape itself reflects and conveys the poetic emotion of the figures. In his search for a new and deeper relationship between the figures and the landscape, he looked back to Domenichino and to Raphael's logge, the most revered sources of figure painting for classically minded artists. Claude's difficulties with his figures have always been notorious; Sandrart commented that they 'remain unpleasant in spite of the fact that he takes great pains and works hard on them and drew for many years in Rome in the academies from life and from statues.' Only a few red chalk drawings remain to confirm his interest in academic studies from the live model. However, an unusually large figure drawing, *Samuel anointing David* (Plate 71), suddenly marks a break

with the bamboccesque style of his early figures and with the rich and complex groups of his early port scenes. This is the preparatory drawing for the picture of the same subject in Paris, which is derived directly from Raphael's fresco in the logge of the same subject. The nobility of the figures, and their clear frieze-like arrangement, are new in Claude's art.

In the landscapes of the mid-1640s, firmly structured and balanced, clear and brightly coloured, Claude develops this classical style. It is a moment in his art epitomized by the *Landscape with the Judgment of Paris* (Plate 67). This is a well-known subject, painted by many artists in the Renaissance; it had been a favourite of the Bolognese painter Francesco Albani; Claude himself had painted an earlier version in 1633. Paris, on Mount Ida, is choosing which of the three goddesses, Juno, Minerva and Venus is most beautiful; he awards the prize, a golden apple marked 'for the fairest' to Venus. Claude's arrangement of the figures, and particularly the pose of Paris himself, echoes the most celebrated rendering of this subject, Marcantonio Raimondi's engraving after Raphael. The three goddesses are clearly identified with their traditional attributes; Venus with Cupid, Minerva with spear and helmet, and Juno with her peacock. The pose of Minerva,

71 *Samuel anointing David*. Pen with brown, red and green wash, on two sheets pasted together in the centre, 19·6 × 57·3 cm. (7¾ × 22½ in.). Haarlem, Teyler Museum. This is the preparatory study for the picture in the Louvre, of *c*.1643 and the last of the series of commissions from Claude's early patron, Cardinal Giori. It is Claude's most ambitious and largest figure drawing, and reflects the composition of a fresco by Raphael in the Loggia.

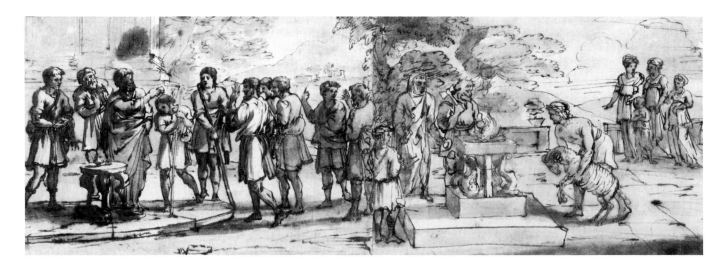

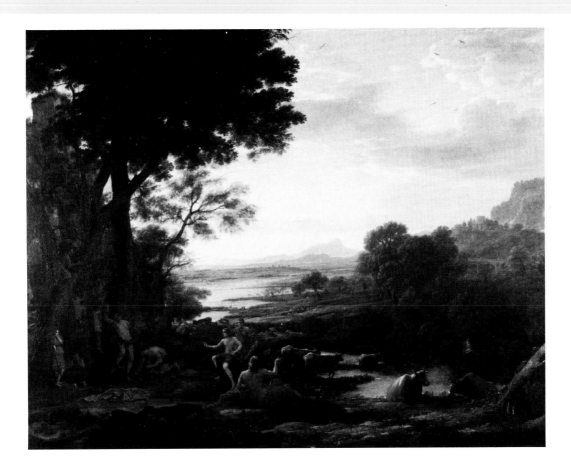

72 *Landscape with the Flaying of Marsyas*. 1645–46. Oil on canvas, 120·5 × 158 cm. (47 × 62¼ in.). Holkham Hall, Viscount Coke. The story is from Ovid; Marsyas, after his defeat in a musical contest, is flayed by Apollo; the woodland gods mourned for him, and their tears became a river. The figures are strikingly classical, Marsyas himself an ideal classical nude.

undoing her sandal, is based on a well-known classi-cal type. These are the largest and most beautiful of Claude's figures in a landscape up to that time. Their classical style, and their relationship to the landscape, suggest his debt to both Raphael and Domenichino. The landscape itself is broadly and clearly structured. A central group of trees divides the canvas into halves. A distant view, bright and sharp – so different from the misty vistas of the 1630s – balances the figure group, which is encircled by the rocky cliff and dark foreground. The light is warm and clear, the colours glow, and the reds and blues of the draperies are unusually strong. The painting was commissioned by the Marquis de Fontenay-Mareuil, at this date French Ambassador to Rome. He is said to have owned pictures by Raphael and Guido Reni and may have admired in

Claude his enrichment of the most classical traditions of Renaissance art. In this work, and in a painting of the following year also based on a composition by Raphael, the *Landscape with the Flaying of Mar-syas* (Plate 72) there is a new sense of the beauty of symmetry and of harmonious proportions. Baldinucci tells us that Claude 'placed the vanishing point where he pleased; but he used to divide the height of the picture into five parts, the horizon – that is the axis of the visual rays – being the second from the bottom'. This holds true for very many pic-tures, and moreover Claude created a sense of balance and order by the subtle rhythms of his plac-ing of compositional accents. Many of the pictures of the 1640s and early 1650s fall into contrasting halves, yet Claude links these halves by dividing both the height and width by thirds and fifths. In

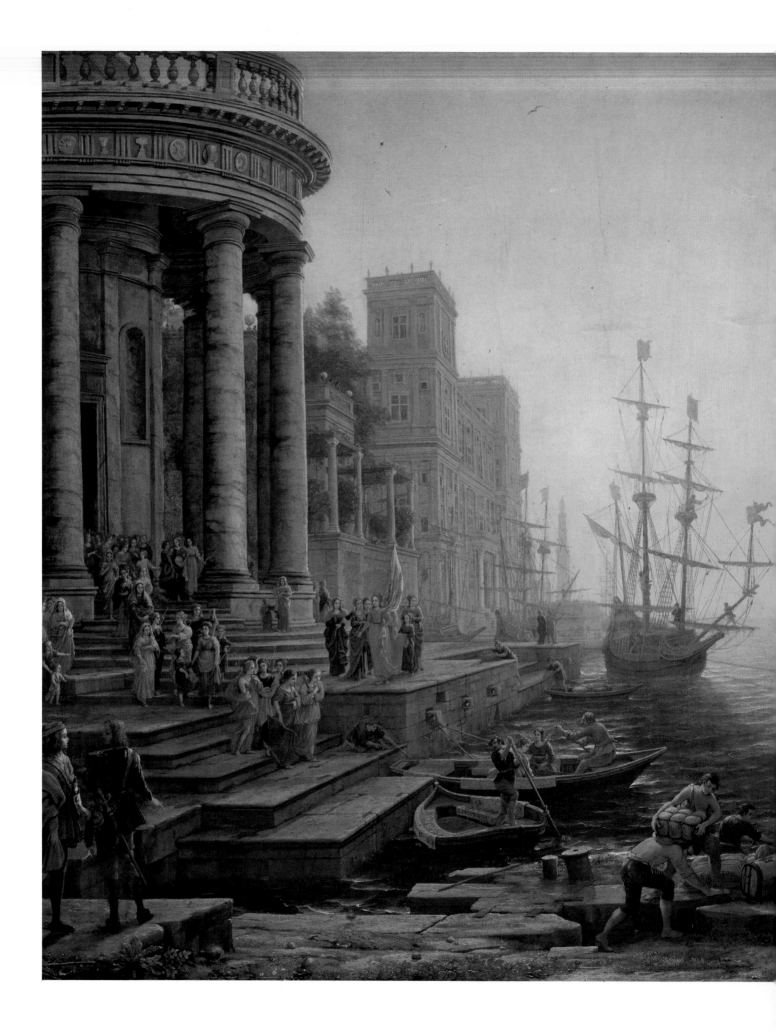

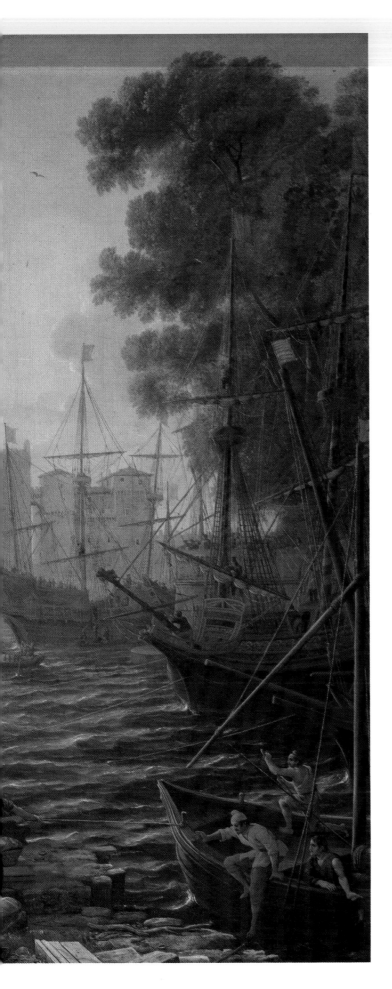

73 *Seaport with the Embarkation of St. Ursula.* 1641. Oil on canvas, 113 × 148·6 cm. (44½ × 58½ in.). London, National Gallery.

74 *Giovanni Francesco Grimaldi* (1606–1680). *St. Stefano Rotondo in an imaginary Landscape.* Pen and ink, 20 × 32.5 cm. (7¾ × 12¾ in.). London, British Museum.

the *Landscape with the Flaying of Marsyas* the upturned hand of the river god links the two halves; the figure group, encircling Marsyas, fills a third of the width, and is exactly balanced by the open vista in the centre. Similarly, in *Landscape with the Judgement of Paris* (Plate 67), it has been shown that Paris and the goddesses, who fill a third of the width, are matched by the distant opening on the right.

From the mid-1640s, Claude's most important patron was Camillo Pamphili, the Pope's nephew, who was an amateur poet and enthusiastic musician. His main claim to fame in the sphere of the visual arts was his patronage of the sculptor Alessandro Algardi at the Villa Belrespiro, outside the Porta San Pancrazio, which he and the Pope had begun in 1644. The Villa Belrespiro reveals throughout a refined taste for the most pure classical art. Its façade is unadventurous, yet enlivened by a lavish display of classical sculptures, antique reliefs, and sarcophagi fronts; within it is embellished by the most delicate and elegant stucco decorations by Algardi, which look back to ancient and Renaissance art, and with classical landscapes by the Bolognese

painter Giovanni Francesco Grimaldi (Plate 74). Grimaldi worked at the villa as architect and landscape painter from 1645–7; his style is an undisguised tribute to his distinguished Bolognese predecessors, and he played an important role in the renewal of interest in Bolognese landscape in both Rome and Paris.

It is striking that Claude's own pictures for Camillo Pamphili are amongst his most classical, and look back in both composition and mood to the Bolognese tradition. They were perfectly in keeping with the style of the Villa Belrespiro, for which they were destined. The first was the *Landscape with Apollo and Mercury* (Plate 58). This became one of Claude's favourite subjects which he painted six times, the last in 1667. The subject epitomizes the mood of pastoral poetry; in Sannazaro's *Arcadia*, the shepherds find the scene painted on Pan's temple. Claude's picture looks back to Domenichino's fresco from the Villa Aldobrandini, yet here there is a more touching, poignant contrast between Apollo's wistful music and the sunny tranquillity of the richly coloured, radiant landscape, so clear and sharp, so

delicately detailed, and so jewel-like in its finish.

Camillo Pamphili next commissioned from Claude a more ambitious landscape, *Landscape with dancing figures (The Marriage of Isaac and Rebecca, or The Mill)* (Plate 1) with a pendant, *Seaport with the Embarkation of the Queen of Sheba* (Plate 76). However, before Claude delivered these works Pamphili fell from favour. In 1647 he renounced his Cardinal's hat to marry Olimpia Aldobrandini, the rich widow of Paolo Borghese. Both his mother and the Pope were violently opposed to the match, and Pamphili and the Princess were forced to leave Rome, and for the next four years they lived in disgrace at Frascati. Meanwhile, Claude completed the paintings for the Duc de Bouillon, a distinguished French military man who, from 1644–47 served in Rome. Later, when Pamphili returned to favour, two more pictures were ordered; a second version of *The Mill*,

and a new pendant, the *Landscape with a Procession to Delphi* (Plate 70).

This group of works are the final flowering of Claude's classical style of the 1640s. *The Marriage of Isaac and Rebecca* (the subject is inscribed on a tree stump in the centre) looks back to the idyllic themes of the 1630s – to scenes of country dances in sunny woodland glades, and to idyllic river views with tranquil mills and glimpses of small temples. Yet it is also the most elaborate of the richer pastorals of the 1640s (Plate 75), where the lyricism of a virginal nature is replaced by a sense of the slow rhythms of country life and of age old rural tasks which recall the poetry of the *Georgics*.

Splendid trees frame a deep central vista, where the brilliant blue water, still and clear, leads the eye to the slopes of distant mountains. It is recognizably the landscape of the Tiber Valley, with the great

75 *Pastoral Landscape*. 1646. Oil on canvas, 99 × 129.5 cm. (39 × 51 in.). San Diego, California, Timkin Art Gallery. This is one of the loveliest of the many pastorals of the 1640s, which suggest the ideal beauty of Virgil's Italy, where rivers glide under ancient walls, and the cattle – when the sun sets – drink 'clear water when the evening star is cooling'.

aqueducts in the distance, and a lovely play of light on distant plains. And yet it is also an enchanted world, where the dance in the foreground reflects a universal harmony. Everywhere there is the sense of a landscape enriched for and cared for by men and women, a landscape whose lovely fertility fulfills their needs. The aqueduct brings water to the mill, where washerwomen work; the fishermen's boats glide on the crystalline water; huntsmen pause to watch the dance; at the end of a long summer's day, cattle and goats move slowly homewards. The picture conveys a sense of the beauty of country life in an eternal summer – that pastoral life described by Virgil where farmers lead:

> a life of innocence
> Rich in variety; they have for leisure
> Their ample acres, caverns, living lakes,
> Cool Tempes; cattle low, and sleep is soft
> Under a tree . . .

In the seventeenth century the image of a Golden Age haunted the imagination of poets; Gabriele Chiabrera wrote of an earlier race 'whose dances were eternal, eternal their songs, and for them the sun arose without threat of clouds . . .'

Few pictures create so intensely an imagined world, so rich in detail to delight and charm the spectator; it is as if Claude has brought together, in a wonderful anthology, the many motives of his earlier pastorals. The device of the framing trees, the spectators as though in the wings of a theatre, heighten the sense of looking at an enchanted land. Yet the real and the ideal blend, and the picture's clear perfection is softened by odd discrepancies of scale and style. Some of the startlingly large foreground figures are strikingly classical – most obviously the standing shepherd, who looks like a quotation from a classical relief – while the little group with their child seem to have wandered in from an earlier picture. The soldiers on the left marvel at the radiant scene before them; they represent another world of warfare and action, pausing, perhaps in envy before the idyllic peace of pastoral life, where 'far from the clash of arms, the earth herself . . . freely lavishes/An easy livelihood.'

As a pendant Claude painted the *Seaport with the Embarkation of the Queen of Sheba* (Plate 76). In 1641 his *Seaport with the Embarkation of St. Ursula* (Plate 73) introduced a series of grander seaports, that illustrate stories from the Bible and classical history. These paintings, enriched with increasingly magnificent architecture, suggest the glamour of distant lands and the heroic deeds of legendary figures. *The Embarkation of St. Ursula* is crowded and dramatic; the effect of brilliant sunshine is overwhelming, and Claude has experimented with more complex figure groups – the women vivid and touching, chattering as they leave church – and setting their strong local colours against the subtly graded tones of the sea, where the play of shadows and the pattern of taut ropes and rigging suggest the movement of its windswept surface. The theme is developed in the *Seaport with Ulysses returning Chryseis to her Father* (Plate 79), an unusual subject from Homer's *Iliad*. The groups of genre figures strung out across the foreground are reminiscent of earlier works, and yet the total effect is richer, and the dark shadow cast by the ship dominates the composition more dramatically than in *Seaport with the Embarkation of St. Ursula* (Plate 73).

The Seaport with the Embarkation of the Queen of Sheba is stiller and more spacious. The story is told in the Book of Kings, Chapter X; the Bible tells how the Queen, having heard of the fame of Solomon, came to test his wisdom. Claude turns her overland journey 'with a very great train, with camels that bare spices, and very much gold, and precious stones', a subject rare in art, into a sea voyage. He inscribes it on the steps, and having given the spectator this clue he builds around the figures an imaginary port which is extraordinarily richly detailed and which conveys the exotic splendour and brilliant hope of the Queen's departure for romantic lands. It is less fanciful than the *St. Ursula*, where the ships are seventeenth-century, the buildings a capricious blend of Renaissance and medieval; here the ships, painted and carved with classical ornament, are convincingly antique. The picture combines motifs from the *St. Ursula* with a variation on the composition of the *Seaport with Ulysses*; yet

76 *Seaport with the Embarkation of the Queen of Sheba*. 1648. Oil on canvas, 148·5 × 194 cm. ($58\frac{1}{2}$ × $76\frac{1}{3}$ in.). London, National Gallery. The subject is inscribed on the steps on the right of the picture; the picture is signed, and, uniquely in Claude's work, inscribed with the name of the patron, the Duc de Bouillon, on a stone on the left.

77 *View of the Temple of Delphi*. Pen with brown wash, 27·7 × 42·4 cm. (11 × 16⅔ in.). Venice, Galleria dell'Accademia. This is a preparatory drawing for the picture, and lacking the figures, it has a more abstract, visionary beauty; the brightness of the light, moving forward from the horizon, softens and unites the forms.

the narrative details such as the trumpeters on the balcony who herald the Queen's departure, and the porters along the shore who load her rich cargo, are more carefully structured around the dominant central theme. The rising sun suggests the unknown land to which she is to travel; it gleams on the water, and in the left foreground a boy shields his eyes. The Queen herself is the centre of a brightly coloured group which descends the steps, to a small boat which will row her out to the larger vessel on the horizon. The steps are still in darkness, while the morning light catches the top of the columns; on the left, the Corinthian column is edged with the most delicate border of silvery light. The beauty of the aerial perspective, the harmonic colour, the shifting

patterns of light and shade across the rhythmic movement of the waves – these are the effects which are so precisely described by Baldinucci. The painting's lucidity and order are conveyed by the subtlety of the proportion and the beauty of the perspective. A series of horizontals lead the eye into the distance; these are linked by diagonals, marked by the steps and by the three small boats that lead to the distant schooner, the mast of which falls on the vertical axis. It has been demonstrated that the picture is proportioned in fifths both horizontally and vertically, with the horizon at two fifths of the height and the column on the left and the palace occupying one fifth of the composition's width. It forms, with its pendant, contrasts characteristic of

Claude's work — a seascape and a landscape, the light of the early morning and that of a late summer afternoon.

Claude painted a second version of *The Mill* for Camillo Pamphili and another pendant, the *Landscape with a Procession to Delphi*, (Plate 70). This picture shows Delphi, the great religious centre of the Greeks, where stood the famed temple of Apollo. Claude's Delphi bears little resemblance to ancient descriptions; his temple is imaginary, with a vague resemblance to St. Peters; his procession, and the sacrifice in the distance, perhaps suggest ancient and Renaissance reliefs. Yet the picture evokes the site's legendary splendour, where, as the *Homeric Hymn to Apollo* describes, 'Numberless races of men built the temple all around, With hewn stones, to be a theme of song forever' . . . 'and as many as dwell on fertile Peloponnesus, and on Europe, and throughout the sea-girt islands will consult it.' The picture is Claude's most magical evocation of an imagined classical past. The landscape itself attains a new majesty; it is remoter, stranger than the sunny valley of its pendant. Such a past is not recreated from the researches of antiquarians, but through reverie and contemplation; the beauty of the vista, and of the ethereal temple, white and azure, that gleams before it, suggests that over the horizon there lies the promise of a fabled land, a land to which we journey and which is not on our scale. The foreground trees, and those in the middle distance, create a vast arch, where the rising sun, dramatically obscured by drifting clouds, casts its radiance across the vault of the sky. The arch itself creates a sense of journeying to a promised land — it recalls Tennyson's *Ulysses*, to whom 'all experience is an arch wherethro'/gleams that untravell'd world, whose margin fades/For ever and for ever when I move.'

The *Landscape with a Procession to Delphi* marks a turning point in Claude's art. It is intensely romantic, and the effects of light are spectacular; yet it also looks onto the more remote, heroic pictures that Claude was to develop throughout the 1650s.

78 *Study of a Tree*. Brown wash and chalk on apricot tinted paper, 26·2 × 20 cm. (10⅓ × 8 in.). London, British Museum. The effect of the framing trees is similar to those in the *View of Delphi with a Procession*. The drawing has a decorative beauty, as trees and boughs curve and frame the distance, and the leaves are patterned, leaf by leaf against the rosy sky, with an almost Chinese delicacy.

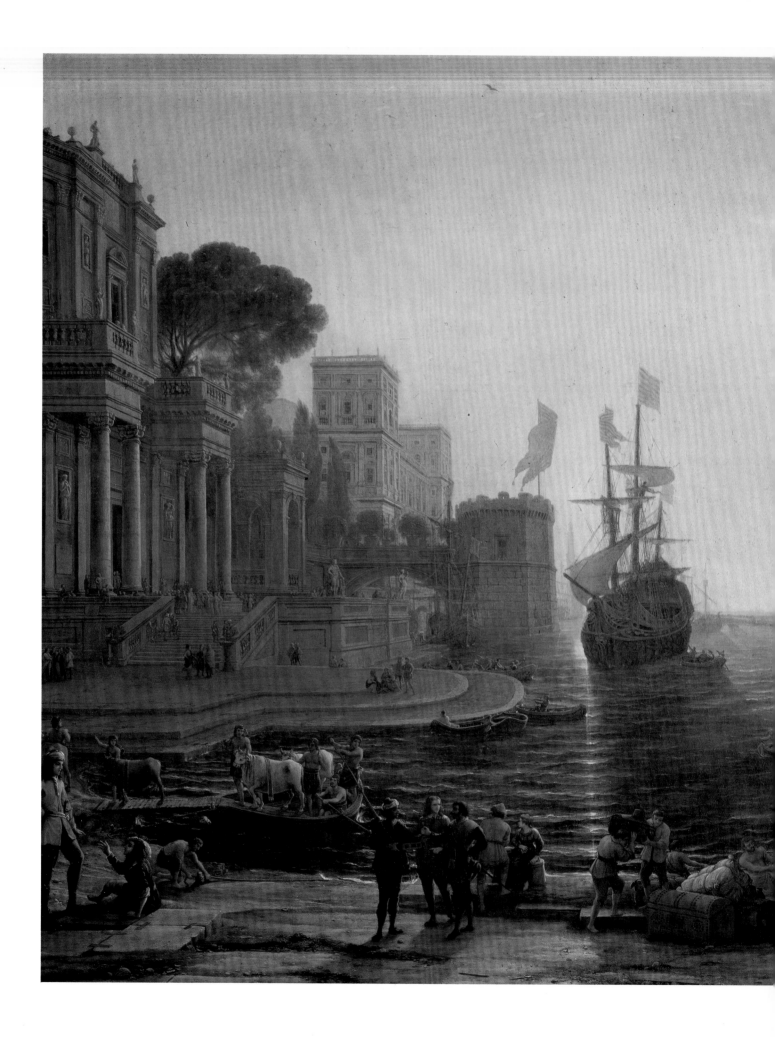

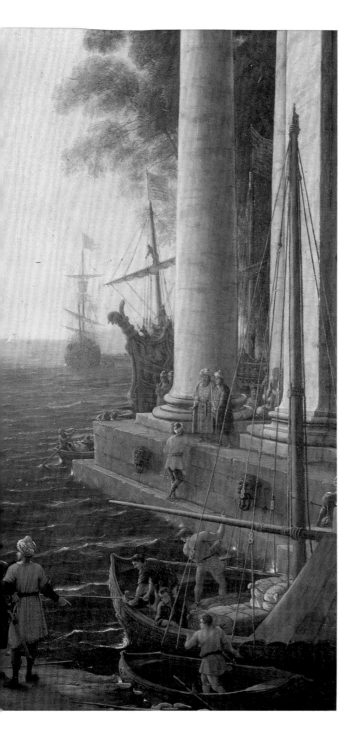

79 *Seaport with Ulysses returning Chryseis to her Father*. 1644. Oil on canvas, 119 × 150 cm. (46⅘ × 59 in.). Paris, Musée du Louvre. The main theme is shown as a tiny detail on the steps of the palace. Agamemmnon, threatened by the wrath of Apollo, returns his concubine, the Trojan captive, Chryseis, to her father, a priest of Apollo.

80 *View of the Sasso*. 1649. Pen and two shades of light brown wash, 19·0 × 26·8 cm. (7½ × 10½ in.). Rotterdam, Museum Boymans-Van Beuningen. The Sasso, a large rock, is ten miles to the south of Civitavecchia; beyond lies the sea, dotted with sails. This is a new kind of nature drawing, perhaps influenced by Bolognese landscape drawings; it looks on to the rocky landscapes of the 1650s.

THE GRAND STYLE
1650–60

The last years of Innocent X's era had been darkened by family intrigues and disappointments; when the aged Pope died in 1654, isolated and irritable, he left behind a bitter family. The new Pope, Fabio Chigi, who had been secretary to Innocent X, took the name of Alexander VII. With Alexander – witty, elegant, deeply cultured and possessed of a wide humanist learning – the Golden Age of Urban VIII seemed to revive, and scholars and writers again gathered at his court. As a young man he had written Latin verse in the style of Horace, and taken an antiquarian interest in painting, sculpture and medals. Alexander became a great patron of the arts and, disturbed by Rome's decay, sought to renew its ancient glory. Despite severe economic problems, he embellished the city with a wealth of new squares, churches, and palaces.

At the height of his power, Claude continued to enjoy a spectacular success and to draw his patrons from the most noble ranks of society. Fewer of his pictures went to Paris, yet highly placed churchmen visiting Rome continued to commission major works from him. Outwardly his life remained untroubled by events. In 1650 he moved to another house in the same quarter of Rome; the chapter of the Minimi della Trinità dei Monti ceded him a house on the via del Babuino, with the sign of the three fish, opposite the Arco dei Greci, and Claude lived here until his death. His house had four rooms on the first floor and a studio on the ground; it was richly furnished, and at Claude's death he owned 150 pic-

tures. Poussin lived nearby. In 1654 Claude was offered, but refused, the post of 'first rector' of the Accademia di San Luca. Towards the end of the 1650s, probably in 1657/8, his pupil, Giovanni Domenico Desiderii left Claude's house where he had lived for twenty five years 'treated more as a son than as a servant'. His departure was stormy; according to Baldinucci, a rumour had spread through Rome that he painted Claude's pictures and Desiderii became swollen headed and enraged at his small recompense. He does seem to have had some reputation as a painter; Félibien mentions him in his *Entretiens*, saying that Claude 'had a disciple called Giandomenico who made himself known for having copied him well'. A group of drawings, close to Claude's early studies of trees and wooded scenes, yet lighter and more decorative, has been attributed to Desiderii. More recently, a painting, *Landscape with Ponte Molle*, inscribed GDf 1651 has been published by Marcel Roethlisberger. The picture is close in style to Angeluccio and to Claude's pictures of the mid 1640s, a period when Claude's works were perhaps most easy to imitate. Desiderii died soon after he left Claude's studio.

In the early 1650s Claude began to move away from the pastoral towards a more heroic vein (Plate 81). He began to paint grave and elevated themes from the Bible and classical literature; the landscapes are built of noble forms, of majestic trees and austere, rocky cliffs. Composed of grand and sweeping horizontals, they suggest a breadth of

81 *Landscape with Apollo and the Muses*. 1652. Oil on canvas, 186 × 290 cm. (73 × 114 in.). Edinburgh, National Gallery of Scotland. This, the largest of Claude's surviving pictures, introduced the heroic scale and elevated subject matter of the 1650s; Claude returned to the theme several times in drawings and paintings.

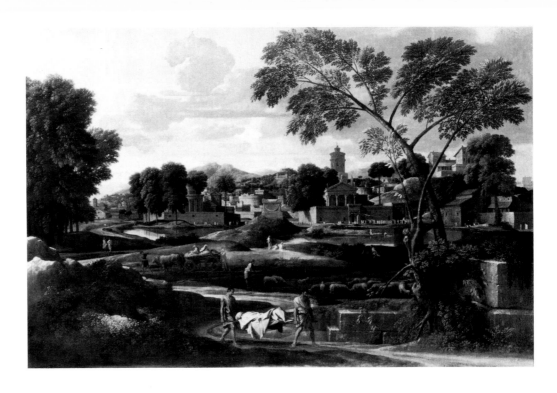

82 Nicolas Poussin (1594–1665). *The Burial of Phocion*. 1648. Oil on canvas, 114 × 175 cm. (45 × 68⅞ in.). Earl of Plymouth, on loan to the National Museum of Wales. A winding path leads to a stately city enriched with antique buildings indebted to Palladio's antiquarian studies; in the 1650s Claude's landscapes show similar classical cities.

vision as overwhelming as the deep vistas of infinite space had been in the 1640s. Classical cities structure the landscape, giving weight and form to the middle distance, and setting the grandeur of man's architecture against the majesty of nature. The pictures no longer glow with rich colour and bright light; the light is cooler, the colours are muted blues and greens; pendants explore more subtle contrasts than those of sea and land.

In this development Claude was at one with the deepest aspirations of seventeenth-century landscape painters. Since the Renaissance, artistic theory had held that the crowning achievement of the painter was history painting, which took as its subject the grand passions and heroic acts of mankind and portrayed noble themes from the Bible or classical literature. Landscape was considered a lowly form of art, the speciality of inferior northern painters.

Yet earlier in the century, with the Aldobrandini lunettes (Plate 51), Annibale Carracci had created 'a history painter's landscape' where the grandeur of

the landscape and the harmony of its structure match the nobility of human action. Annibale founded the traditions of ideal landscape painting; they were perfected by Poussin in a series of major landscapes painted between 1648–51.

In *The Burial of Phocion* (Plate 82) the severe landscape reflects the theme, the burial of the statesman Phocion, an austere Stoic hero, unjustly condemned to death and to an unworthy burial. The landscape is rigidly structured, horizontals and verticals balanced, and everywhere there is a sense of order and harmony. The light is the clear light of noon, and it reveals, with crystalline clarity, the unchanging beauty of the world of nature. In Claude's landscapes there is always a sense of the movement of light and air; yet in the 1650s he began to structure his landscapes more closely around a human theme, and occasionally his landscapes have a sharp stillness that is reminiscent of Poussin (Plate 1). His approach to detail became more scholarly; such fanciful temples as that in the *Procession to Delphi*

104

83 Salvator Rosa (1615–1673). *Landscape with the Baptism of Christ. c.*1654. Oil on canvas, 173 × 260 cm. (68 × 102⅓ in.). Glasgow, Art Gallery and Museum. Here Rosa unites a grandeur – new in his work – with an unusual richness of detail and effects of fleeting light; in the 1650s he responded to the majesty of Bolognese landscape and to Poussin's austere vision.

yield to more classical buildings.

Over the same period, 1647–51, Poussin's brother-in-law Gaspard Dughet was completing a remarkable series of landscape frescoes in the Roman church of San Martino ai Monti; these frescoes show panoramic sweeps of distant plains, and convey a new sense of the vastness of the land. Salvator Rosa returned in 1649 from nine years at the Medici court in Florence. By this date Rosa, immensely ambitious and avid for glory, bitterly regretted his reputation as a painter of small landscapes and genre, and arrived in Rome fired with the desire to establish his fame as a learned artist, whose serious and philosophical subjects should rival the classic grandeur of Poussin and of Raphael. In his satire *La Pittura*, Rosa adopted the humanistic creed:

'Let the painter be learned, well versed in
Every branch of knowledge, and steeped in
The myths and histories and rites of ancient
times'

His landscapes of the 1650s, such as the *Landscape with the Baptism of Christ* (Plate 83) – majestic, rocky and severe – continue the traditions of Domenichino.

At this most classical moment, Claude turned to the revered landscapes of High Renaissance Rome and renewed his interest in the logge of Raphael. In the early sixteenth century the Lombard painter Polidoro da Caravaggio painted two remarkable landscapes in the church of San Silvestro al Quirinale, representing the legends of St. Mary Magdalene and of St. Catherine of Siena (Plate 85). In both these works the forms are monumental and of awe inspiring grandeur; a landscape of towering cliffs, rushing torrents and deep forests is embellished with antique ruins, obelisks, temples, and colonnades, suggesting a world of ancient and remote grandeur where small Christian figures enact their dramas before the splendours of a lost pagan world, their significance echoed by the immensity of the setting. Polidoro was passionately involved with classical antiquity, and drew his subjects from

84 *Landscape with David and the three heroes.* 1658. Oil on canvas, 112 × 185 cm. (44 × 73 in.). London, National Gallery. Claude's majestic landscapes remain based on a close study of nature; the towering cliffs and cave are drawn from a small, strikingly naturalistic painting of a sheepfold in the Campagna, probably dated 1656, which Claude left to his nephew Joseph (Vienna, Akademie der Bildenden Kunste).

85 Polidoro da Caravaggio (1490/1500–1543). *Landscape with the Mystic Marriage of St. Catherine*. Encaustic wall painting. Rome, San Silvestro al Quirinale.

Roman history and mythology. He wanted his landscapes to suggest ancient art; his works were important to both Claude and Poussin. Claude made drawings from both these works and one may sense their compositions reverberating through the decade.

The *Landscape with Apollo and the Muses* (Plate 81) was the first of an outstanding series of monumental landscapes of the most noble and elevated subject matter. Ironically it was commissioned by the weak and lazy Camillo Astalli. After the downfall of Camillo Pamphili, the Pope in despair of finding loyal support had suddenly elevated this young Roman nobleman to the rank of Cardinal and made him a member of the Pamphili family. As Cardinal Astalli-Pamphili he enjoyed his new wealth, and just had time to commission a picture from Claude before his equally sudden fall from favour, when, shorn of wealth and titles, he left Rome in disgrace. Camillo Pamphili and the Princess Rossano

returned in glorious triumph.

Landscape with Apollo and the Muses shows the mountain range of Mount Helicon or Mount Parnassus. The two mountains, mixed since antiquity, were often conflated in the Renaissance. This mountain range, green and tranquil, provided a secluded retreat where Apollo the god of music and poetry (Apollo Musagetes) sang and made music for the Muses. Around Apollo, in the shade of the grove, poets listen to his song. To his right a small temple, the Temple of Immortality, crowns the Mount, and a poet kneels to receive a laurel crown. Below this, the winged horse Pegasus strikes the rock, and from this blow sprang the Hippocrene Fount where poets drank inspiration for their verse. Before Apollo, a crystal spring falls over the rocks, to collect in a still pool where stately swans glide. This is the Castalian spring, which had its source on Mount Parnassus; the wild swans, whose whiteness symbolized the sun, were sacred to Apollo.

A celebrated fresco by Raphael in the Vatican Stanze had established this theme in Renaissance painting. Marcantonio Raimondi engraved a drawing connected with, yet slightly different from, the fresco; Giorgio Ghisi, in a print after Luca Penni, combined Parnassus and Helicon, and showed putti offering laurel crowns to an assembly of poets. Claude drew on these earlier works; most obviously he adapted his slightly stilted group of Apollo and the Muses from Marcantonio's print.

Yet the emphasis in Claude's picture is new. The picture is divided dramatically into halves, with the rocks and trees set against a sweeping plain and mountainous distance. Apollo and the Muses are remote, darkly encircled by the sacred grove. The picture is about artistic inspiration; at its very centre, silhouetted between the trees against the bright light, a poet reaching the summit of the hill, pauses in wonder before them. It suggests the Renaissance belief that the muses are to be sought in solitude, far from the turmoil of the city, in the shade of verdant forests, or at the summit of high hills. The Muses give immortality on this earth and in heaven; yet Parnassus' slopes are steep, and many seventeenth-century poets echo Virgil's:

> But love transports me to Parnassus' steeps;
> I tread with rapture
> heights from which no track
> Beaten by others' winds with gentle slope
> Down to Castalia's springs.

Apollo's music symbolized the harmony of the celestial spheres; as the sixteenth-century mythographer Natalis Comes wrote 'The spirit of Apollo forcefully moves these Muses; residing amongst them, he embraces the universe', and in Claude's picture the woods and rocks seem to echo Apollo's song.

A series of increasingly monumental works take up the theme of the *Parnassus*. Amongst these were two outstandingly important works for the Roman nobleman, Carlo Cardelli; the *Landscape with the Adoration of the Golden Calf* (Plate 86), and the *Landscape with Jacob and Laban and Laban's daughters*

(Plate 90). His father had had the Roman palace in the Piazza Cardelli decorated with frescoes by Gaspard Dughet. Cardelli himself was an enthusiastic collector, and owned many landscapes and pictures with religious themes. He probably suggested the religious subjects, new in Claude's art, to the artist.

The first of these was the *Landscape with the Adoration of the Golden Calf*. The theme is from the Book of Exodus, Chapter XXXII. In the foreground the people of Israel worship the Golden Calf, which they had implored Aaron to make, in order to bring hope to their troubled wanderings. In the distance, Moses descends Mount Sinai, his anger flaring at their idolatry as he bears aloft the tablets of the law, finally to break them below. The biblical scene takes place in an unusually wide and deep landscape. Between the trees the river leads the eye to distant plains where a city, veiled in shadow, stands against the sky. On top of a marble column – which reflects the light of the fire on one side, and the light of the sun on the other – the golden calf gleams palely. To it the Israelites turn with intense longing; beside them a grave philosopher sits apart, perhaps contemplating their folly, at his side the great silver vessels decorated with scenes showing the creation of Eve and the expulsion from paradise. The peace of this scene, frail and illusory, contrasts dramatically with the rugged harshness of Mount Sinai; the dark greens of the dense and windswept forest, the rushing torrents and towering cliffs, shrouded in violet-grey storm-clouds, all echo Moses' sublime fury.

In a sense the picture looks back to *The Mill*. It recalls the earlier work's distant mountains and waterfalls, and the figures in the wings with their silver vases. And yet it has a new epic grandeur; there are no brilliant reds and blues, but darker colours that create a more sombre mood. In this period Claude began to prepare his more ambitious works with a series of drawings, both to research the details more carefully, and to experiment with the elements of his composition (Plates 88 and 89). Four drawings remain for this picture and they show how Claude, faced with the problem of an unusually complex

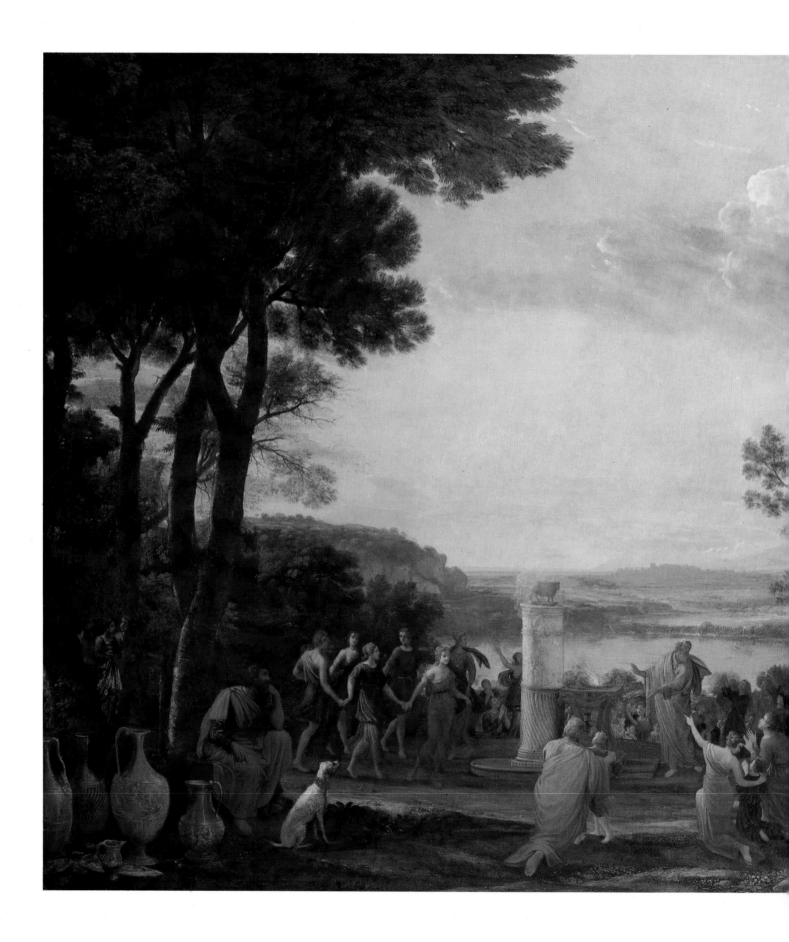

86 *Landscape with the Adoration of the Golden Calf*. 1653. Oil on canvas, 147 × 248 cm. (58 × 97⅔ in.). Karlsruhe, Staatliche Kunstalle. The subject is from Exodus XXXII. The people of Israel worship the Golden Calf, which they had implored Aaron to make. In the distance, Moses, his anger flaring at their idolatry, bears aloft the tablets of the law to break them beneath the Mount.

87 Raphael (1483–1520). *The Adoration of the Golden Calf*. Fresco. The Vatican, Loggias, ninth small vault.

figure group, turned to both Raphael's painting of the same subject in the logge, and to Poussin's *Adoration of the Golden Calf* (London, National Gallery). The dancers themselves are less ecstatic, chaster than those of Poussin; both artists were perhaps inspired by a High Renaissance picture of *Apollo and the Muses* (Florence, Palazzo Pitti) which is echoed in other works by Claude. There are several such sequences of drawings for the large pictures of the 1650s, and several detailed studies for the figure groups.

In 1654 Cardelli commissioned a pendant, the *Landscape with Jacob and Laban and Laban's daughters* (Plate 90). The picture epitomizes the ordered and stately grandeur of this moment in Claude's work. It is built on powerful horizontals, balanced by the verticals of the trees and great

arches of the bridge; the nobility of the buildings, based on the Castel Sant'Angelo and the Torre dei Conti, recall Poussin's Phocion landscapes. Yet Claude is also indebted to an earlier tradition of classical landscape; certain details – the boats on the river, the fishermen, the roots of a tree spread against the blue-green water – vividly recall Domenichino. Within the broad clarity of its framework, and the careful balance of movement and countermovement, the picture is rich in lovely detail and incident.

The figures in this picture derive loosely from Raphael's logge. At this date Claude sought to ennoble his figures, and the 1650s is particularly rich in figure studies. Some, made at the latest stage in the picture's development, explore and refine poses and expressions. Amongst the most splendid are drawings which were done after the picture, which

88 *Adoration of the Golden Calf*. Pen with brown and grey wash, 20 × 26·9 cm. (8 × 10½ in.). London, British Museum. This, the second of four surviving preliminary drawings, combines ideas from Raphael and Poussin. The left side derives from Raphael's logge, while the dancing figures reflect Poussin's painting (London, National Gallery), and Aaron remains close to Poussin in the final work.

89 *Adoration of the Golden Calf*. Pen with deep brown and grey wash, heightened at the bottom, 20·6 × 38·5 cm. (8 × 15 in.). Paris, Musée du Louvre. In this final surviving compositional study Claude elongated the composition and inverted the figure groups. A final study elaborated the dancing figures and spectators. Such sequences of drawings are frequent in the 1650s.

convey Claude's delight in a particularly important figure group, one that had enriched the most splendid of his compositions. Such drawings are often completed with a drawn frame, or perhaps with a landscape background, so that they have the authority of a formal composition. Claude's figures at this date are less purely classical and graceful than the figures in such Raphaelesque works as the *Judgment of Paris* (Plate 67); in his biblical pictures he sought nobler, more spiritual figures, whose majestic bearing should suggest the grandeur of their destiny. He looked back, as Poussin also had done, not only to Raphael's logge, but to the Raphael of the tapestry cartoons, where the figures are weightier and bulkier, their gestures more forceful, and their expressions more powerful. Amongst such works is the impressive study for the *Journey to Emmaus* (Plate 91) where the figures are dramatically set against the light. The paper, as often in this period, is tinted pink, and the figures lavishly enriched with white heightening.

With the death of Innocent X, Claude's patrons once more changed. His most important commissions were from the Chigi, from the Pope himself and from his nephew, Agostino Chigi; Baldinucci tells us that 'as this Pope not only held his qualities in high esteem but also bore him great affection, he had to make other pictures also for the house of Chigi'. The Pope had ordered two pictures, the *Rape of Europa* and the *Coast Scene with a Battle on a Bridge* (Plate 93), while he was still a Cardinal. Both had been delivered when he became Pope. The battle is rare in Claude's work; he emphasizes the contrast between the clash of arms and the beauty of nature; the battle disrupts the tranquil life of the countryside, and the goatherds and their families flee its violence. Claude's battle perhaps suggests the dark side of Virgil's *Eclogues*, where Meliboeus laments:

We flee our homeland; you Tityrus, cool in
 shade,
Are teaching woods to echo Lovely Amaryllis
 . . . Sick myself, look Tityrus,
I drive goats forward . . .

It is characteristic of Claude's increasingly scholarly approach that the soldiers are in accurate Roman armour; in a small sketchbook (National Museum, Stockholm) Claude made drawings after the reliefs on the Arch of Constantine and the famous relief *Barbarians submitting to Marcus Aurelius* (Rome, Palazzo dei Conservatori).

In 1655 Don Agostino Chigi had followed his uncle to Rome, where he soon became keeper of the Castel San Angelo and captain of the papal guards. In 1658, in the year of his marriage to Maria Virginia Borghese, he commissioned the *Landscape with David and the three Heroes* (Plate 84), perhaps intending to hang it at Castel Sant'Angelo or in the palace at the Piazza SS Apostoli where Prince Agostino lived with the Pope's brother, Mario Chigi, and which his brother, Cardinal Flavio Chigi, was later to enrich with many pictures.

The pictures for the Chigi are unusually grand and severe. The grandeur of the paintings perhaps suggests the overwhelming ambition of the Chigi; their Stoic severity, their aspiration to a sterner morality. The Chigi Pope, Alexander VII, had been determined to avoid the worst abuses of nepotism and to preside over a more austere court. In his painting for Agostino Chigi, Claude holds up the stern virtue of David, who refuses to drink the water that the three heroes have brought for him; their risk has been too great, for they have daringly broken through the ranks of the Philistines to obtain it. Such subjects are unusual in Claude's works, though the philosophy of Stoicism, of which this story is a Christian version, was popular in the seventeenth century, and many paintings by Salvator Rosa and Poussin celebrate the iron-willed heroes of Antiquity. Amongst Claude's drawings of this period are related themes from Roman history, such as King Artaxexes drinking, and Marcus Curtius leaping into the Abyss. In the *Landscape with David and the three Heroes* the breathtaking sweep of the landscape with its majestic rocks and trees, and the city of Bethlehem with its wonderful array of pyramids and towers, take up the heroic theme. This is an heroic landscape such as was later described by the French theorist Roger de Piles: 'The heroick style is a com-

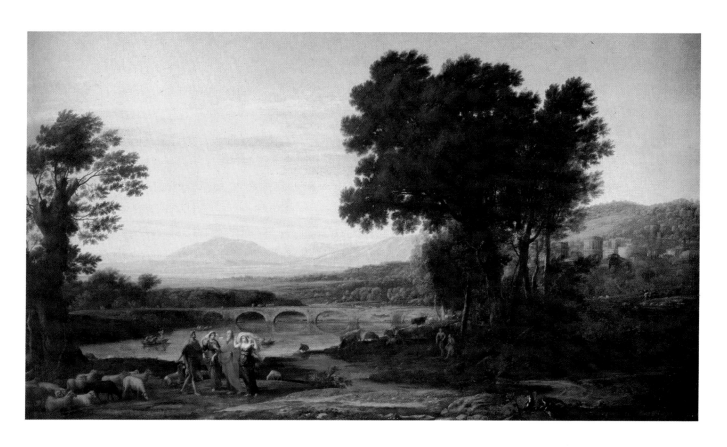

90 *Landscape with Jacob and Laban and Laban's daughters.* 1654. Oil on canvas, 143·5 × 251·6 cm. (56½ × 99 in.). Petworth, Sussex, National Trust. The story is from Genesis XXIX. Jacob wishes to marry Rachel, Laban's younger daughter; he agrees to serve Laban seven years for her.

91 *Journey to Emmaus*. Chalk with brown wash, pink body colour and heightening on pink tinted paper, 15·8 × 20·6 cm. (6¼ × 8 in.). New York, the Ian Woodner Family Collection. This was probably a final figure study for a picture, now lost, of a *Landscape with the Journey to Emmaus*, recorded in *Liber Veritatis* 125; the landscape was deeply indebted to a monumental landscape by Domenichino.

position of objects, which, in their kinds, draw both from art and nature everything that is great and extraordinary in either. The situations are perfectly agreeable and surprising. The only buildings are temples, pyramids, ancient places of burial, altars consecrated to the divinities, pleasure houses of regular architecture: And if nature appear not there, as we every day casually see her, she is at least represented as we think she ought to be.'

The monumental biblical pictures are the crowning achievement of Claude's mature years. Yet there are pictures which with increasing richness evoke the poetry of Ovid. In many of Claude's pastorals the landscapes, as in Sannazaro's *Arcadia*, echo the unhappiness of love, and the poignant moments of sunrise and sunset create an increasingly rich and poetic mood. A sense of the transience of mortal things, and of the destructive power of time, resounds through seventeenth-century lyric verse, as in Tasso's *Aminta*:

'Let us love, since the life of man has no truce with years and soon departs; let us love, for the sun sinks down and rises again, while its short light dies

unto us once for all and sleep brings on eternal night.'

Apollo, in the chariot of the sun, and Aurora, the goddess of the dawn, grace the loveliest of seventeenth-century mythological pictures, such as Guido Reni's ravishing fresco *Aurora*, and Poussin's intensely romantic mythological pictures, *Diana and Endymion* (Detroit, Art Institute), and *Cephalus and Procris* (London, National Gallery); both suggest the passage of time, and Poussin's elegiac pictures suggest the brevity and danger of love between mortal and goddess. In Claude's *Coast Scene with Acis and Galatea* (Plate 94) the lovers, in their insubstantial shelter, are unaware of the one-eyed giant Polyphemus, who, glimpsed on the rugged cliff before Mount Etna, laments his love for Galatea so loudly that 'the whole mountain and the waves below heard the pastoral strains'; later, inflamed with jealousy, he kills Acis with a great rock. Yet here Polyphemus is unstressed, and it is the landscape itself that conveys the swiftness of time and the frailty of love. The beauty of the sea and light echo the lovers' joy; and yet the stormy sky, encircling smoky Etna, foretells impending tragedy. The

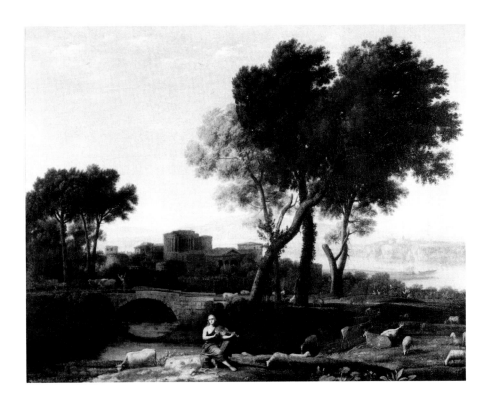

92 *Landscape with Apollo and Mercury.* 1654. Oil on canvas, 74 × 98 cm. (29 × 38½ in.). Holkham Hall, Viscount Coke.

93 *Coast Scene with a Battle on a Bridge.* 1655? Oil on canvas, 100 × 137 cm. (39⅓ × 54 in.). Richmond, Virginia Museum of Fine Arts. The Adolf
 D. & Wilkins C. Williams Fund. It is unlikely that this picture has a specific subject; it is a more classical version of a theme that Claude
 had painted in the 1630s. This is an unusually close variant of the painting which Claude produced for Pope Alexander VII.

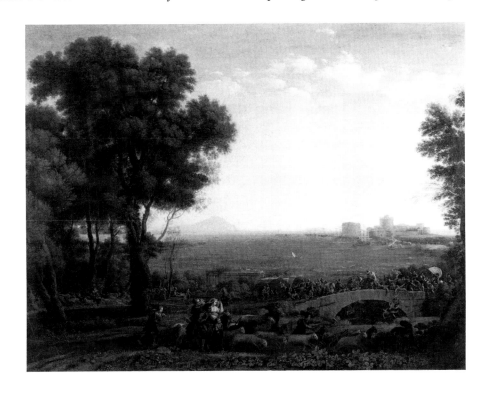

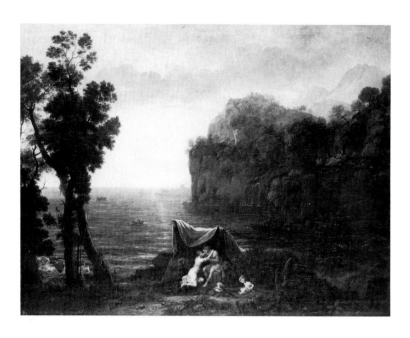

94 *Coast Scene with Acis and Galatea.* 1657. Oil on canvas, 100 × 135 cm. (39⅓ × 53 in.). Dresden, Gemaldegalerie, Staatliche Kunstsammlungen. The picture was re-painted in the eighteenth century, when the putto and the doves, and the shell below the figures in the foreground, were added. Detail opposite.

sun sets, and the darkness of eternal night will follow.

Landscape with Apollo and Mercury (Plate 92) suggests the poignancy of love in a different vein; it contrasts with the lighter, sunnier picture that Claude had painted for Camillo Pamphili. At the centre, a wistful Apollo consoles himself with music; at his feet is the lyre, which, following the *Homeric Hymn to Hermes*, Mercury gave to Apollo, receiving in exchange the stolen cattle. The lyre symbolized the harmony of the universe and the picture suggests the harmony of a natural world enriched by the architecture of man. The emphasis falls on the citadel in the middle ground, silhouetted against a wonderfully luminous distance, and encircled by deep shadows. Apollo's melancholy is heightened by the peace and order of the surrounding world in elegiac mood. The citadel itself recalls the architecture of Poussin's landscapes; the temple is probably based on the temple of Fortuna Virilis, and the ruined temple, with its semi-circular niche, was perhaps suggested by reconstructions of the Temple of Fortune at Palestrina.

The composition of the *Coast Scene with Acis and Galatea* is derived from a type developed in illustrated editions of Ovid, initially by Bernard Salomon in *La Metamorphose d'Ovide figurée* (1557). This had been developed by the Alsatian artist J. W. Baur in his *Metamorphosen* of 1641; Baur's illustrations often have a strong landscape element, and are strikingly close in mood and composition to Claude's Ovidian themes. The picture has a pendant, *Landscape with the Apulian shepherd changed into an olive tree*, 1657 (Mertoun, Duke of Sutherland), which similarly draws on illustrated editions of Ovid; it is closest to a print by Antonio Tempesta.

In the 1650s Claude developed an austere and rocky landscape that reminds us that, in Tasso's *Gerusalemme Liberata*, the century had had its own epic. At the same time poets had begun to move away from descriptions of flowery meads and shady streams towards a new appreciation of more sublime scenery; most dramatic is Carlo de Dottori's ode, *L'Appenino*, (1650–51): 'Bravely daring the dizzying heights of precipitous slopes, man is freed on the steep mountain range; above, rocks thrust their horrid spines to the sun; below, encircled in mist, open up desolate valleys.'

95 *View of the Acqua Acetosa.* 1662. Chalk and wash, 20·2 × 31·2 cm. (8 × 12¼ in.). Thos. Agnew & Sons Ltd. The site, a little north of the Ponte Molle, was famous for its beauty and peace, and many artists sketched there. The girl on the right may be Agnese; other drawings of this period, usually tender and domestic, show a young girl with a pet dove.

ROMANTIC MYTHOLOGIES THE 1660s

The devastations wrought by the Plague of 1656, and the severe political and economic difficulties that beset Rome and the Papacy, brought troubled times to sculptors and painters in the early 1660s. There were fewer distinguished patrons than earlier in the century, and the great Roman families were in decline. Giulio Rospigliosi, deeply cultivated and humane, followed Alexander VII as Pope Clement IX in 1667, and through his papacy the arts flourished. Yet it was all too brief; within two years the austere Clement X, already eighty years old, succeeded to the Papal Throne. This Altieri Pope heralded a new, more frugal era.

Claude's own household saw some changes. From 1659 a little girl, Agnes, then six years old, lived with him; her baptismal certificate records that both her father and mother were unknown. Claude described her as a girl 'brought up in my house where at present she stays for charity'; she may have been his daughter, but this is not certain. In 1663 a nephew, Jean, the son of his brother Denis, arrived from Lorraine to live with him. Sandrart described how Jean 'cared for his whole household and cash, procured colours and brushes, so that he could peacefully attend solely to his studies, which was agreeable to both parties; so he lives in peace and without trouble, and his nephew lives in the hope of being heir to all his uncle has, and until now this little republic stands on good terms.'

Jean's presence may have been particularly welcome to Claude as in 1663 he fell seriously ill, so ill that he drew up his will 'while he was suffering from bad health and lying in bed and afraid that death was impending'. Claude's health was to continue to trouble him; he had been afflicted with gout since his forties, and he remained troubled by it, so that in the last years he worked for only a few hours each day.

A series of vast and immensely ambitious projects had absorbed Claude through the 1650s. In the early years of the 1660s there is, by contrast, a sense of recapitulation, of looking back to the pictures of the 1630s and 1640s, to the more naturalistic pastorals and to the 'wonderful perspectives' on which his early fame had rested. He began once more to draw from nature, in the grounds of the Vigna Madama, and in those tranquil spots in the Tiber Valley and in the valley of the Caffarella where he had so often sketched in the 1630s. These late studies from nature (Plate 95) are quite different from the brilliantly free drawings, with their bold tonal contrasts and decorative patterning of the surface, that fill the Tivoli and Campagna books. They are muted drawings of simple motives, composed informally, often of a quiet naturalism that startlingly looks forward to eighteenth-century drawings. Some have the directness of rapid pen sketches; others, in chalk or in pale, grey-brown washes, create the most delicate atmospheric effect. Like the paintings of the 1660s the drawings also explore subtle modulations of tone.

At the same time, in the years around 1660, in

96 *Coast Scene with Apollo and the Cumaean Sibyl*. 1665. Pen and brown wash on white paper, 195 × 254 cm. (76¾ × 101 in.). London, British Museum, (*Liber Veritatis* 164). The high viewpoint, and bold, monumental forms contrast with the purity and restraint of the pendant; such contrasts are frequent in Claude's late work, and this composition looks on to Plate 106 and was re-interpreted in a similar subject, (Aeneus & the Sibyl).

97 *Landscape with Mercury and Battus.* 1663. Pen and brown wash with white heightening on blue paper, 19·7 × 25·8 cm. (7¾ × 10⅛ in.). *Liber Veritatis* 159. London, Britsh Museum. Here the drawing, windswept, with touches of gold in the sky, is unusually bold and brilliant.

98 *Seaport with St. Alexis.* 1668. Pen and grey-brown ink over perspective lines ruled in chalk; white heightening, sea and sky in blue watercolour, 24·6 × 39·6 cm. (9⅔ × 15½ in.). Haarlem, Teylers Museum. Claude's patron, Clement IX, had earlier written a play on the theme of St. Alexis. It has been suggested that this display of perspective skill, for which Claude was celebrated, was influenced by stage design.

both painting and etching, Claude renewed his delight in pastoral scenes, and there are signs that, ill and tired, he was reluctant to embark on new projects; there are signs, too, that some of Claude's patrons were beginning to express a preference for his earlier style. In July 1662, Jacopo Salviati, the Roman agent of Cardinal Leopoldo de' Medici, wrote to the Cardinal: 'Mr Claude has some old drawings, but in small number, and he does not want to part with them, saying that he uses them. Now that he is old it seems too tiresome to him to make new things; he therefore offers to copy two of them and to give us the copies. Morandi does not want to accept, saying that nowadays his works contain weaknesses and are more than a hundred miles from the quality of the old ones. Now what is worse, he

will have to be paid generously, since he only fixes a price to persons of lower class. Please it your eminence to advise how you want to be served . . .'

Claude had done very few etchings since the 1630s, yet in 1662 and 1663 he did two etchings of quintessentially pastoral scenes – *Mercury lulling Argus to sleep*, and *The Goatherd* (Plate 100), wishing perhaps to revive an interest in this kind of theme. Moreover, between 1660 and 1668 he had the French engraver, Dominique Barrière, issue five etchings of his pictures; these were all of early works, painted between 1643–46, and three of them were sea ports, a subject that Claude had neglected since the 1640s.

The Pope himself had been a close friend of Claude's for many years, and had bought pictures in the 1630s and 40s. He commissioned no new

99 *Time, Apollo and the Seasons.* 1662. Etching, first state, 18·2 × 25 cm. (7⅛ × 9¾ in.). London, British Museum.

100 *The Goatherd.* 1663. Etching, second state, 17 × 22·5 cm. (6⅔ × 8¾ in.). Oxford, Ashmolean Museum. In this last etching Claude returned to the bucolic mood of the 1630s.

101 *Landscape with Cephalus and Procris reunited by Diana.* 1664. Oil on canvas, 99 × 132·5 cm. (40 × 52¼ in.). Private collection. This, a favourite subject of Claude's, is adapted from Ovid. Procris has fled her jealous husband Cephalus; later they are reconciled, and Diana, with whom Procris has sheltered, gives her a dog and magic spear. Cephalus, through a tragic error, later kills Procris with the same spear.

works in this later period, yet their friendship still flourished; in his will Claude left Rospigliosi 'two drawings of my studies of his choice, for the good advice which he has always given me'. Only two of Claude's distinguished patrons were singled out in this way. Clement IX had a wide and eclectic taste in the arts; in the 1630s he had made his name as a dramatist, and his plays – amongst them the *S. Alessio* and *Chi soffre speri* (both 1639) – suggest a liking for classical allegory. He was moreover a passionate admirer of Poussin, and owned two of his learned allegorical paintings, *The Dance to the Music of Time* (London, Wallace Collection) and *Time saving Truth.* It may have been the Pope who suggested the unusual subject of Claude's etching, *Time, Apollo and the Seasons* (Plate 99), which is indebted to the picture by Poussin. In a pastoral landscape, where ruins suggest the passage of time, Father Time plays

his harp. The sun god, Apollo, obeys his music; behind him, their hands linked, the Four Seasons dance rhythmically in a circle, suggesting the perpetual cycle of the year. The preparatory drawing for the etching, and four other drawings associated with etchings, have been in the Rospigliosi collection since the eighteenth century. In 1668 Barrière issued an etching after Claude's *Coast Scene with Mercury and Aglauros* which Claude had painted for Rospigliosi in 1643. The etching was issued the year after he became Pope, in homage to him, and to add lustre to Claude's own name. Very little is known about Claude's own relationship with Poussin; Poussin never mentions him in his many letters; yet in 1665 Abraham Brueghel wrote to the eminent Sicilian collector, Don Antonio Ruffo: 'Now Poussin does nothing else any more than sometimes (venture out) for the pleasure of a little glass of good wine

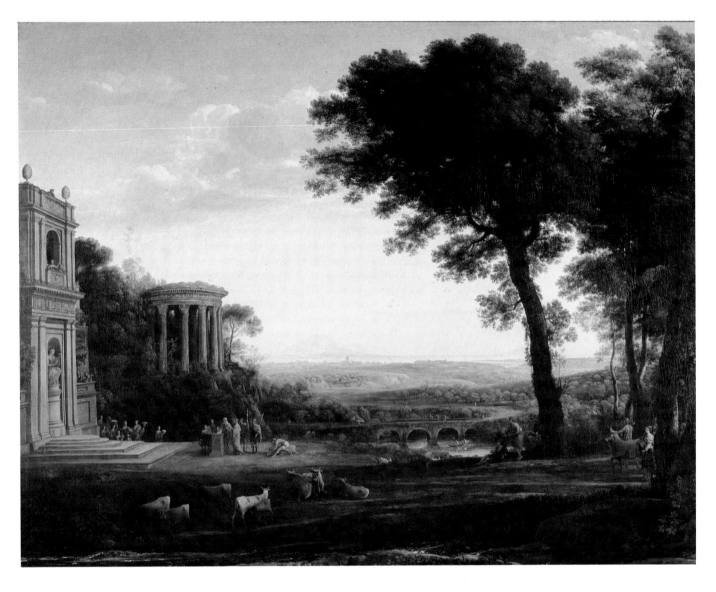

102 *Landscape with the Father of Psyche sacrificing to Apollo*. 1662? Oil on canvas, 175·5 × 223 cm. (69 × 87¾ in.). Anglesey Abbey, National Trust. The composition takes up the theme of the *Landscape with a Procession to Delphi*. In 1670, when Emilio Altieri, a relative of the patron, became Pope, Claude made a drawing after the composition, inscribed with the subject (London, British Museum).

with my neighbour Claude Lorrain' – a sentence that touchingly suggests an old and long friendship.

The other patron mentioned by Claude in his will was the Abbé Louis d'Anglure, sieur de Bourlemont, the French chargé d'affaires in Rome; to him Claude left 'a small picture on panel of cyprus wood which represents a moonrise, with a gilt frame, . . . for the favours I and my relatives have always received.' Very little is known about de Bourlemont, although the Journal of the French traveller, de Monconys, gives an all too brief glimpse of French collectors and connoisseurs in Rome, visiting the antiquities and the studios of Poussin – by this date revered by the French as the greatest painter since Raphael – and Claude; in Claude's studio de Monconys saw 'the beautiful landscape which he has made for M. de Bourlemont.'

An outstandingly lovely set of pendants for de Bourlemont, the *Landscape with Cephalus and Procris reunited by Diana* (Plate 101) and the *Coast Scene with Apollo and the Cumaean Sibyl* (Plate 96) develops the softer, more pastoral vein of Claude's art into a new, melancholy poetry, which poignantly suggests the transience of love and beauty. These are both Ovidian scenes, that look back to earlier renderings of the same subjects in the 1640s; as so often in that earlier period, they pair a landscape with a seascape, and contrast the bright morning light with a warm and glowing sunset.

The *Landscape with Cephalus and Procris* is a woodland scene, green and tranquil, which suggests the wonder and enchantment of solitude in the virgin calm of the countryside and recaptures the mood of his romantic pastorals. The landscape is strikingly simple, an untouched landscape of woods and hills and distant plains, without the rich detail of earlier pictures. The colour is soft and refined, a narrow range of cool blues and pure greens suggesting the green depths of the forest and the play of light on distant hills.

The picture's freshness and tranquillity contrast with the more haunting, elegiac beauty of the *Coast Scene with Apollo and the Cumaean Sibyl*. Apollo granted the Sibyl her wish to live as many years as there were grains in a heap of dust. Yet the Sibyl forgot to ask for perpetual youth, and was condemned to wither into endless age. The splendour of the ruined city around them – which contrasts with the untouched beauty of the round temple, reminiscent of the temple of the Sibyl at Tivoli – and of the setting sun over the Bay of Naples, with Capri on the horizon, echo the theme of transience.

The picture is close in mood to Sannazaro's elegy on the ruins of Cuma:

> 'Here, where the renowned walls of famed Cumae rose, the prime glory of the Mediterranean, where visitors often hurried from far off shores to see your tripods, great Apollo . . . And where prophesying Sibyls keep their secrets, Now the shepherd keeps his well-fed sheep at evening . . . Thresholds once sturdy with holy trophies are trampled down, and grass covers the toppled statues of gods. So many works of art and artisans, so many famous tombs, so many holy ashes, one ruin covers all.'

The picture is the last of the works done for French patrons that recall the beauty of an ideal Italy. The fame of the Bay of Naples, both naturally beautiful and enriched with the most splendid classical ruins, was second only to that of Rome itself. Steeped in the myths and legends of antiquity, every site, every stone called to mind the poetry of Ovid, Virgil and Sannazaro.

In the same years the drawings in the *Liber Veritatis* began to assume a new importance. As Michael Kitson has written: 'It is here that the drawings become most beautiful. The *Liber Veritatis* now lay at the very centre of Claude's activity as a draughtsman; it was the task which called forth his greatest and most subtle powers in the art'. These drawings are more pictorial than hitherto and Claude creates, with strikingly limited means, both colour and light. Occasionally, in the drawings on white paper, done in pure pen with short, vibrant strokes, Claude suggests an extraordinary effect of glittering light. In the blue paper drawings the contrasts of light and dark are more dramatic; brilliant white heightening suggests the rays of the rising or setting

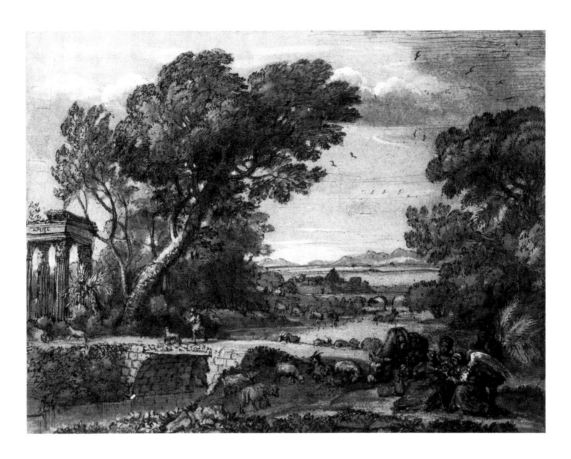

103 *Landscape with the Rest on the Flight into Egypt*. 1661. Pen and brown wash with white heightening, on blue paper, 19·8 × 26 cm. (7⅘ × 10¼ in.). *Liber Veritatis* 154. London, British Museum. In the early 1660s the drawings in the Liber Veritatis are more elaborate. Here, the beauty of the colour, the white heightening brilliant against the blue of the paper, adds to the mystery and grandeur of the landscape.

sun; transparent washes add the most subtle shades of brown and grey (Plates 103 and 97).

For his Italian patrons Claude was beginning to paint more unusual and complex subjects, drawing on a wider range of literary sources. His patrons from northern Europe admired above all the naturalism of his works, his miraculous rendering of the light at different times of day; yet for his Italian patrons, men of the most exalted rank, learned and scholarly, Claude created landscapes rich in history, that suggest the grandeur of a distant past, a vanished antique world that sheds its glory on the present.

The first of these great aristocratic patrons of the 1660s was Angelo Paluzzi degli Albertoni, Marquess of Rosina, and the head of an old and noble Roman family. In 1667 Albertoni's son, don Gasparo Paluzzi degli Albertoni, married Laura Altieri, the sole Altieri heiress and niece of the future Clement X, and

this marriage opened up glittering prospects for both father and son. Their fortunes were rapidly advanced by Cardinal Emilio Altieri, who gave to Gaspar the Altieri palace and the Altieri name and rank of Prince.

The subject of Angelo's first commission to Claude, the *Landscape with the Father of Psyche sacrificing to Apollo*, (Plate 102) is connected with the immense ambitions of his family, for the picture shows a father negotiating an advantageous marriage for his daughter. It is taken from Apuleius' *Golden Ass*, a late Antique romance, which is a blend of picturesque scenes of sorcery and enchantment, with hints of philosophical myth. At its centre lies the allegory of Cupid and Psyche, a story enriched with all the elements of fable – the enchantress, the magic palace, the invisible suitor, and the painful trials of the heroine and her final marriage in heaven. The

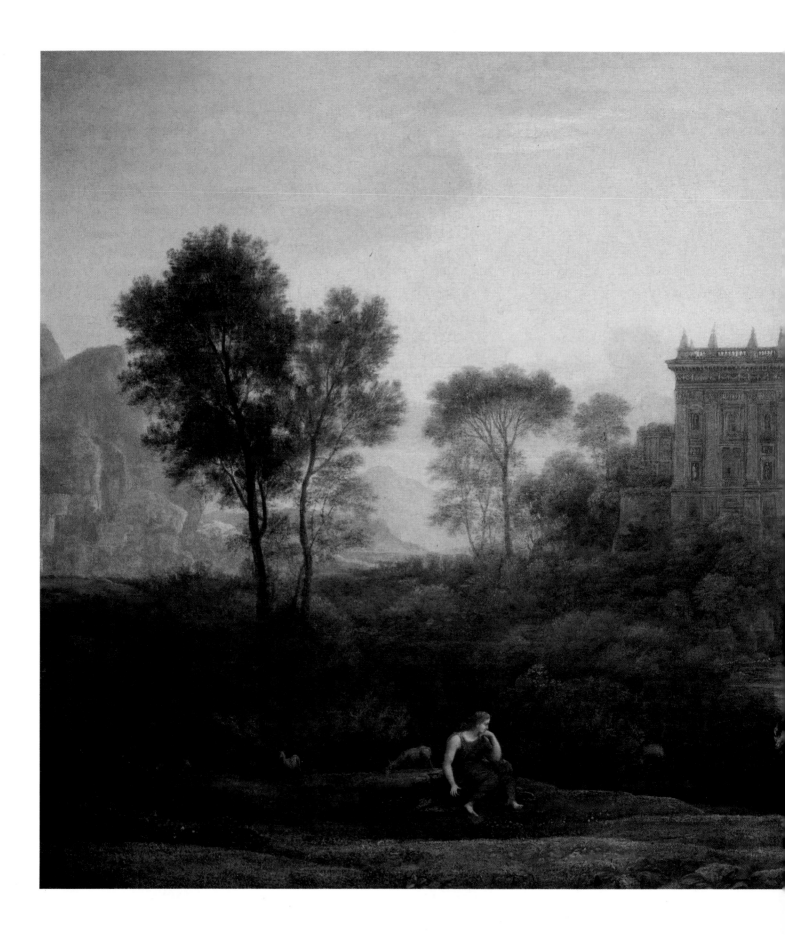

104 *Landscape with Psyche at the Palace of Cupid (The Enchanted Castle)*. 1664. Oil on canvas, 88·5 × 152·7 cm. (35 × 60 in.). London, National Gallery. This is perhaps Claude's most celebrated painting; its popular title, the *Enchanted Castle*, was first used in an engraving after the picture of 1782.

story had been popular in the Renaissance, when it had inspired famous decorative schemes, outstandingly the decorations by Raphael in the Loggia of the Villa Farnesina, and Giulio Romano's in the Palazzo del Te. The schemes of both artists are light hearted and witty, warm and erotic renderings of these picaresque tales of the trials and loves of the gods. In the 1530s the Master of the Die, an engraver working in the circle of Marcantonio Raimondi, issued a series of influential engravings with long quotations from the story. In the seventeenth century the romance retained its popularity, especially in France and in Italy; it was retold in Italy by Chiabrera, by Marino in the *Adone* in 1623, and later in France by La Fontaine. From the Renaissance the story was interpreted allegorically; the Greek word, Psyche means soul, and the love of Psyche for Cupid, and her painful wanderings, were interpreted as the soul's quest for union with the divine being.

Claude's picture, the *Landscape with the Father of Psyche sacrificing to Apollo*, shows the opening episode of Apuleius' romance. The King consults the oracle of Apollo in Miletus, to find a husband for his daughter Psyche, a maiden so beautiful that even Venus was smitten by envy. Yet Apollo's response is terrible, a dreadful prophecy that Psyche should be 'clad in mourning weed/And set on rock of yonder hill aloft/Her husband is no wight of human seed,/But serpent dire and fierce as may be thought.'

The deeply shadowed foreground, where a sacrificial bull waits in the wings, creates a sombre prelude to the story. In the distance the crowned King, with the priest, shrouded in white robes, enact their solemn rituals before a statue of Apollo with his lyre. Beyond, a stately procession bears gifts; and within the circular temple a vast throng of tiny figures kneel in worship before a statue of Fortune on her wheel.

The landscape, of breathtaking spaciousness, is composed of broad and sweeping horizontals; it concludes the series of monumental landscapes that had opened with the *Parnassus* in 1652. Yet the figures bear a new relationship to nature. They are small, caught in a bright wedge of light, and dwarfed by the immensity of the natural world. The picture movingly conveys the sense of a distant world of

remote and legendary grandeur. The round temple, unusually pitted and marked by time, recalls the Temple of the Sibyl at Tivoli; the loggia on the left is decorated with stories from the life of Apollo, showing Apollo and Marsyas and Apollo and Mercury.

A little later Claude began a series of nine pictures, between 1663–82, for Prince don Lorenzo Onofrio Colonna (1637–89), Duke of Palliano and Tagliacozzo, Grand Constable of the Kingdom of Naples. After the death of Paolo Giordano Orsini, the Colonna – for many centuries the bitter rivals of the Orsini family – dominated Roman Society. They were an ancient Roman family who boasted a proud ancestry, and whose illustrious forerunners included Pope Martin V, and the celebrated poet Vittoria Colonna, the friend of Michelangelo. Despite crippling debts which forced them to sell land and estates, the Colonna nonetheless continued to be important patrons of the arts.

Lorenzo Onofrio was the most vivid and fascinating member of the family. In 1661 he made an ill-fated marriage to Marie Mancini, one of the great beauties of the age, the niece of Cardinal Mazarin, and loved by Louis XIV. In the early years of their marriage the two played a brilliant role in Roman society. Marie Mancini shone in the world of theatre and music. Yet finally, tired by Colonna's many infidelities, she left him, and his later years were spent in retirement from society.

Colonna was also an original and interesting patron of the arts who commissioned works from a wide range of Roman artists. He had a special love of landscape painting and patronized Grimaldi and Salvator Rosa; from Gaspard Dughet he acquired a particularly lovely series of gouache landscapes, and Dughet also frescoed a room, in an old part of the Palazzo Colonna, with a series of illusionistic landscape pictures. From the storms of his present life Colonna looked back with nostalgia to the glories of the past, and he had the vast gallery of the Palazzo Colonna decorated with a dazzling, brilliantly coloured fresco extolling the heroic deeds of his ancestor at the battle of Lepanto. In the Colonna gallery today, one may still sense, more vividly than

elsewhere in Rome, the richness of the great Roman collections where Claude's works originally hung.

Both the sumptuous splendour of the Colonna Gallery, and the elegiac poetry of Claude's landscapes, suggest in different ways the fading grandeur of the great Roman nobility. The pictures that Claude painted for Prince Colonna are amongst the most interesting and beautiful of his entire career. Their subjects are often unusual, their sources in Ovid, Virgil, Apuleius, and the outstandingly obscure Nonnus. Colonna liked mythological subjects, of melancholy and romantic themes, such as Dido and Aeneas, Psyche abandoned by Cupid, Egeria mourning her dead husband Numa – themes which suggest the brevity and pain of love and which may perhaps reflect the stormy nature of his own romantic life. Claude's pictures sometimes include references to the Colonna family and to their noble lineage and suggest that the relationship between artist and patron was close.

The first of Claude's pictures for Colonna was a *Rest on the Flight into Egypt*, 1663 (Lugano, Thyssen Collection), and this was followed by a series of pictures of increasingly interesting subjects. Between 1664–5 he painted two scenes that take up the story of Apuleius' *Golden Ass*, the *Landscape with Psyche at the Palace of Cupid* (Plate 104), usually known as the *Enchanted Castle*, and the *Psyche saved from drowning herself* (Cologne, Wallraf Richartz Museum). The first picture was described by Baldinucci as 'Psyche on the seashore'; he added that it was 'considered of outstanding beauty'.

The subject of this picture, the *Enchanted Castle*, is not entirely clear. After the dreadful decree of the Oracle at Miletus the god Cupid falls in love with Psyche, and the Zephyr wafts her gently to his magic palace. Here, in darkness, forbidding her to know who he is, he visits her as his lover; yet she, spurred on by her jealous sisters, defies his command, and by the light of an oil lamp, gazes on his immortal beauty. A drop of oil wakens Cupid; he discovers her treachery, and abandons her.

The picture perhaps shows Psyche's arrival in Cupid's Kingdom, when the Zephyr wafts her to 'a deep valley, where she was laid in a soft grassy bed of most sweet and fragrant flowers'. After rest, she sees 'in the middest and very heart of the woods, well nigh at the fall of the river . . . a princely edifice, wrought and builded, not by the art or hand of man, but by the mighty power of a god'. The figure of Psyche herself is taken from an engraving by the Master of the Die showing precisely this episode. And yet the melancholy of the picture suggests Psyche's grief at her abandonment. When Cupid left, Psyche wept and lamented, then 'threw herself into the next running river, for the great anguish and dolour that she was in.' This is the subject of the pendant, and it seems slightly unlikely that Claude should have painted two such large works to illustrate a few lines in Apuleius, which describe almost the same moment. Claude perhaps intended to show the opening of the story, and yet to create a wistful mood that suggests the later sorrows of lost romantic love.

Psyche sits in the foreground, a heavy, sombre figure, stilling 'the troubles and thoughts of her restless mind', alone in Cupid's magic realm, where the shy deer emphasize the effect of solitude. Beyond towers the castle, secret, brooding, 'builded not by the art or hand of man'; the castle rises from sheer rock, an impregnable medieval fortress, yet brightened by the strangely elegant Renaissance facade – reminiscent, perhaps, of the Villa Doria Pamphili, built by Claude's earlier patron, Camillo Pamphili. The light is the melancholy light of dusk. The pallid disk of the sun is low in the sky, the transparent trees dark against it, and its rays touching the edges of the medieval tower. Long shadows fall across the foreground, and a pale evening sunlight still catches the silvery cliffs and glitters on the tiny white sails in the beckoning distance. The colours are an extraordinarily narrow range of cool blues, and greys and greens, the colour of sea and sky echoed in Psyche's robes; the subtle modulation of tone creates a powerful emotional effect. *The Enchanted Castle* is a painting of haunting symbolic power, perhaps partly due to its simplicity, to the strikingly simple juxtaposition of the woman, the castle, the vast expanse of sea and forest. It evokes, not the sunny classical world of *The Mill*, but the landscape

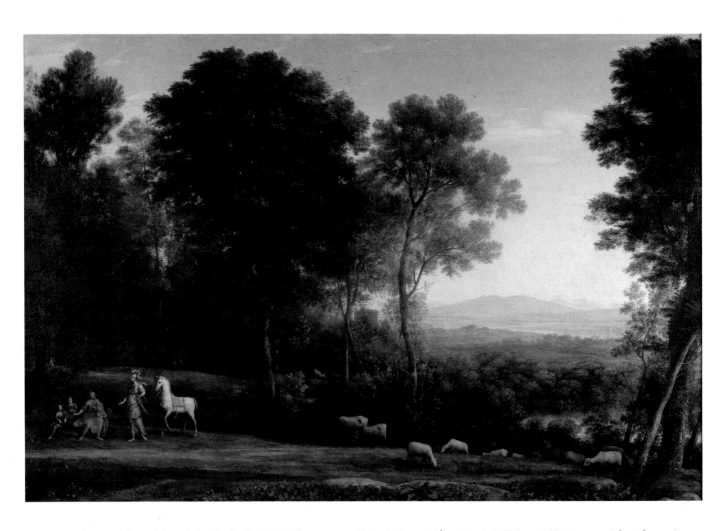

105 *Landscape with Erminia and the Shepherds.* 1666. Oil on canvas, 92·5 × 137 cm. (36½ × 54 in.). Holkham Hall, Viscount Coke. The purity of the greens, the simplicity of the landscape, and the subtle rhythms of the trees, spread out across the landscape in broad horizontals, widely spaced, and softly blown in the breeze, are characteristic of the 1660s.

106 *Landscape with the Nymph Egeria mourning over Numa.* 1669. Oil on canvas, 157 × 199 cm. (62 × 78⅓ in.). Naples, Museo e Galleria Nazionali di Capodimonte. The picture is probably a pendant to the *Landscape with Bacchus at the Palace of the dead Staphylus* (Rome, Rospigliosi-Pallavicini coll.) a rare subject from Nonnus, again concerning the death of a King; Colonna was perhaps interested in such elegiac subjects.

of fairytale, the *selva oscura* of Dante, the dense forest of the *Sleeping Beauty*, far away and deeply mysterious. In seventeenth-century theatre this landscape, with the forest glade and magic palace, was a standard stage set, which alternated with the city and harbour scenes.

Its pendant, *Psyche saved from drowning herself*, 1665, shows the next moment in the story when the 'gentle water would not suffer her to be drowned' and threw her upon the bank amongst the herbs, where she is cherished by Pan and the goddess Echo who were sitting by the riverside. In this equally sombre picture Claude follows the text very precisely. Here the landscape is broader, more spacious, and the light rosier, perhaps the light of early morning that suggests Psyche's renewal. Psyche is a touchingly small, frail figure, her arms outstretched and her head turned to the light; she is saved by the river, shown by Claude as a winged putto. The mood of the picture, the longing expressed in Psyche's pose, the sense of rebirth after despair and darkness, suggest that Claude was perhaps aware of the interpretation of this story as the soul's yearning for divine beauty. The two pendants share the same horizon, which falls on the line of the Golden Section; the distant views balance one another precisely, and when the pictures hang side by side they are linked in an overall harmony by the subtle accents of figures and buildings.

A little later, in 1669, another picture for Colonna takes up the theme of mourning. *The Landscape with the Nymph Egeria mourning over Numa* (Plate 106) shows the nymph grieving over her dead husband, Numa, one of the legendary kings of Rome. Her laments disturb the rites of the goddess Diana near Nemi, and later she became a spring. The landscape is recognisably that of Nemi, the 'mirror of Diana', the small town with its high tower perched on the sheer rock and still recognizable today. The Colonna family owned estates there, and the single column on the right is an allusion to the family arms. The picture perhaps conveys Colonna's pride in his descent from the earliest Roman Kings; and yet its beauty is haunting and deeply elegiac, and the cold, muted colours poignantly suggest the brevity of love

and life. The high viewpoint distances the landscape, so that the little town of Nemi, the small Pantheon, the temple of Diana, seem to fade before us with the beauty of a dream, where past and present mingle, and reality and memories blend. In these late years Claude's fading distances are not simply naturalistic; the grey-green colours, the transparency of light and air, seem to suggest a remoteness in both time and space. It is a landscape rich in mythological association, whose mood deepens through the 1670s: sometimes the landscapes seem veiled in nostalgia.

Other landscapes develop the simplicity and restraint introduced with the *Landscape with Cephalus and Procris*. His literary sources became richer and more varied and in 1666 he painted the first of two scenes from Tasso's *Gerusalemme Liberata*. This, the *Landscape with Erminia and the Shepherds* (Plate 105), was painted for Prince Falconieri; Claude later painted a pendant, *Coast Scene with the Embarkation of Carlo and Ubaldo* (Toronto, Art Gallery of Ontario). Tasso's *Gerusalemme Liberata*, published in 1581, is an epic poem which was modelled on Virgil and took for its subject the siege and capture of Jerusalem by the Crusader Godfrey of Bouillon. It became the inspiration of many painters who were drawn, not to the dull accounts of battles, but to the romantic adventures of lovely pagan women, such as the sweet Erminia, who was secretly consumed with love for Tancred, the most dashing of the Christian warriors. The moment chosen by Claude, when Erminia seeks refuge in the peasant's hut, had earlier been painted by Domenichino, who had established the pattern followed by Claude, with small figures at one side set against a varied landscape. This tender passage is one of the freshest descriptions of the pastoral dream in Renaissance poetry; it forms an idyllic interlude amid the clash of heroic arms. The gentle Erminia, clad in stolen armour and seeking the wounded Tancred, is fleeing her pursuers when she comes upon a shepherd who is weaving baskets of osier whilst listening to the rustic music of three boys. They are startled by her armour; the old shepherd then proceeds to describe the beauty of

his simple life, where in peaceful solitude he watches his herds and the swift deer, the fish bright in the river, and the flight of small birds, their feathers gleaming in the sky. Erminia is enchanted. Claude's picture perfectly conveys the charm of Tasso's description. It is a lovely rendering of the *locus amoenus*, with its green shade and cooling water; Erminia herself is an elongated, insubstantial figure, her horse the magic horse of fairy story; and the pure greens, whose subtle modulation alone leads the eye into the distance, create a dream-like, melancholy poetry.

Equally pure and direct are two biblical scenes, *Landscape with Abraham expelling Hagar and Ishmael* (Plate 107), and *Landscape with Hagar, Ishmael and the Angel* (Plate 108). These were painted for the Viennese Count Friedrich von Waldstein, who had developed a love of art in Rome as a young man, and who commissioned the pictures from Claude during a stay in Rome in 1667. A series of letters, three from Claude himself, and ten from Henrico von Othenheim, a Flemish cleric who acted as Waldstein's intermediary, give a detailed account of the development of these pictures. These are of great interest; they suggest most forcibly that what most interested both Claude and his patron was the effect of light at a particular time of day. They show consecutive scenes from the biblical story in Genesis, and Claude himself described them as 'celui d'Abraham et Agar qui est le soleil levan . . . et l'autre qui est l'ange qui montre la fontaine a Agar qui rapresent l'après-midi.' The comments on the development of the paintings suggest Claude's perfectionism; even after the varnishing Claude retouched them with azure, to bring them to a greater degree of perfection. Still later, in July, Othenheim wrote that Claude was again ill with gout, yet 'in two or three days he will be able to resume work, but not on these paintings,

as he will now give them the last finish, and for this he has to loosen his hand for three or four days before he touches our paintings; I shall shortly get from his hands – if he remains in good health – the one which is as good as finished and in which he only wants to change some minor points in order to give it a major light, it is the one of the sunrise. Patience therefore.'

The Landscape with Abraham expelling Hagar and Ishmael shows Abraham's servant, and his son by her, Ishmael, driven from the house at the demand of Abraham's jealous wife, Sarah; in the pendant, Ishmael, tormented by thirst, lies in pain, while an angel directs Hagar to a fountain. These paintings movingly convey the uncertain destiny of a frail mother and child driven into a wild and inhospitable world. The second picture, with its harsh, rocky terrain, and dramatic light, is the starkest of Claude's paintings; in the first he creates a startlingly simple and tender contrast between the rich splendour and order of Abraham's palace and the wide-expanse of landscape, ringed by snow-capped peaks, beyond.

In these landscapes of the 1660s one senses Claude uniting the most naturalistic effects with a purer, more abstract ideal of beauty. Neo-classical critics were to champion Poussin; yet perhaps Claude was seeking an ideal not unlike that described by Bellori in his famous lecture *Idea* delivered in 1664, when he defines an ideal beauty created by selecting and refining forms studied in nature – 'The Idea constitutes the perfection of natural beauty, and unites the true to the semblance of things present to the eye; she always aspires to the best and the wonderful, whereby she not only emulates but surpasses nature and manifests to us as elegant and accomplished the creations which nature is not wont to show perfect in every part.'

107 *Landscape with Abraham expelling Hagar and Ishmael.* 1668. Oil on canvas, 106 × 140 cm. (41¾ × 55 in.). Munich, Alte Pinakothek. The elegant Mannerist architecture looks back to the seaports of the 1640s, yet here its pure geometry creates a striking contrast with the simplicity of the landscape.

108 *Landscape with Hagar, Ishmael and the Angel*. 1668. Oil on canvas, 106 × 139·5 cm. (41¾ × 55 in.). Munich, Alte Pinakothek.

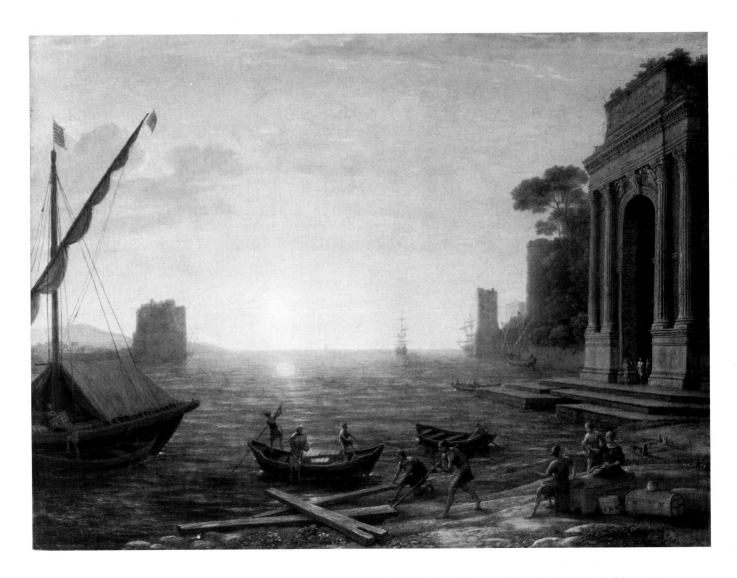

109 *Coastal Scene at Sunrise*. 1674. Oil on canvas, 66 × 97 cm. (26 × 38 in.). Munich, Alte Pinakothek. This picture, painted for Franz Mayer
von Regensburg, is based on an early etching; there is an earlier painted version, 1634, in the Hermitage, Leningrad.

LEGENDARY HEROES

The year 1669 saw the death of Giulio Rospigliosi, a Pope for two years only but nonetheless witness to a flourishing of the arts. He was deeply mourned by the Roman people. His successor, Emilio Altieri, already aged eighty, took the name of Clement X as tribute to him. Altieri had little interest in the arts. His reign was fraught with economic difficulties; temperamentally attracted to the simple life, he seriously resisted the excesses of nepotism. Clement's policy of frugality and restricted economy were followed with even greater enthusiasm by the austere and grave Pope Innocent XI, who succeeded him in 1676. The luxury and splendour of the Barberini and Chigi courts were denied to their followers, and official patronage of the arts declined. Few new families rose to display the wealth – or cultivate the adventurous and eclectic taste – that had characterized the great patrons of the early Seicento.

However, the change of Pope once again heralded a new circle of patrons for Claude. His patrons continued to be drawn from the most noble and learned families in Rome; there is a sense, in these final years, that his relationship with his patrons became increasingly close. The grand aristocracy were threatened by economic disaster, but through Claude's landscapes, rich in history and mythology, they were able to look back to a more glorious, untroubled past.

In this ultimate and perhaps greatest period of his art, Claude's themes widened and became more universal. *The Landscape with the Nymph Egeria mourning over Numa* is the first of a series of landscapes, painted between 1669–82, each strikingly bold and strange in composition, that evoke the haunting beauty of myth and legend, or the heroic events of a legendary era in Rome's early history. Their themes are drawn from Ovid, or from a source almost new to Claude, Virgil's *Aeneid*; they are sublime, idealized pictures, their mood deeply mysterious and prophetic. At this late date Claude followed his texts very precisely, and the landscape is more deeply expressive of the subject than hitherto. He sought to recreate the vanished world of classical antiquity, that world in which the mind and imaginations of his patrons was steeped. He painted those classical sites most celebrated in Rome's history, such as Lake Nemi, 'the mirror of Diana', where the nymph Egeria mourned her dead husband Numa, a legendary King of early Rome; the sites of the *Aeneid*, rich in associations, such as the ancient Chalcidic fortress of Cuma; Apollo's Delos; the stately temples and glittering harbour of tragic Dido's Carthage. However, many of these landscapes suggest the continuity of past and present, appearing like dreams or memories of ancient times in which strange figures stand like actors bewitched by the beauty of the real world. A sense of remoteness is suggested in different ways. In some of the late works a high viewpoint seems to distance a landscape that is massively built up of monumental and austere forms; others, low lying, simply composed,

110 *View of Delphi with a Procession*. 1673. Oil on canvas, 101·7 × 127 cm. (40 × 50 in.). Chicago, The Art Institute Robert A. Walker Memorial Fund. Justinus' *History* describes how 'The central part of the rock falls back in the shape of an amphitheatre . . . In the winding of the rock, about half way up the hill, there is a small plain, and in it a deep fissure in the ground, which is open for giving oracles.' (Quoted M. Roethlisberger).

create the same effect through the abstract beauty of space and light. Above all, the weirdly elongated figures suggest a shadowy world; frail, insubstantial, they seem one with the encircling air and light.

The rise of the Altieri brought back to favour Camillo Massimi, their valued advisor. Massimi, a relative of the distinguished collector Vincenzo Giustiniani, had long been an important collector and a passionate Antiquarian himself, with a deep knowledge of ancient art and archaeology; in a sense he brings to an end those great traditions of patronage that had been founded by Giustiniani, one of Claude's earliest patrons. Massimi was deeply interested in ancient painting; he had discovered Roman paintings in the Baths of Titus and had commissioned a copy of the celebrated Vatican Virgil;

he owned a hundred and sixty drawings of antique pictures by Bartoli. Massimi was one of the few outstanding patrons drawn to both Claude and to Poussin. With Poussin he enjoyed a close friendship, often suggesting to him unusual subjects for paintings; he also purchased several of Poussin's paintings. In the 1640s, at the start of a brilliant career, he had commissioned two pictures by Claude. However, his career had faltered and in the 1650s and '60s he had been out of favour and his patronage restricted. In the 1670s, with the rise of the Altieri, Massimi's fortunes unexpectedly revived; created Cardinal, he was once again in a position to commission works, and Claude did two outstanding pictures for him, *View of Delphi with a Procession* (Plate 110), and the *Coast View with Perseus and the Origin of Coral* (Plate 111).

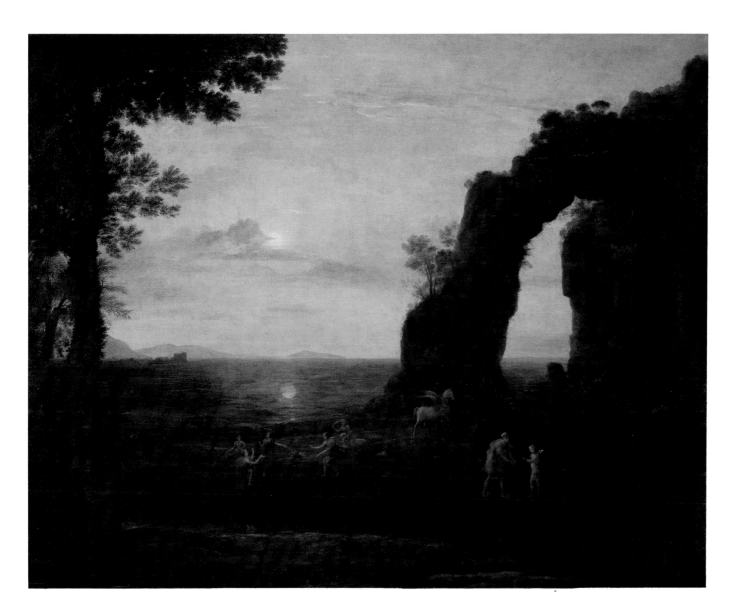

111 *Coast View with Perseus and the Origin of Coral.* 1674. Oil on canvas, 100 × 127 cm. (39⅓ × 50 in.). Holkham Hall, Viscount Coke.

No doubt Massimi played an important role in the subject and form of the pictures, and these works are the result of a fruitful relationship between artist and patron. In Claude, Massimi found an artist who could recreate the landscape of that classical world which formed the basis of his intellectual life. Claude had earlier painted a view of Delphi, a work which suggests the beauty of the fabled site. Yet for Massimi he followed precisely the description given by Marcus Justinus' *Historiae Philippicae*, a source which Claude himself noted on his preparatory drawing – 'il tempio di Apollo in delfo sopra l'monte parnaso/cavata da giustino historico'. The source was no doubt suggested by the Cardinal, and Claude has refined other details in a scholarly way; a boy plays the double flute; the fanciful temple of the earlier picture has yielded to one which is based on a reconstruction of the Temple of Jupiter Feretrius published in A. Donato's *Roma vetus ac recens*, 1635. Astonishingly this later work – where Apollo's temple crowns the awesome, rocky slopes of Mount Parnassus – truly suggests the sublime grandeur of Delphi's spectacular site, which Claude had never seen. Yet despite this more scholarly approach, the mood of Claude's picture is intensely elegiac; the frail, ethereal figures seem the dream of a distant, mythical past.

The pendant's subject, *Perseus and the Origin of Coral*, is an uncommon one, taken from Ovid. Perseus, aided by the head of Medusa, whose look turned men to stone, and by the winged horse Pegasus, had killed the dragon guarding the princess Andromeda. In Claude's picture he has laid Medusa's head on a bed of sea weed on the shore and, encircled by wondering sea nymphs, the red blood hardens the sea weed, creating pink coral. A preliminary drawing is inscribed 'pensier de Illmo il Cardinale di massim', and it seems likely that Massimi chose the subject; he owned a drawing by Poussin of the same rare story, which similarly shows Perseus washing his hands, Pegasus tied to a palm tree. The story may have had a special significance for Massimi. In view of the prominence of the tethered winged horse Pegasus – who was associated with Apollo and the Muses as well as with Perseus

– an underlying theme may have been the transformation of reality into art through the creative intellect. Claude, who so often used Ovid's *Metamorphoses*, very rarely illustrated the process of metamorphosis itself. This theme is suggested by the magical beauty of the picture itself; Claude has invested the scene of metamorphosis with an astonishing atmosphere of numinous significance. The composition is pared down to its essentials, the forms are simplified, and as in the *Enchanted Castle* of ten years earlier, the great planes of sea and sky isolate the images and give them the heightened resonance of a dream. Above all the picture is dominated, even in its present darkened state, by the extraordinary effect of the pale, silvery light and by the endless variation and modulation of colour in the sea – the realm of mutability. Oddly, it is not clear whether this is sunlight or moonlight. It now strikes the viewer overwhelmingly as moonlight, and this is true too of the outstandingly beautiful Liber drawing, and of other drawings connected with it. Yet an inventory taken in 1677, after Massimi's death, describes it as sunrise. Claude may have seen such rock arches on the Neapolitan coastline, and similar motifs occur in his early works and in decorative frescoes of the early seventeenth century (Plate 112), yet nowhere else does his treatment attain such antique grandeur, and Claude may perhaps have been inspired by an ancient painting. In 1661 he had copied a Roman fresco, then much celebrated, which had been discovered in the Barberini Gardens, and which also shows an immense rock arch, though very different in effect (Plate 112). The painting, and other late works by Claude, recall in an extraordinary way, the celebrated Roman series of Odyssey frescoes in the Vatican, which were discovered in 1848. These pictures for Massimi, both strikingly unusual works, introduce the dramatic motives of Claude's late pictures; the towering rocks and wild slopes of Mount Parnassus would have balanced the great rock arch of the *Perseus and the Origin of Coral*.

At the same time Claude's works were still in demand outside Italy. In the 1670s he painted three works for Freiherr Franz Mayer von Regensburg, the Counsellor to the Elector of Bavaria, and a friend of

112 *Copy from an antique landscape*. Pen, 21·4 × 30·9 cm. (8½ × 12¼ in.). Inscribed at the bottom left 'CLAV Fecit Romae/1661/paise antique,' London, British Museum. This is a copy of an ancient painting which had been discovered in the Barberini gardens in 1624–5.

Sandrarts. Von Regensburg already owned two early works; the three pictures of the 1670s are all based on earlier etchings and Sandrart describes the first as though it were a painting of the 1630s: 'he represented clearly the second hour of the afternoon and how the cattle are again driven out through a brook into a beautiful landscape with trees, ruins, and manifold expressions of fields and mountains, all very similar to real nature . . .' Perhaps encouraged by Sandrart, von Regensburg may have preferred the naturalism of Claude's early style; in any event, Claude's etchings would have been more available than the late pictures. *The Coastal Scene at Sunrise* (Plate 109), is based on an earlier etching, *Harbour with Rising Sun* (Plate 34). The picture illustrates both the constancy and variety of Claude's art; it returns to an earlier theme, yet in mood it is quite new. The figures are smaller, the colours cool and restrained, and it attains a new purity and formal simplicity.

In the last ten years of his life Claude painted six works showing scenes from the adventures of Aeneas, all, save one, scrupulously following the text of Virgil's epic poem the *Aeneid*. Two earlier pictures show subjects from the poem, but in these late years the work acquired a new and deeper significance for the artist. It has been shown that he read it in an Italian translation by Annibale Caro, first printed in Venice in 1581. Many artists took subjects from the *Aeneid*, and decorative cycles adorned Roman palaces, amongst them a series in the Palazzo Spada (a scene here showing the Trojan Women setting fire to their fleet is strikingly close to Claude's painting of the same subject of 1643), and Pietro da Cortona's celebrated cycle in the Palazzo Doria Pamphili in Piazza Navona. Yet the subjects chosen by Claude are almost without precedent. He was not painting a series, and his pictures were done for different patrons; yet they are intensely personal, linked by their theme of journeying. They were painted for the most distinguished and learned of his great Roman patrons, men proud of their

ancient lineage, some of whom boasted their descent from Aeneas himself.

Virgil's great epic tells of the legendary origins of the Roman nation. After the downfall of Troy, the Trojan prince, Aeneas, the son of Venus, escaped with his followers and embarked on a long and perilous journey to Italy. Here he settled; Aeneas became the first Roman, and the first Rome was founded. Virgil was writing of events in the long distant past, and at the same time celebrating the glories of his own time. Aeneas is a shadowy figure, driven on by duty and destiny, caught between the past of Troy and the uncertain future of Rome; as Jackson Knight has written: 'The story of Aeneas' wandering leads from prophecy to prophecy and sign to sign.' Claude was drawn to moments rich in portent, scenes suggesting ensuing violence or death, or scenes of prophecy. In the Renaissance, and in the seventeenth century, the *Aeneid* was interpreted allegorically, and the events of Aeneas' long journey were seen as moral stages towards the attainment of virtue, or Italy. It is possible that Claude was aware of this interpretation, as his pictures movingly convey a sense of questing, of ever seeking a higher goal, a sense created partly by the changing light on distant seas or harbours; they are the pictures of an old artist. These landscapes link past and present; adorned with buildings from ancient and modern Rome, they suggest the grandeur of an earlier era, and the magnificent ruins of its downfall, set against the unchanging beauty of the landscape.

The first of these late pictures to show the adventures of Aeneas is the comparatively small *Coast View of Delos with Aeneas* (Plate 113), painted for a French patron who has not yet been satisfactorily identified. In this Claude drew not on the *Aeneid* but on Ovid's *Metamorphoses*, which ends with a short account of Aeneas' wanderings. Ovid tells how Aeneas, with his father Anchises, and his son, Ascanius, arrive in Delos – the city of Apollo. Here they are welcomed by Anius, King and priest of Apollo. Anius received Aeneas into his home and temple, and 'showed him the city, the famous shrine, and the two trees to which Leto had once clung when she was giving birth to her children.' Leto's children were the divine twins, Apollo and Diana, and Ovid had earlier described how she had given birth 'leaning against a palm, and with the help of Pallas' olive tree' – a detail precisely followed by Claude. A further scene from Leto's life is represented on the relief set into the portico of the priest's house; it shows Apollo and Diana rescuing their mother from the giant Tityus. At Delos, Apollo consults the oracle who, in Virgil's words, tells him to 'Seek out your ancient mother. And from this land the House of Aeneas, the sons of his sons, and all their descendants shall bear rule over earth's widest bounds.'

Claude's picture looks back to, and re-interprets, his earlier picture which had similarly shown a great shrine to Apollo, the *Landscape with a Procession to Delphi* (Plate 70). The richness of the earlier painting has been reduced to a new simplicity and clarity. The colours are cooler, the air transparent; the clear blues of Aeneas and Anchises' robes are echoed in the woman's dress and beyond in the delicate rectangle of the small flags against the sunlit blue of the sea. The preparatory drawings, of which four survive, suggest that Claude thought in terms of a more heroic composition, richly crowded with figures and majestic architecture; only at a late stage did he return to the bridge and temple of his earlier work. In doing so he created a more poetic composition that attracts through subtle and delicate contrasts. The dignity and nobility of the figures who enact their drama in the foreground, before the severe Doric columns, are set against the idyllic peace and timeless charm of the pastoral life around them.

Apollo's shrine is based on the Pantheon, a building which Claude included in several of his landscapes. Since the Renaissance the Pantheon had been venerated as the noblest architectural monument of Antiquity; moreover it was not only the greatest of the ancient pagan monuments but also, for over a thousand years, a Christian church. In the seventeenth century Bernini had added two bell towers; the Piazza del Pantheon was cluttered with vendors' stalls and a jumble of small medieval houses; the Roman pavement had sunk, and the building no

113 *Coast View of Delos with Aeneas*. 1672. Oil on canvas, 100 × 134 cm. (39$\frac{3}{8}$ × 52$\frac{3}{4}$ in.). London, National Gallery. The king and priest of Delos, Anius, welcomes Aeneas, his aged father Anchises, and his son Ascanius, and points to the shrine of Apollo.

longer rose high from the ground. Alexander VII had dreamed of renewing its ancient glory; amongst Bernini's drawings are sketches of a restored Pantheon. Claude's Pantheon looks back to the buildings' original state; it suggests the future glory of Rome, prophesied by the Oracle. Ian Kennedy has written – 'The Delos temple is undoubtedly the finest variation on the Pantheon that Claude ever painted. Rising up in the calm and rarified air, with its combination of grandeur and simplicity, it seems the perfect embodiment of an earlier, more heroic age whose grimmest tragedies have been sanctified and purified by the passing of time.' As economic troubles grew, and the population of Rome dwindled, past glories offered consolation.

This picture was followed by a pair of scenes from the *Aeneid*, painted for Prince Falconieri for whom Claude had earlier painted two scenes from Tasso. The first of these was a *Coast Scene with Aeneas Hunting* (Plate 114); a year later Claude added the pendant, *Coast Scene with Aeneas and the Cumean Sibyl* (Plate 115). In the *Aeneas Hunting*, Claude created a new kind of landscape, a wild rocky shore, thickly wooded, almost eerily remote; Aeneas is silhouetted against its bleakness, suggesting his isolation as leader in a strange and inhospitable land. The landscape is modelled on Virgil's description, and throughout, Claude followed his literary source with striking fidelity:

'There is a haven there, at the end of a long sound, quite landlocked by an island in the shape of two breakwaters, which parts the waves entering from the open sea and draws them off into long channels. On each shore a frightening headland of rock towers massively into the sky; and the wide expanse of water which they overshadow is noiseless and secure. Beyond the water a curtain of trees with quivering leaves reaches downwards, and behind them is an overhanging forest-clad mountainside, mysterious and dark. There is a cave directly in front at the foot of the cliffs.'

In this haven, on the shores of north Africa, after the ravages of a terrible storm, Aeneas and the Trojans landed; Aeneas and Achates went hunting, and brought back seven stags to feed the crews of the seven surviving ships. Claude shows seven ships lying in the harbour; in the foreground, Aeneas brings down the leaders of the herd, and then shot others as they fled 'among the green forest trees'.

For the pendant Claude chose a moment, as in the *Coast Scene with Delos*, that leads to the prophecy of Rome's glory. Aeneas, led by the Cumean Sibyl, is about to begin his descent into the underworld. This is one of the most celebrated episodes in the book, and it links past and present. Aeneas is racked with guilt at the ghosts of the past, of Palinurus, Dido, and Deiphobus, and yet the book ends with a majestic array of the ghosts of future Roman heroes. The picture is now lost, but the drawing in the *Liber Veritatis*, strikingly simple, intensely romantic, is one of the loveliest; perhaps the picture had something of the magical beauty of the *Origin of Coral*. Hero and prophetess are isolated in an ancient landscape, remote and solitary, framed by trees, and by a frail circular temple, suggesting the evocative temple of the Sibyl at Tivoli. At the centre Aeneas, who 'with dauntless pace . . . followed where she led', points to where Avernus – that 'lake of black water and the glooming forest' – protects the deep cave that gives access to the underworld. The sky is filled with the beauty of the rays of the rising sun (Virgil wrote that the Goddess first appeared 'soon before the first gleam of the rising sun'). The extraordinary beauty of the light and shore, Euboean Cuma's coast, create a poignant contrast with the darkness and terror of Aeneas' journey, and yet at the same time suggest the glory of its outcome. The landscape is an idealized rendering of Virgil's scene, based on a careful study that Claude had earlier made from a map of the area.

There followed the largest and most elaborate of Claude's scenes from the *Aeneid*, the *Landing of Aeneas in Latium* (Plate 118). This was painted for Prince Altieri, the nephew of the Pope, and an inscription on a preparatory drawing makes it clear that the Prince chose the subject.

Don Gasparo Altieri was the outstanding patron from the Pope's inner circle. The ambitions of his father, the Cardinal Paluzzi degli Albertoni Altieri, who had negotiated for his son a marriage with the

Pope's niece and sole heir, Laura Altieri, were gloriously fulfilled. Father and son, who now both bore the name Altieri, became immensely powerful; Prince Gasparo became Gonfalioniere of the church and commander of Castel Sant'Angelo. Their sense of the supreme importance of their destiny and of the grandeur of their ancient lineage was given brilliant expression in the extensions to the new family palace, the Altieri palace, built next to the church of the Gesu. Carlo Maratta's fresco in the great hall, the *Triumph of Clemency* (a play on the Pope's name) was the supremely important work of this period, colder and more classical than the boldly illusionist frescoes from earlier in the century, and yet as extreme in its flattery. To the right of the fresco, beside Justice and Abundance, Don Gasparo Altieri, in ancient armour, bears his standard of office, above the crossed keys of the papacy. From Claude, Don Gasparo commissioned the great *Landing of Aeneas in Latium* as a pair to the earlier *Landscape with the Father of Psyche sacrificing to Apollo*, commissioned by his father. Again the subject implied the most

overwhelming flattery; the Altieri (along with other ancient Roman families) traced their origins back to Aeneas, and from Aeneas' ship flutters the Altieri flag.

Aeneas' arrival in Latium had caused terrible war and bloodshed. Aeneas, weary with suffering, was sleeping by the river bank, when the river god, 'old Tiber himself', rose from the waters and told him in a dream to seek an alliance with King Evander of Pallanteum, a small city inland on the Tiber, destined to become the future Rome. Aeneas then chose 'a pair of bireme ships from his fleet, manned them with rowing crews' and began his journey inland. The journey described by Virgil is marvellous and strange: 'Greased pine timbers slid by over shallow water. The very waves wondered, and the woods, strangers to such a sight, were surprised to see floating in the river the brightly painted ships with the warriors' far-gleaming shields.' Finally they arrived at Pallanteum, where the Arcadians were feasting. The Arcadians were afraid, but Pallas, the son of King Evander, bravely greeted them. 'The

114 *Coast Scene with Aeneas Hunting*. 1672. Oil on canvas, 111 × 158 cm. (43¾ × 62¼ in.). Brussels, Musée des Beaux Arts.

chieftain Aeneas then answered from high on his ship's stern, stretching out in his hand before him an olive spray in token of peace.' It is this moment, when Aeneas holds out the olive branch, that Claude has shown. Aeneas is welcomed by King Evander, who invites him to their feast celebrating Hercules' defeat of the monster Cacus, who had his lair on the Aventine Mount; Evander points to its rock face, with overhanging crag. Later they travel round the sites of the future Rome, to 'Tarpeia's Place and the Capitol, which is now all gold, but was once wild and ragged . . .' Then they see the ruins of ancient men, the citadels of Janiculum and Saturnia, founded by Father Janus and Saturn.

Claude has followed Virgil's description of the topography with exactitude. To the left is an idealized view of Mount Aventine, crowned with antique buildings, amongst them the Pantheon; across the Tiber lie the ruined cities, whose names are noted on an early compositional sketch. Beyond, the river Tiber sweeps to the sea, past the ruined arches of the Ponte Rotto, an old broken bridge of the second century BC which still stands in Rome, below the Isola Tiberina.

In this picture above all, Claude is profoundly in harmony with the spirit of Virgil's classicism and with the measured nobility of his epic poem. He creates a landscape rich in a sense of wonder, prophetic of future splendour and of heroic deeds and valour. At its centre Pallas gallantly greets Aeneas, boldly silhouetted in pale scarlet against the deep blue of the river, and behind him fidus Achates and his son Ascanius. These small figures, so fantastically elongated, so mute and stiff in gesture, their antique boats so richly and exotically detailed, create a sense of wonder and strangeness; they seem to suggest the legendary grandeur of an earlier race of heroes. It has been thought that the height of Claude's figures, most extreme in these paintings from the *Aeneid*, was intended to convey nobility. Certainly in the *Aeneid* itself great heroes are tall; Latinus, the aged king, hears news that 'tall strangers, wearing unfamiliar dress had arrived'; King Evander recalls his admiration for Anchises: 'as he walked Anchises towered high above all the rest'.

The great sweep of the river itself conveys the Trojans' epic wanderings, and the sheer scale and majesty of the landscape accentuate the portentous significance of the meeting. The shepherds are normally proportioned and on a different scale; they also seem to exist in a different time from the shadowy, distant figures from a world beyond history. Claude prepared this vast and immensely ambitious work with an unusual number of preparatory drawings; it was the only picture finished in 1675, and only one had been painted in 1674. Amongst these drawings is one of the Aventine, with the broken arch of the Ponte Rotto in the foreground. This drawing was done from nature and yet its forms are already idealized, and look towards the grandeur of the completed picture. Claude evokes the past through a deep knowledge of that landscape which had inspired classical literature, and like Virgil, he combines the real and the ideal, the past and the future.

This was an outstandingly important work, and Claude made two drawings which record it, as well as the drawing in the Liber Veritatis. This was a practice which became increasingly common in his late years, and the precise purpose of these works is not entirely clear. Some may have been intended for sale; others perhaps suggest his pleasure in the picture. The drawing in the Uffizi after the *Landing of Aeneas in Latium* (Plate 118) is one of the most spectacular. The edges of the leaves are touched in with tiny strokes and dots, creating a soft decorative beauty. A thin, golden wash suggests a warm light, and the wavering lightness and delicacy of the drawing seems to veil only lightly the abstract beauty of the composition.

Towards the very end of his life, in the years between *c.* 1677 and 1682, Claude moved towards a new style. In the drawings of his final years Claude began to use very short pen strokes, that create an effect of vibrant light; occasionally the touch is so soft, the pale grey and grey brown washes are so evanescent, and the figures so charming and graceful, that the drawings seem to look forward to the rococo style of the eighteenth century. Elsewhere, in paintings such as the *Mount Parnassus with Apollo*

115 *Coast Scene with Aeneas and the Cumean Sibyl*. 1673. Pen and brown ink with paler grey and grey brown washes; white heightening, on blue paper *Liber Veritatis* 183. 19·2 × 25·5 cm. (7½ × 10 in.). London, British Museum. The picture which this drawing records is missing; the drawing shows Aeneas' descent into the Underworld, described by Virgil in the *Aeneid*, VI, 260–3.

116 *The Landing of Aeneas in Latium.* Black chalk, pen, brown and grey wash, heightened with white, 24·7 × 33·1 cm. (9¾ × 13 in.). Florence, Uffizi. At the left is the inscription 'l'arrivo d'Anea a palante. al monte evantino. Claude i.v.F Roma 1675.' This drawing, more elaborate than the *Liber* drawing, records the most celebrated of Claude's late works; in his late years Claude frequently made such reproductive drawings.

117 *Landscape with Jacob and Laban and Laban's daughters.* 1676. Pen, brown ink, wash, black chalk on white paper, 19 × 25.2 cm. (7½ × 10 in.). *Liber Veritatis* 188. London, British Museum. This drawing records a picture (now in London, Dulwich College Gallery) done for Claude's patron Freiherr Franz Mayer von Regensberg.

and the Muses (Plate 121), and drawings such as *Landscape with the Sibyl receiving Aeneas* (Plate 119), there is a return to the stupendous scale and grandeur of the 1650s and occasionally there are again reminiscences of Polidoro da Caravaggio and of Annibale Carracci's *Entombment*. Amongst the last few drawings in the Liber are some, such as the *Landscape with Jacob and Laban and Laban's daughters*, (Plate 117) of outstanding fragile beauty, where tiny dots and touches of the pen give a delicate structure beneath the pattern of pale washes. Occasionally one may feel that Claude's line was becoming shaky with extreme old age, as in the *Rest on the Flight into Egypt* (Plate 120), and yet he retained his power to suggest, through washes of misty blues and greys, a haunting and mysterious beauty. The later pictures are harmonies of subtly varied greens, lighter and paler than hitherto, the feathery trees and foliage created by a minute and delicate brushwork.

Amongst his patrons Prince Colonna continued to play an outstanding role, and it was for him that Claude painted his last works, the *Mount Parnassus with Apollo and the Muses*, perhaps the *Mount Parnassus with Minerva visiting the Muses* (Jacksonville, Florida, the Cumner Gallery of Art) and his final Virgilian pictures, the *View of Carthage with Dido and Aeneas leaving for the Hunt*, 1676, (Hamburg, Kunsthalle) and its pendant, *Landscape with Ascanius shooting the Stag of Silvia* (Frontispiece). This is Claude's last picture, and he died before he could include it in the *Liber Veritatis*. Its story is again one which foreshadows tragedy and momentous events. Virgil tells how the Trojans landed in Latium, and were then welcomed by King Latinus. Juno, enraged by their safe arrival, sent the fury Alecto to unleash the horrors of war. Alecto saw Ascanius, Aeneas' son, out hunting, and incited him to slay the pet stag belonging to Sylvia, daughter of Tyrrhus, master of Latinus' royal herds. This, 'the principal cause which started the tribulations to come', provoked war, and the victory of the Trojans led to the founding of the imperial city of Rome.

The picture looks back to Claude's earlier hunting scene, the *Coast Scene with Aeneas Hunting* (Plate 114) and the drawings suggest that Claude first experimented with the subject in 1669, when he was also beginning to work on that picture. Yet the landscape no longer shows Libya's barren shores, but the rich and fertile beauty of Latium, Aeneas' promised land. Claude suggests the idyllic landscape described by Virgil, where the lush foliage and the still pool offer refuge to the deer that has paused to cool itself in the stream, 'taking relief from the heat in the shadow of its green bank'. The colours are light and cool, and the brushwork extraordinarily minute and delicate, patterning the leaves of the feathery trees against the sky, and weaving harmonies of rich colour across the deep reflections on the pool and in the waves that lap the distant cliffs. And yet, the peace and magical beauty of the landscape seem touched with a sense of ensuing darkness. It is evening and the heat of the day has passed. A storm rises; a thundery light catches the gloomy castle on the craggy hillside, and the tops of the trees seem to stir in a cold wind.

Ascanius, taller and yet more weirdly elongated than his companions, his cloak brighter than their muted browns and mauves, dominates the foreground. A taut horizontal links the hunter, his hands 'guided by some deity', to the stag, its horns decorated 'with soft garlands' and its neck oddly long. The stag gazes back at him, motionless in fear. Nature mirrors the terror of the action; light thickens, and Ascanius' swift arrow brings with it cruel war. As in medieval painting, the subsidiary figures are smaller. The boy with the dog is normally proportioned. They all stand in the shadow of a majestic ruined temple, and great slabs of masonry and fallen columns lie deeply buried in the foliage. These are the ruins of the future Rome; such was the landscape of Claude's own day, rich in ancient remains, that evoked dreams and memories of an earlier and more heroic era.

Claude's links with his family in Lorrain had remained close throughout his life. Sometime in the 1670s he had been joined by another nephew, Joseph, the son of his brother Melchior; in 1681 he wrote to his relatives in Chamagne, saying that he was waiting a peaceful end. Through Pascoli, who

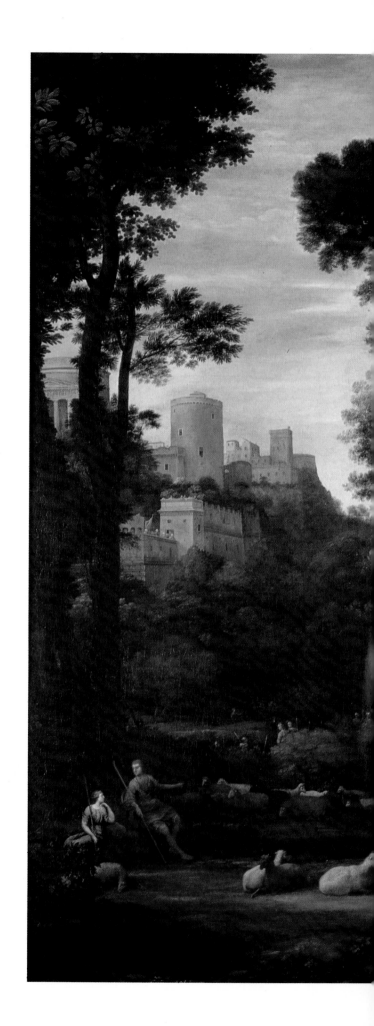

118 *The Landing of Aeneas in Latium*. 1675. Oil on canvas,
175·5 × 225 cm. (69 × 88½ in.). Anglesey Abbey, National Trust.

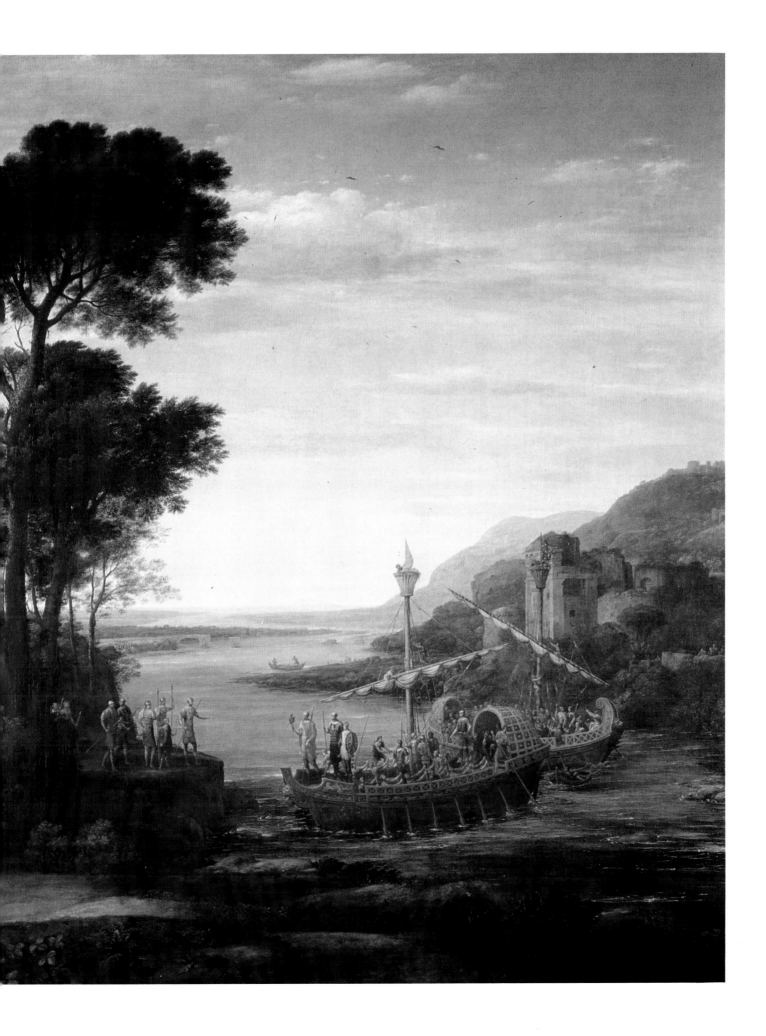

119 *Landscape with the Sibyl receiving Aeneas.* Pen and brown ink with grey and brown wash; heightening, 18·5 × 25·2 cm. (7¼ × 10 in.). Chatsworth, Devonshire collection. Reproduced by permission of the Chatsworth Settlement Trustees. The Sibyl shows Aeneas the temple at Cuma; the drawing suggests the sublime scenery of the opening of the Aeneid's sixth book, where 'Apollo rules enthroned on high' and 'the vast cavern beyond, which is the awful Sibyl's own secluded place.'

120 *Rest on the Flight into Egypt.* 1682. Chalk, pen, light grey and blue washes, white heightening, on blue paper, 12·8 × 16·7 cm. (5 × 6½ in.). Washington, National Gallery of Art. Gift of R. Horace Gallatin. This moving, slightly tremulous drawing shows Claude, in extreme old age, returning to a theme that had attracted him since the early 1630s.

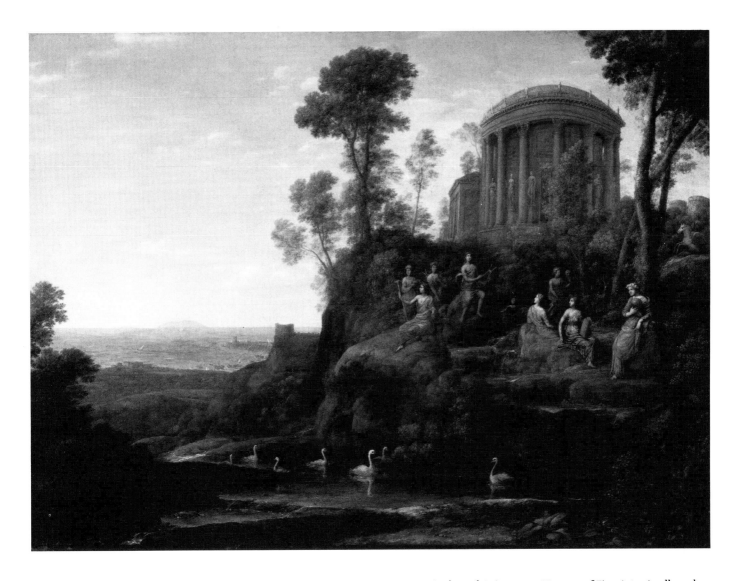

121 *Mount Parnassus with Apollo and the Muses*, 1680. Oil on canvas, 98 × 135 cm. (38½ × 53⅓ in.). Boston, Museum of Fine Arts. Apollo and the Muses, on Mount Parnassus (or perhaps Mount Helicon, the home of the Muses where the Hippocrene fount sprang from a blow made by Pegasus' hoof) are enthroned in a landscape whose beauty and splendour seem the source of artistic inspiration.

knew Joseph, we have a vivid account of Claude in old age, 'his mind still worked, and he always had for conversation either artists, or craftsmen, or other personalities, who took a great delight in hearing him talk; and almost always he talked about his profession . . . he used to narrate with great satisfaction the misfortunes and dangers encountered in his youth, the persecutions made against him by other artists in his mature years, the traps and ambushes prepared by the envious in order to abuse his work and to discredit him in his old years. . . . With such and similar discourses he passed the time at the end of his life; but his gout increased incessantly.'

Claude died in 1682, and was buried in the church of Santissima Trinità dei Monti; his nephews, Jean and Joseph, dedicated his monument:

'To Claude Gellée Lorraine, born at Chamagne, the outstanding painter, who represented marvellously the rays of the rising and setting sun over the landscape, and in this city where he practised his art earned the highest praise amongst the great.'

NOTES

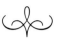

Introduction

p.12 VIRGIL, *The Eclogues*, Penguin Classics, 1984, p. 41.
 VIRGIL, *The Georgics*, Penguin Classics, 1987, p. 143, p. 91.
p.13 SANNAZARO, J., *Arcadia*, translated R. Nash, Wayne State University
 Press, Detroit, 1966, p. 90.
 VIRGIL, *The Georgics*, Penguin Classics, 1987, p. 93.
 HORACE, *The Complete Odes and Epodes*, Penguin, 1986, Epode 2.
 PALLAVICINO, S., *Del bene*, 1644, in *Trattatisti e narratori del Seicento a
 cura di E. Raimondi*, Milan – Naples, 1960, p. 257.
p.17 WHITFIELD, C., *A Programme for Erminia and the Shepherds*, Storia
 dell'Arte, No. 19, 1973, pp. 217–29; quoted R. Spear, *Domenichino*, Yale
 University Press, New Haven and London, 1982.
 URBAN VIII, *Poemata*, 1726.
 SANDRART's life of Claude is printed in English translation in M.
 Roethlisberger, *Claude Lorrain: the Paintings*, 1961, pp. 47–50.
 BALDINUCCI's biography of Claude is printed in English translation in
 M. Roethlisberger, *Claude Lorrain: The Paintings*, 1961, pp. 53–62.

Chapter 1

p.19 BALDINUCCI: M. Roethlisberger, 1961, p. 53–4.
p.25 SANDRART: M. Roethlisberger, 1961, p. 49.
p.33 JOACHIM DU BELLAY, *Les Antiquités de Rome*, XXVII, p. 41, Garnier
 Flammarion, Paris, 1971.
 SANDRART: M. Roethlisberger, 1961, p. 47.
p.35 ibid. p. 49.
 SANDRART, *Teutsche Academie*, Vol. 1, Part 1, p. 71; translated M.
 Roethlisberger, 1961, p. 51.
p.38 SANDRART's autobiography in the appendix of his *Teutsche Academie*.
 1675; translated M. Roethlisberger, *Claude Lorrain: The Paintings*, 1961,
 p. 51.
p.40 BALDINUCCI: M. Roethlisberger, 1961, pp. 53–62.
 SANDRART: from the life of Titian in the *Teutsche Academie*, 1675,
 translated M. Roethlisberger, 1961, p. 52.
p.44 BALDINUCCI: M. Roethlisberger, 1961, p. 56.
p.45 URBAN VIII (Mafeo Barberini), *Poemata*, 1726, p. 120.
p.49 BALDINUCCI: M. Roethlisberger, 1961, p. 58.
 THEOPHILE DE VIAU, *Oeuvres Poetiques*, Lille, 1951, p. 16.
p.57 BALDINUCCI: translated M. Kitson, *Liber Veritatis*, 1978, p. 20.

Chapter 2

p.61 *Claude Lorrain e i pittori lorensi in Italia nel XVII secolo*, exhibition
 catalogue, 1982, p. 280.
p.64 ROETHLISBERGER, *Tout l'oeuvre peint de Claude Lorrain*, 1986, no. 159,
 p. 106.
p.65 VIRGIL, *The Georgics*, Penguin Classics, 1987, p. 82.
p.72 JEAN JACQUES BOUCHARD, *Journal*, Vol. II, p. 475, ed. E. Knnieff, Turin.
 HORACE, *The Complete Odes and Epodes*, Penguin Classics, 1986, Odes
 Book 1, p. 76.
p.73 E.J. TRECHMANN, *The Diary of Montaigne's Journey to Italy*, translation,
 London, 1929, p. 164.
p.80 JOACHIM DU BELLAY, *Les Antiquités de Rome*, VII, p. 30, Garnier
 Flammarion, Paris, 1971.
p.89 PASCOLI, *Life of Claude*, 1730; translated M. Kitson, *The Art of Claude
 Lorrain*, 1969, No. 131, p. 58.
p.94 VIRGIL, *The Georgics*, Penguin Classics, 1987, p.92.
 GABRIELE CHIABRERA, *Il Secol d'Oro in Delle Opere di Gabriele Chiabrera*,
 Venezia, 1757, Delle Opere, III, p. 62.

THE HOMERIC HYMNS, translated Apostolos N. Athanassakis; John
Hopkins, University Press, Baltimore and London, 1976, p. 23.

Chapter 3

p.101 A. FELIBIEN, *Entretiens*, 1725, p. 167; cited M. Roethlisberger, *Claude
 Lorrain: the Paintings*, 1961, p. 61, no. 39.
p.105 SALVATOR ROSA, *La Pittura*, lines 175–77.
p.109 VIRGIL, *The Georgics*, Penguin Classics, 1987, p. 109.
 NATALIS COMES, *Mythologies libri decum Padua*, 1616, p. 583; translated
 E. Winternitz, *Musical Instruments and their Symbolism in Western Art*,
 London, 1967.
p.114 VIRGIL, *The Eclogues*, Penguin Classics, 1984, p. 31.
p.116 E.G. HOLT, *A Documentary History of Art*, Vol. II. Princeton University
 Press, Princeton, N.J., 1982, p. 178, (de Piles).
 TASSO, *Aminta*, translated E. Grillo, London, 1924, p. 95.
 OVID, *Metamorphoses*, Penguin Classics, 1968, p. 306; M. Kitson, *Liber
 Veritatis*, 1978, no. 141.
p.118 Carlo de Dottori L'Appenino; cited in C. Jannaco, *Il Seicento*, Milan,
 1973, p. 221.

Chapter 4

p.121 Claude's will is printed in translation in M. Roethlisberger, 1961, p. 64,
 with codicils of 1670 and 1682.
 SANDRART; M. Roethlisberger, 1961, p. 49.
p.124 This letter is translated in M. Roethlisberger's *Claude Lorrain: The
 Drawings*, p. 21; it is published in a French translation in *Bulletin de
 la Soc. Historique de l'Art Francais*, 1931, p. 237.
p.126 Letter from Abraham Brueghel to Don Antonio Ruffo, Rome, 22 May
 1665; quoted M. Roethlisberger, *Claude Lorrain: The Paintings*, 1961,
 p. 62, and published in *Bollettino d'Arte*, X, 1916, p. 173.
p.128 W.J. Kennedy, *Jacopo Sannazaro and the uses of Pastoral*, 1983,
 pp. 75–76.
p.132 APULEIUS, *The Golden Ass*, translated W. Adlington Loeb, ed. 1915,
 p. 195.
p.137 This letter is printed in M. Roethlisberger, *Tout l'Oeuvre peint de Claude
 Lorrain*, 1975, p. 14.
 These letters are published in J. Morper, *Johann Friedrich Graf von
 Waldstein und Claude Lorrain in Munchner Jahrbuch der bildenden,
 Kunst*, 12, 1961, p. 215, and translated by M. Roethlisberger in
 National Gallery of Art, Washington; Studies in the History of Art,
 No. 15, p. 51.
p.137 E.G. Holt, *A Documentary History of Art*, Vol. II, Princeton University
 Press, Princeton, N.J., 1982, p. 96.

Chapter 5

p.144 M.ROETHLISBERGER, *Claude Lorrain; The Drawings*, 1968, no. 1057.
p.145 SANDRART, M. Roethlisberger, 1961, p. 50.
p.146 OVID, *Metamorphoses*, Penguin Classics, 1955, p. 302.
 VIRGIL, *The Aeneid*, Penguin Classics, 1985, p. 78.
p.148 I. KENNEDY, *Claude and Architecture*, Journal of the Warburg and
 Courtauld Institutes, 35, 1972, p. 267.
 VIRGIL, ibid. p. 32; p. 33; p.155.
p.150 ibid. pp. 203–4; p. 211; p. 180; p. 205.
p.153 ibid. p. 190.
p.157 M. ROETHLISBERGER, *Claude Lorrain: The Drawings*, 1968, p. 5.

Epitaph from Claude's tombstone, Church of Santissima Trinita dei Monti of
the Friars Minor, Rome; transl. D. Russell, *Claude Lorrain*, 1982, p. 47.

BIBLIOGRAPHY

Sources

The sources for Claude's life are a brief biography written by the German painter and writer Joachim von Sandrart, who knew Claude in Rome in the 1630s, and a biography (written between 1682–96) by the Florentine art historian Filippo Baldinucci. These have both been published in full, in an English translation, in Marcel Roethlisberger's catalogue of the paintings. Unless otherwise stated the quotations in the text are from these translations.

General

BLUNT, A., *Art and Architecture in France, 1500–1700*, 3rd revised edition, Harmondsworth, 1973.

HASKELL, F., *Patrons and Painters. A Study in the Relations between Italian Art and Society in the Age of the Baroque*, New Haven – London, 1963.

MAGNUSON, T., *Rome in the Age of Bernini*, Stockholm, 1982 and 1986.

MARTIN, J.R., *Baroque*, New York – London, 1977.

PASTOR, L.F., von, *The History of the Popes*, 40 vols., translated R.F. Kerr and D.E. Graf, London.

POSNER, D., *Annibale Carracci: A Study in the Reform of Italian Painting around 1590*, 2 vols., London – New York, 1971.

SALERNO, L., *Pittori del Paesaggio del Seicento a Roma*, 3 vols., Rome, 1977.

The Paintings

ROETHLISBERGER, M., *'The subjects of Claude Lorrain's Paintings'*, Gazette des Beaux Arts, 55, (1960), pp. 209–24.
Claude Lorrain: The Paintings, 2 vols., Berkely – Los Angeles, 1968.

ROETHLISBERGER, M. and CECCHI, D., *L'Opera completada di Claude Lorrain Classici dell' Arte*, Milan, Rizzoli, 1975.

RUSSELL, D., CHIARINI, M., DAMISCH, H., ROETHLISBERGER, M., WHITFIELD, C., *Claude Lorrain, 1600–1682; A Symposium*, Studies in the History of Art, National Gallery of Art, Washington, articles, 1984.

WADDINGHAM, M., *Claude Lorrain*, The Masters, 55, 1966; an excellent short introduction.

The Drawings

CHIARINI, M., *Selected Drawings*, Pennsylvania State University Press, 1968.

KITSON, M., *Claude's Books of Drawings from Nature*, Burlington Magazine, CIII, 1961, pp. 252–57.
Claude Lorrain: Liber Veritatis. London, 1978.

ROETHLISBERGER, M., *Claude Lorrain: the Drawings*, 2 vols., University of California Press, 1968.
Claude Lorrain: the Wildenstein Album, 1962.

Exhibition Catalogues

Claude Lorrain e i pittori lorenesi in Italia nel XVII secolo, Exh. Cat., Accademia di Francia a Roma, Rome, 1982.

Claude Lorrain, London, Thomas Agnew and Sons Ltd., 1982; introduction Julian Agnew.

L'Ideale Classico del Seicento in Italia e la pittura di paesaggio, Palazzo dell'Archiginnasio, Bologna, 1962.

KITSON, M., *The Art of Claude Lorrain*, Hayward Gallery, Arts Council of Great Britain and the Northern Arts Council, London, 1969.

LUNA, J., *Claudio di Lorena*, Musée du Prado, 1984.

ROETHLISBERGER, M., *Im Licht von Claude Lorrain*, Munich, 1983.

ROSENBERG, P., *France in the Golden Age: 17th Century French Paintings in American collections*, Musée du Louvre, the Metropolitan Museum of Art, and the Art Institute of Chicago, Paris – New York Chicago, 1982.

RUSSELL, H.D., *Claude Lorrain, 1600–82*, National Gallery of Art, Washington, 1982.

Special Studies

GOWLING, L., *Nature and the Ideal in the art of Claude*, Art Quarterly 37, 1974, pp. 91–7.

KENNEDY, I.G., *Claude and Architecture*, Journal of the Warburg and Courtauld Institutes, 35, 1972, pp. 260–83. This is a seminal work, and most of the observations on Claude's architecture are indebted to it.

KITSON, M., *The Place of Drawing in the Art of Claude Lorrain*, Acts of the XX International Congress of the History of Art, 111, Princeton, 1963, pp. 96–112.
The Relationship between Claude and Poussin in Landscape, Zeitschrift für Kunstgeschichte, 24, 1961, pp. 142–62.

ROETHLISBERGER, M., *'Les pendants dans l'oeuvre de Claude Lorrain'*, Gazette de Beaux Arts, 55, 1960, pp. 209–24.

In addition to these works, the author also consulted the following more specialized works whilst preparing this book:

BROWN, J., and ELLIOTT, J.H., *A Palace for a King – the Buen Retiro and the court of Philip IV, 1980*.

KENNEDY, I.G., *Claude Lorrain and Topography*, Apollo 90, October 1969, pp. 304–9.

KITSON, M., *Swanevelt, Claude Lorrain et le Campo Vaccino*, Revue des Arts, 8, 1958, pp. 215–20, and pp. 258–66.
Claude Lorrain: Landscape with the Nymph Egeria, the 49th Charleton Lecture, Newcastle-upon-Tyne, 1968.
The Altieri Claudes and Virgil, Burlington Magazine 102, 1960, pp. 312–18.
Claude's earliest coast scene with The Rape of Europa, Burlington Magazine, 1973.

LEVEY, M., *Claude's Enchanted Castle*, Burlington Magazine, Nov. 1988, CXXX, pp. 812–20.

MCKAY, A.H., *Virgilian Landscape into Art*, in Virgil, ed. D.R. Dudley, London, 1969.

PUGLIATTI, T., *Agostino Tassi, tra conformismo e liberta*, Rome, 1977.

ROETHLISBERGER, M., *Additional works by Goffredo Wals and Claude Lorrain*, Burlington Magazine 121, 1979, pp. 20–28.
Claude's View of Delphi, Museum Studies, The Art Institute of Chicago, 1, 1966, pp. 84–95.

RUSSELL, D., *Claude's Psyche Pendants: London and Cologne*, in *Claude Lorrain 1600–82, A Symposium 1984*, pp. 67–81.
Claude Lorrain in the National Gallery of Art, Reports and Studies in the History of Art, Washington D.C., 1969, pp. 34–57.

WATERHOUSE, E., *Ascanius Shooting the Stag of Sylvia*, in *Enjoying Paintings*, ed. D. Piper.

WILSON, M., *Second Sight 1*, London, National Gallery Exhibition, 1980.
Claude: The Enchanted Castle Exhibition, The National Gallery, London, 1982.

INDEX

Italic numerals refer to plate numbers

Aldobrandini, Olimpia 93, 108
Alexander VII, Pope 17, 101, 114, 116
Altieri, Angelo Paluzzi degli Albertoni, Marquess of Rosina 129, 148–9
Altieri, don Gasparo Paluzzi degli Albertoni 129, 148–9
Altieri, Emilio (Pope Clement X) 17, 121, 129, 141, 148–9
Angeluccio, Claude's assistant 81
Landscape with Huntsman 65
Apuleius, *Golden Ass* 129, 132, 133
Astalli, Camillo (Cardinal Astalli-Pamphili) 108
Baldinucci, Filippo 17, 19, 28, 40, 44, 52, 56, 101, 114
Barberini, Maffeo (Pope Urban VIII) 13, 17, 20, 40–1, 44–5, 48, 61
Baur, J. W., *Metamorphosen* 118
Bellay, Joachim du 33, 80
Bentivoglio, Cardinal Guido 38, 40–1
Bouchard, Jean-Jacque, journal of 72
Bouillon, Duc de 61, 72, 93
Breenbergh, Bartholomeus 21, 32, 36, 37
Moses and Aaron changing the River of Egypt to Blood 16
Bill, Paul 20, 21, 33, 36, 41, 64, 81
Harbour View 30
Landscape with Christ at Emmaus 17
Buen Retiro, paintings commissioned for 53–4, 56–7; *42, 43, 47, 48*
Carracci, Annibale 64, 65, 69, 104
Landscape with the Entombment of Christ 65, 153
Landscape with the Flight into Egypt 65, 104; 51
Chiabrera, Gabriele 45, 94
Chigi, Fabio (Pope Alexander VII) 17, 101, 114, 116
Claude Lorrain (Claude Gellée)
birth and early years 19
travels to Rome and Naples 19
works as assistant to Claude Deruet 19
returns to Rome and settles in Italy 19–20
death 157
will 124, 128
and Poussin 126, 128
biblical subjects 53, 56, 64, 81, 101, 116
contre-jour effects 37, 44
copper, paintings 28, 45, 73
figures 88, 112, 114
mythological subjects 38, 64, 81, 101, 104, 116, 141
patrons 9, 13, 17, 33, 38, 40, 49, 61, 64, 72, 92–3, 101, 108, 109, 114, 124, 126, 129, 132, 137, 141, 142, 144–5, 148–9, 153
drawings 36–7, 37, 64, 73, 121, 150, 153
reproductive 150; *116*
sketchbooks 32, 37, 114
Campagna book 37, 73, 121; *27*
Liber Veritatis 56–7, 128–9, 148, 150, 153; *26, 62, 96, 97, 103, 115*
Tivoli book 73, 121; *53, 54, 69*
Adoration of the Golden Calf

88, 89
Campo Vaccino 25
Cascades of Tivoli 56
Coast with Sailing Boats 33
Coast Scene with Aeneas and the Cumean Sibyl 148; 115
Coast Scene with Apollo and the Cumean Sibyl 128; 96
Copy from an antique landscape 112
Farmhouse on the Tiber 37; 27
Journey to Emmaus 114; 91
Landing of Aeneas in Latium 150; 116
Landscape with Jacob and Laban and Laban's daughters 153; 117
Landscape with Mercury and Battus 97
Landscape with the Rest on the Flight into Egypt 103
Landscape with the Sibyl receiving Aeneas 153; 119
Landscape with Tobias and the Angel 77; 62
Oak Tree in the Campagna 19
Pastoral Figures 6
Rest on the Flight into Egypt 153; 120
Rocks by a Torrent 54
Samuel anointing David 88; 71
Seaport with St. Alexis 98
Ship in a Storm; half-title
Study of a Tree 78
Tiber Valley 80; 66
Tree Trunks in the Campagna 3
Trees and Rocks by a Waterfall 18
View from Mont Mario 9
View of the Acqua Acetosa 10
View of Genoa 8
View of the Sasso 80
View of the Temple of Delphi 77
View of Tivoli 73; 53
Wooded View 4
etchings 33, 52
Harbour with Lighthouse 34
Mercury lulling Argus to sleep 124
the Cowherd 41
The Goatherd 124; 100
The Shipwreck 31
The Tempest 28; 22
Time, Apollo and the Seasons 126; 99
Cephalus and Procris reunited by Diana 101
Coast Scene with Acis and Galatea 116, 118; 94
Coast Scene with Aeneas Hunting 148; 114
Coast Scene with a Battle on a Bridge 114; 93
Coast Scene with Delos 148
Coast Scene with Europa and the Bull 40; 29
Coast Scene with Mercury and Aglauros 126
Coast Scene with the Port of Santa Marinella 48; 37
Coast View of Delos with Aeneas 146, 148; 113
Coast View with Perseus and the Origin of Coral 142, 144; 111
Coastal Scene at Sunrise 145; 109
Delphi with a Procession 96–7; 70
Finding the Infant Moses 53; 42
Harbour Scene with

Campidoglio 32–3; 24
Landing of Aeneas in Latium 149–50; 118
Landscape with Abraham expelling Hagar and Ishmael 137; 107
Landscape with the Adoration of the Golden Calf 109, 112; 86
Landscape with Apollo and Mercury (1645) 92; 58
Landscape with Apollo and Mercury (1654) 118; 92
Landscape with Apollo and the Muses 81
Landscape with the Apulian shepherd changed into an olive tree 118
Landscape with the Arrival of Aeneas at Pallanteum 148
Landscape with Ascanius shooting the Stag of Sylvia 153; frontispiece
Landscape with the Burial of St. Serapia 56; 43
Landscape with Cephalus and Procris reunited by Diana 38, 128, 136; 101
Landscape with a Country Dance 45; 35
Landscape with dancing figures (The Marriage of Isaac and Rebecca, or the Mill) 92, 93–4, 96, 109; 1
Landscape with David and three Heroes 114; 84
Landscape with Erminia and the Shepherds 136–7; 105
Landscape with the Father of Psyche sacrificing to Apollo 129, 132, 149; 102
Landscape with the Flaying of Marsyas 89; 72
Landscape with a Goatherd 39
Landscape with Hagar, Ishmael and the Angel 137; 108
Landscape with Hagar and the Angel 49
Landscape with an imaginary View of Tivoli 73; 57
Landscape with Jacob and Laban and Laban's daughters 112; 90
Landscape with the Judgement of Paris 88–9, 112, 114; 67
Landscape with Narcissus and Echo 68
Landscape with the nymph Egeria mourning over Numa 136, 141; 106
Landscape with a Procession to Delphi 93, 146; 70
Landscape with Psyche at the Palace of Cupid (The Enchanted Castle) 133, 136; 104
Landscape with a River 15, 28
Landscape with a Rustic Dance 64–5; 50
Landscape with St. Maria Cervello 46
Landscape with St. Onofrio 45
Landscape with Shepherds 60
Landscape with Tobias and the Angel 55
Marriage with Isaac and Rebecca 40–1
Mount Parnassus with Apollo and the Muses 150, 153; 121

Mount Parnassus with Minerva visiting the Muses 153
Pass of Susa 28
Pastoral Caprice with the Arch of Constantine 80; 64
Pastoral Landscape 2
Pastoral Landscape 49; 38
Pastoral Landscape 75
Pastoral Landscape with Castel Gandolfo 45, 48; 11
Pastoral Landscape with the Ponte Molle 77, 80, 81, 61
Port of Ostia with the Embarkation of St. Paula 56; 47
Psyche saved from drowning herself 133, 136
Rape of Europa 114
Rest on the Flight into Egypt (1631) 28; 21
Rest on the Flight into Egypt (1663) 28; 21
River Landscape 28; 23
Roman Forum 32–3; 32
Seaport, with Setting Sun 41, 44; 7
Seaport with the Embarkation of the Queen of Sheba 92, 94, 96; 76
Seaport with the Embarkation of St. Ursula 94; 73
Seaport with Ulysses returning Chryseis to her Father 79
Seaport with the Villa Medici 36
Siege of La Rochelle by Louis XIII 28; 14
Temple of Bacchus 69
Temptation of St. Anthony 53
Tobias and the Angel 53, 56; 43
View of Carthage with Dido and Aeneas leaving the Hunt 153
View of Delphi with Procession 142, 144; 110
View of the Roman Campagna from Tivoli 77; 59
View of Rome with the Trinità de'Monte 35–6; 26
Clement IX, Pope 17, 49, 64, 121, 124, 126, 141
Clement X, Pope 17, 121, 129, 141, 148–9
Colonna, Prince don Lorenzo Onofrio 132–3, 136, 153
Crescenzi, Cardinal G. B. 25, 52
Domenichino 65, 69, 88, 89, 105, 112, 136
Flaying of Marsyas 92; 52
Landscape with Tobias laying hold of the fish 55
Dughet, Gaspard 52, 69, 77, 109, 132
described as pupil of Claude 28
San Martino ai Monti frescoes 105
View of Tivoli 63
Elsheimer, Adam 21, 28, 88
Aurora 20
Felibien, André 64
Entretiens 101
Fontenay-Mareuil, Marquis de 61, 72, 89
Grimaldi, Giovanni Francesco 92, 132
St. Stefano Rotondo in an Imaginary Landscape 74
Guistiniani, Marchese Vincenzo 38, 142
Horace 13, 72
Innocent X, Pope 61, 101

Justinus, Marcuis, *Historiae Philippicae* 144
Landscape painting 20–1, 104
literary sources 9, 12–13, 17, 49, 64–5
ruin pictures 21, 25, 32
Maratta, Carlo, *Triumph of Clemency* 149
Massimi, Cardinal Camillo de 142, 144
Medici, Cardinal Leopoldo de 45, 124
Napoletano, Filippo 28, 36, 38
Landscape with a Country Dance 21
Ovid, *Metamorphoses* 81, 118, 144, 146
Pamphili, Camillo 61, 92–3, 96, 108, 133
Pamphili, Gianbattista (Pope Innocent X) 61, 101
Pascoli 153, 157
Life of Claude 17, 81
Philip IV (King of Spain) 49, 52–3, 56–7
Plessis de Liancourt, Roger du 61, 64
Poelenbergh, Cornelis 21, 64, 88
Polidoro da Caravaggio 153
Landscape with the Mystic Marriage of St. Catherine 105, 108; 85
Poussin, Nicolas 17, 40, 52, 69, 101, 108, 114, 142
and Claude 126, 128
Adoration of the Golden Calf 109, 112
Burial of Phocion 104; 82
Cephalus and Procris 116
Dance to the Music of Time 126
Diana and Endymion 116
Time saving Truth 126
Raphael 88, 89, 105, 109, 112, 114, 132
The Adoration of the Golden Calf 87
Reni, Guido, *Aurora 116*
Rosa, Salvator 17, 114, 132
La Babilonia 116
La Pittura 105
Landscape with the Baptism of Christ 105; 83
Rospigliosi, Giulio (Pope Clement IX) 17, 49, 64, 121, 124, 126, 141
Salomon, Bernard, *La Metamorphose d'Ovide figurée 118*
Sandrart, Joachim von 17, 19, 25, 32, 33, 35, 40, 45, 88, 145
Sannazaro, *Arcadia* 12, 13, 17, 92, 116
Swanevelt, Herman van 38, 48, 52
Landscape with Christ tended by Angels 40
Tassi, Agostino 19, 20–1, 25, 28, 41
Seascape with a Shipyard 13
Tasso
Aminta 13, 116
Gerusalemme Liberata 13, 136
Urban VIII, Pope 20–1, 41, 44–5, 48, 61
Val, François du 61, 64
Velasquez, *Pope Innocent X 61*
Veronese, Paolo, *Rape of Europa 40*
Virgil
Eclogues 12, 17
Georgics 72
The Aeneid 141, 145–6, 148, 150, 153
Wals, Goffredo 19, 28
A Country Road by a House 21; 12